# AIRBRUSH:
## The Complete Studio Handbook

# Radu Vero
# AIRBRUSH:
## The Complete Studio Handbook

Edited by Barbara Wood

Watson-Guptill Publications/New York

First published 1983 in New York by Watson-Guptill Publications,
a division of Billboard Publications, Inc.,
1515 Broadway, New York, N.Y. 10036

Published in the United Kingdom by Columbus Books,
24 Red Lion Street, London WC1R 4PX
ISBN 08 6287 031-3

**Library of Congress Cataloging in Publication Data**
Vero, Radu.
  Airbrush: the complete studio handbook.

  Includes index.
    1. Airbrush art—Technique.   I. Wood, Barbara,
1948–       II. Title.
NC915.A35V47   1983        751.4′94        82-21816
ISBN 0-8230-0166-0

Manufactured in Japan

First Printing, 1983

1  2  3  4  5  6  7  8  9/88  87  86  85  84  83

# ACKNOWLEDGMENTS

I would like to express thanks to Barbara Wood, whose literary talent and sensitivity transformed my manuscript into readable, intellectually pleasant English; to David Lewis and Marisa Bulzone of Watson-Guptill, for their continuous encouragement, advice, and professional skill in solving the inevitable problems that occur in publishing such a complex book; to Brian D. Mercer of Graphiti Graphics for his perseverance in creating a beautiful yet practical book design; to Suzanne Haldane, who took the black-and-white photographs; to Laura Penn, who agreed to pose for some of the photographs; and to Lou Suffredine, who photographed all the steps for the color portrait demonstration in Chapter 15—a difficult operation. Dr. Liane Deligdish, Associate Professor of Pathology, Mount Sinai Hospital, kindly assisted in producing the microphotographs.

My gratitude goes also to my wife, who assisted me throughout my work on this book, and to my mother, who posed patiently for several hours for the portrait contained in the gallery and who played an important role in my artistic development with her great artistic sense and sharp criticism.

Special thanks to Roger Musich for his continuous, friendly, and affectionate support together with constructive criticisms and suggestions, and to John Trentalange and Tom Domanico for their assistance in collecting artwork and their patience in listening to and analyzing some points in the book.

Finally, thanks to the artists who enthusiastically shared their knowledge and artworks for the gallery.

# TECHNICAL CONSIDERATIONS

The choice of an airbrush is a subjective decision. No recommendations are made in this book for any particular design or brand, but guidelines are offered in Chapter 1. Any fine instrument will perform well when used for the techniques described herein.

In contrast, Winsor & Newton gouache pigments (in tubes) and Dr. Martin's Transparent Water Colors (in bottles) are recommended throughout. They have been used for the illustrations because of their excellent properties for airbrush work and their large variety of rich, brilliant hues. A consistent system of color names also makes it easier for you to reproduce the exercises and illustrations exactly.

Bear in mind, however, that because of the nature of printing reproduction processes, the illustrations in the book may not always be faithful to the originals. Even with the finest dot screen and highest-quality paper, the halftone dot would be many times larger than the pulverized unit ejected by a fine airbrush. In addition, four-color printing processes, which use combinations of magenta, process yellow, cyan, and black only, are not capable of reproducing the subtleties of tones and hues created by overlapping sprays of an original airbrush work (see Chapter 3). Every effort has been made to print the illustrations accurately, but only by re-creating them yourself will you be able to see exactly what is intended.

# PREFACE

When the United States entered the war against the Fascist powers in the early 1940s, U.S. diplomatic relations with Romania were severed. One of the many consequences was that American movies were no longer shown in Romanian theaters. They were replaced by boring and unwanted German, Italian, and French films, all instruments of Nazi propaganda.

The American movies had been accompanied by truckloads of promotional material, including large display posters for the fronts of the theaters. Under the new regime, theaters were left bare inside and out; some type of promotion had to be devised. Painting poster-size—as large as 10 by 35 feet (3 by 10.5 m)—portraits of movie actors and actresses with the brush was a time-consuming and uninviting solution. Garullo Garulli, an Italian photo retoucher long established in Bucharest, suggested the airbrush, and he demonstrated that he could produce a complete poster, in full color, in one-quarter of the time necessary for the old brush method.

Garulli was a man of simple education and limited talent. His posters were really quite amateurish; their chief merit was the speed with which they were produced. But two of his disciples, Ilie Costescu and Sandu Lieberman, developed a new style based on the principles they learned from Garulli. Costescu, a graduate of the Bucharest Institute of Fine Arts, was gifted with an amazing color sense; Lieberman had enormous ambition, inexhaustible energy, and great physical reserves. Their airbrush work was characterized by realism in design, great rapidity of implementation, and breathtakingly brilliant color harmonies superbly suited to commercial purposes and obtainable only with the airbrush. Lieberman eventually established himself as a portrait artist in New York City, where he died in 1976. One of his last works, a portrait of the late Nelson Rockefeller, is displayed in the Hall of Governors in the State Capitol Building, Albany, NY. Costescu is retired and lives in Bucharest.

This book would not exist were it not for these two artists, who guided my first steps in the field of airbrush. I wish to express my complete and unequivocal admiration for them and their talent.

R.V.

# CONTENTS

# INTRODUCTION

> Professionalism is a very necessary and healthy basis to begin any work, in any field of art. . . .
> —Constantin Stanislavski

The airbrush is a painting instrument that can produce effects ranging from pencillike lines to smooth, uniform areas of color, with countless variations in between. It can build color harmonies that are richer and more subtle than those any brush technique can produce, including a nearly fluorescent effect in adjacent hues. It is a versatile tool that can render both hard materials and nearly insubstantial wisps of smoke or fog. Whereas grading and transparence are laboriously implemented in brushwork, with the airbrush they can be done more quickly and accurately. But the greatest advantage of the airbrush is its ability to translate artists' new, revolutionary visions in a totally different way from classical methods of painting.

Airbrush work has been done for many years, and there are many excellent examples of airbrush illustration. Why, then, is this book needed? Aren't these illustrations proof that artists know everything there is to know about airbrush technique?

The fact is that there are many artists who use the instrument, but only a small percentage of them have mastered the complete range of airbrush techniques. This can be seen in their works, but it is also evident from the way the technique has been treated in existing books about the airbrush. These books end before the complete range of techniques has even been hinted at, and without mentioning the possibility that other ways of using the airbrush might someday be discovered. Some of the books adequately cover the basic masking methods, technical details, and retouching procedures, but learning to use the airbrush this way is like learning to play the piano with only one hand.

A key word in the approach to airbrush technique in this book is *spontaneity*. Airbrush masking is a painstaking and time-consuming mechanical operation. Each spray must be analyzed in advance and planned carefully; the process ensures the accuracy of the final rendering, but it is detrimental to artistic spontaneity. The free artist needs a method of airbrushing that liberates him or her from the constraints of the mask, one that does not interrupt the creative flow of ideas. That method is the use of a continuously moving shield: the artist uses both hands—one with the airbrush and one with the shield—which must cooperate continuously. This free technique does not replace masking; it is an additional technique that enables the artist to work fluently and spontaneously. Nor is the shield the ultimate airbrush method; future artists may well develop an even greater range of techniques to enrich airbrush imagery.

The airbrush was much in favor in the 1920s and 1930s; then interest waned. Recently, however, interest in airbrush has become stronger than ever. This fluctuation may reflect the poor initial use of the tool. The resurgence of interest is probably a result of artists' realizing that airbrush had not yet reached its potential as they struggled for new modes of expression.

A final word of caution: the airbrush is not a miracle instrument. Trying to master it with no prior study of three-dimensional space, the geometry of matter, the interplay of light and shadow, and color relationships leads nowhere. And the airbrush cannot be mastered quickly. It requires patient, tenacious practice and study, and years of effort, sometimes without results.

With this book you can study and learn the basic concepts and techniques of airbrush, but this is only the beginning. Good luck to you!

# Part One.
# Preparations

# THE AIRBRUSH

The first step in the study of the airbrush is an analysis of the anatomy and mechanics of the tool. After noting what is common to all airbrushes, we shall examine the differences between them—not according to manufacturer, but according to the functioning and uses of each type. The purposes of this study are to learn what kind of airbrush is most suitable for a particular style of work and to understand how the airbrush is constructed so that you can repair most malfunctions yourself, without the help of a specialist.

The airbrush is an extension of the hand, which carries out the directives of the brain; choosing the instrument that will best complement this brain-to-hand process therefore involves important subjective considerations. Before discussing the types of airbrushes, however, let us analyze the principles of their operation.

## The Spray-gun Principle

The spray gun is used for large, coarse painting jobs; the airbrush, for more refined and delicate works. But both operate with the same basic principle. To demonstrate this, try a very simple experiment. Fill your mouth with water, bend your head down as shown in Figure 1-1a, and, rounding your lips into a small o, blow the water out forcefully, with pressure from your lungs. The water will stream out; droplets will form only when most of the water is gone.

Now repeat the exercise with your head held upright (Figure 1-1b); all the water will exit in a spray. In this second case the air from the lungs does

not push the water from behind as before; rather, the water is pulled in droplets into the stream of air. The tongue spontaneously lifts small amounts of liquid to the level of the mouth opening. The force of the air stream breaks the bonds between the water molecules (Figure 1-2) and propels the resulting

Figure 1-1. *(a)* Water blown from the mouth while the head is bent downward streams out. *(b)* Water blown from the mouth with the head upright sprays out.

Figure 1-2. Tongue movements bring water to the level of the mouth opening; air pressure breaks apart the water molecules to create a spray.

spray out of the mouth. The smaller the mouth opening and the stronger the spray, the finer the droplets will be.

Simply stated, the spray-gun principle is this: when a liquid enters a stream of pressurized gas, its molecular bonds are broken and it forms a spray of discrete droplets. As the basis for the instrument diagrammed in Figure 1-3, however, this principle would not work, because gravity would pull the fluid down to fill chamber C, and the air stream would push it from behind. The result would be the sort of fluid stream produced by blowing water with the head bent downward. If aperture A is smaller than or even equal to aperture B, however, the air would push the liquid back toward its source (small arrow)

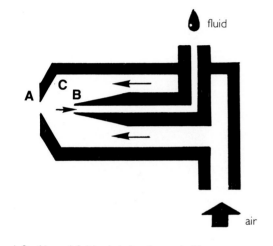

Figure 1-3. Air and fluid admission in a primitive spray-gun system.

instead of propelling it out. (Remember this fact for when you are investigating the cause of a faulty spray.)

We could modify the spray-gun mechanism by extending the fluid tube as shown in Figure 1-4 to remedy these problems. The air could no longer

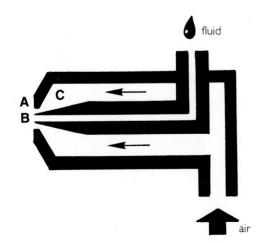

Figure 1-4. First improvement on the initial concept: fluid cannot be pushed back from the opening.

force the fluid backward; but the liquid still flows down by gravity and would produce a messy spatter. A more controlled spray might result if the liquid could be pulled upward somehow.

Reversing the direction of the fluid pipe results in the configuration shown in Figure 1-5. Air forced under pressure (large arrow) exits through aperture A; the fluid, through aperture B. Will this produce a fine spray? In fact, the airflow through A sucks out the existing air in the fluid pipe, which is replaced by fluid; the same thing happens when you drink liquid through a straw. This force-pressure effect was analyzed in mathematical equations by the eighteenth-century physicist Daniel Bernoulli and

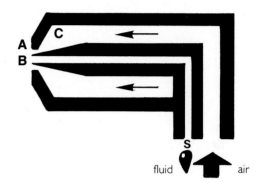

Figure 1-5. Second improvement: fluid is not pulled into the tube uncontrollably by gravity but is sucked upward.

was named after him. The principle is more easily grasped if you consider the direction of the arrows rather than their source; whether air is sucked from A or pushed from S, the principle is the same.

The simplest device constructed with this mechanism is the mouth diffuser (Figure 1-6). If you have ever used one, you are familiar with the coarseness and irregularity of the spray it produces—as well as with the fatigue caused by having to blow

Figure 1-6. The mouth diffuser.

so hard to make it work. The latter problem is easily remedied by replacing human lungs with a source of mechanically compressed air, but further refinement of the air and fluid elements is necessary to create the spray gun.

First, a device is needed to control or even interrupt the flow of air; this is usually accomplished by means of a lever (*L* in Figure 1-7). The lever can block or release air and therefore fluid. A primitive spray gun sprays a spot more or less like Figure 1-8. That spray is adequate for painting large surfaces but cannot be used in artwork. For artwork, a way must be found to spray the fluid in a more regular pattern. The ideal spray is symmetrical, like Figure 1-9; the spray that produces such a pattern is released from the spray gun in the shape of a cone (Figure 1-10).

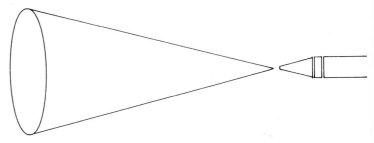
Figure 1-10. A regular pattern is produced by a conical spray.

Figure 1-11. The air and fluid openings must be concentric and coaxial to produce a cone.

Figure 1-7. Air admission can be controlled with a lever.

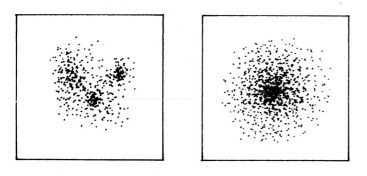
Figure 1-8. (Left) Irregular pattern of spray produced by a primitive spray gun.

Figure 1-9. (Right) Symmetrical pattern of spray obtained with a good instrument.

A conical spray can be obtained by making the air and liquid apertures concentric—having the same center—and coaxial—on the same axis of an imaginary cone (Figure 1-11). The workings of this refined spray gun are illustrated in Figure 1-12. Note that a circular spray pattern results if the axis of the cone is perpendicular to the painting surface; if the surface or the spray gun is slanted, the pattern of the

spray is elliptical. An irregular spray like Figure 1-13 is an indication of mechanical trouble.

With constant pressure this type of device will spray uniformly. To make it suitable as an artistic tool, however, one further adjustment must be made. To change the intensity of the color sprayed, the intensity of the spray itself must be variable, like the pressure of a pencil on paper or a brush against canvas. There must be a way to control the amount of fluid emitted. The additional refinement is a needle inserted in the fluid pipe. Figure 1-14 shows three critical positions of the needle. In *a* it blocks the tip of the fluid pipe entirely so that only air can flow if the lever is in the correct position. In *b* the needle is retracted slightly into the tube and blocks only part of the tip, so that only a small amount of fluid can be released. The needle is fully retracted in *c*; when it is in this position, fluid can be sprayed freely. The position of the needle has to be controlled by the same lever (*L* in Figure 1-7) that adjusts airflow; this lever must therefore have a double action. Of course, the motion of the lever can produce a much wider range of air and fluid release than is illustrated here.

The addition of the needle has another advantage: because it permits closing of the fluid pipe, it is no longer necessary to pull liquid upward. Fluid can be allowed to flow down with gravity. The benefit of this arrangement will be explained later.

These are the basic principles underlying the operation of the airbrush. Only instruments that make use of the double-action lever are used in

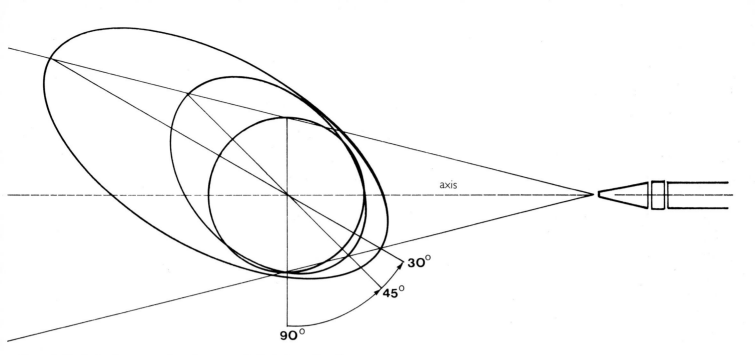

axis

**30°**

**45°**

**90°**

Figure 1-12. A circular spray pattern becomes elliptical when either the spray gun or the surface is not perpendicular.

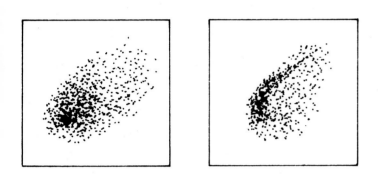

Figure 1-13. Irregular sprays like these are symptomatic of a malfunctioning instrument.

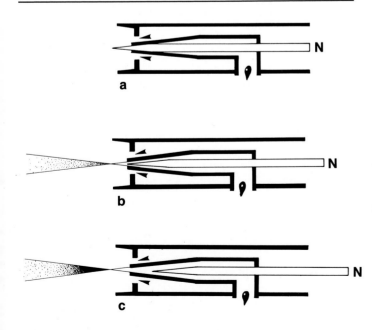

a N

b N

c N

Figure 1-14. Three critical positions of the needle. (a) Air only; no fluid admitted. (b) Some fluid admitted. (c) Maximum fluid admitted.

artwork, so we shall confine the discussion to that type and ignore spray guns and airbrushes having only single-action levers. Keep in mind that although there is a wide variety of double-action-lever airbrushes, their basic mechanism, with the exception of the Paasche Turbine airbrush (see page 16), is the same. Cap, tip, and needle are the three indispensable components that allow air and liquid to work together under the complete control of the lever.

## Choosing an Airbrush—a Comparative Anatomy

The major determinant in your choice of an airbrush should not be its brand or design but the quality of manufacturing. Most will work equally well at first, but some have a shorter life span. Although some parts, such as needles, tips, and caps, may have to be replaced every year or two because of wear, the airbrush itself should last a professional lifetime.

When you buy an airbrush, compare the various brands. On the assumption that weight is indicative of sturdy construction and durability, select a heavier one. Carry with you a small magnifying glass called a linen tester (Figure 1-15) so that you can scrutinize the quality of each airbrush. Examine the finish of the chrome exterior and of the plastic or metal handle. Study the manufacture of the cap, tip, and needle to be sure that these parts are carefully made.

In addition to the foregoing criteria, there are some other factors, including subjective ones, that you must consider when shopping for an airbrush. Without using brand names, we shall describe the

Figure 1-15. Linen tester.

Figure 1-16. Double-action painting instruments:
1. Spray gun—very large and coarse
2. Spray gun—very large but can be used for some details; better hand control than type 1
3. Airbrush—medium-size with large color capacity
4. Airbrushes—for graphic illustration and fine art
5. Paasche Turbine airbrush—for extremely fine artwork and expert touching

components of airbrushes and the variations you will encounter so that you can weigh the advantages and disadvantages in light of your own preferences.

**General Types** The five categories of airbrushes are silhouetted in Figure 1-16; each type is made by many manufacturers in many different models. Categories 1 and 2, which are spray guns, are similar. The first type holds more liquid, but your choice between the two types would be determined by the freedom of movement you need rather than the size of the paint container. More finely detailed artwork could be executed better with the second type, even if the paint container needed refilling several times. Spray guns in category 1 are best for painting simple, large, flat surfaces.

Categories 3 and 4, both of which are used by graphic and fine artists, are related. The difference is that the paint container for category 3 types is usually larger. These categories, especially number 4, are the focus of our study. Category 5, the Paasche Turbine, is a fine-arts instrument as well, but it operates on a slightly different principle. It is without doubt the finest tool for the expert artist and retoucher, but it is not recommended for beginners because it is a delicate instrument capable of producing finely detailed work. As only an extremely skilled airbrush artist would be capable of using the Paasche Turbine, we shall not discuss it here.

**Paint Containers** The five variants of airbrushes in category 4 differ in the kind of paint container they have. Types a, b, and c are cups attached to the body of the instrument. The cups rotate as the angle of the airbrush relative to the working surface changes, so that they always remain vertical to prevent spills (Figure 1-17). A container attached underneath the airbrush body (type b) will not obstruct the field of vision, but it must be small enough not to bump against the working surface when you bring the airbrush tip close for fine details. A cup attached above the airbrush (type a)

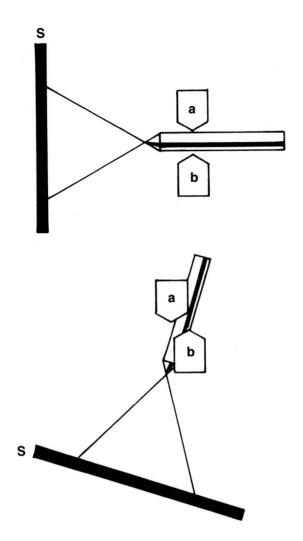

Figure 1-17. Vertical and horizontal positions of paint containers attached above (*a*) and beneath (*b*) the body of the airbrush.

Figure 1-18. Sections of suction-fed (*a*) and gravity-fed (*b*) paint containers.

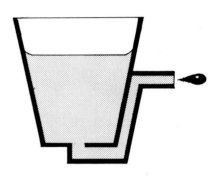

Figure 1-19. Section of a compromise cup.

Figure 1-20. Diagram of the basic airbrush mechanism.

can be larger. It discharges color through gravity, whereas the *b* type releases it through suction. Both types have a lid (Figure 1-18), a simple one in the case of *a* but more complex in *b* because the suction pipe is attached to it. Both also have a hole (*H*) which permits the pressure within the cup to be balanced by air intake as fluid is used.

The cup of type *c* (Figure 1-19) is a compromise between the first two, situated in the middle of the airbrush body. In some ways it is quite practical—it is easily detachable for replacing, cleaning, and adjusting—but it has no lid, so there is more danger of spilling paint, especially for artists who use energetic hand movements. Unfortunately, most fine airbrushes manufactured in the United States are of this type.

Type *d*, a permanently fixed cup, and type *e*, a simple opening in the body of the airbrush, are designed to hold smaller amounts of medium.

**Levers** In order to understand the two different types of double-action levers that control air and fluid, compare Figure 1-12 (page 15) and Figure

1-20 (which is essentially Figure 1-12 plus a needle). Without the needle, the lever that admits air draws fluid instantly. With the needle, air can flow without pulling liquid. The lever must be designed so that it moves the needle as well as controls air intake.

There are two ways of accomplishing this. With the arrangement diagrammed in Figure 1-21, depressing the lever (*a*) releases air only; the fluid is still blocked by the needle. Pulling the lever back (*b*) retracts the needle, which permits the air to draw fluid. The vertical and horizontal movements work independently.

Figure 1-21. The independent type of lever. (a) Air is admitted when the lever is depressed. (b) Fluid is admitted when the lever is pulled backward.

Figure 1-22. The fixed type of lever. (a) No air or fluid admission. (b) When the lever is pulled back, first air only is admitted; further pulling admits fluid as well.

The second type of lever mechanism, called *fixed*, is shown in Figure 1-22. The lever, hinged at point H, moves only backward and forward. When it is fully forward (a), neither air nor fluid is released. When it is pulled backward (b), it first pushes down the valve to allow air to pass through; further movement in the same direction brings the lever against the needle system, which forces the needle to retract and allows fluid to be released. This mechanism is designed so that the lever controls admission of proportional amounts of air and liquid—the more liquid released, the greater the amount of air there is to spray it.

The independent-action lever is operated by two different finger movements, whereas the fixed type requires only one. The fixed type, however, requires greater sensitivity to determine the borderline between air admission and fluid admission. On the other hand, the action of the fixed type is usually looser and easier to manipulate than that of the independent type. The choice of lever type is thus determined by habit or preference rather than by any objective technical superiority of one or the other, as some other writers have incorrectly suggested. Both types are available from many different manufacturers, although the fixed type is found primarily in European-made models.

As the drawings suggest, the needle goes right

through the fluid stream; each designer has contrived methods of preventing fluid spills back into the lever chamber or handle. There is also a variety of systems for returning lever, needle, and valves to their initial positions. In some brands the lever is difficult to move because of too-tight washers, too-powerful springs, or poor manufacturing, so take care to choose an airbrush that you can operate with a smooth, easy, unobstructed finger motion. Some may be a little stiff at first simply because they are new.

**Heads** The assemblage of cap, tip, and needle constitutes the airbrush head (Figure 1-23). The funnel shape of the inside of the cap (C) protects the needle and guides the flow of air. The tip is quite fragile and prone to fluid erosion, so you may have to replace it from time to time. Cap, tip, and needle can all be removed for cleaning, or for replacement with new permanent pieces or with pieces of a different-size set. The finest tip hole measures 0.3 mm, but there are at least two larger diameters for larger works. Most models have a washer (W) between the tip and body; others have only beeswax.

**Handles and Needle Systems** The needle locks into the rear handle, which is shaped to fit comfortably in the hand. The handle also protects the needle system (Figure 1-24), composed of a spring

Figure 1-23. Section of an airbrush head.

| | | | |
|---|---|---|---|
| cap | **W** | washer | |
| tip | **C** | funnel | |
| body | **N** | needle | |
| fluid | ∞ | bubble formation | |
| air | **A** | air admission | |

Figure 1-24. The needle system.

Figure 1-25. Junction between airbrush and hose.

(S), which holds the needle (N) against lever pressure; an action-adjusting sleeve (A), which reduces or expands the path of action of the lever; and a lock nut (L), which permits extraction of the needle.

**Air Connections** On the lower part of the airbrush there is a connector for the hose from the air source (Figure 1-25). This contains the washered valve for air admission (seen in Figures 1-21 and 1-22), a spring to counterbalance the action of the lever, and a valve nut to close the system.

**Your Final Selection** When you have determined which features are suitable for the type of work you plan to do and what type you will be most comfortable using, choose the model incorporating those features that has the highest-quality manufacturing. *Always* purchase two or three extra needles, caps, and tips with the airbrush to ensure that you have spare parts.

Before you use your new airbrush, carefully dismantle it to analyze its construction and compare its specific characteristics with the generalities discussed in the preceding pages. You must be familiar with every detail of your instrument in order to operate, clean, maintain, and repair it properly.

## Air Sources

At the other end of the hose you must have an air source capable of supplying a constant, clean, and uniformly pressurized stream of air. The choice of a source hinges on three factors: cost, the amount of air required, and the acceptable noise level.

A variety of airbrushes can be bought for approximately the same price, but the cost of air compres-

sors can range from less than a hundred dollars up to five or six times as much. If you are a professional, you should consider investing in the best quality in order to enjoy all the benefits a fine compressor can provide.

The accompanying chart analyzes various types of air sources, ranked according to cost. Because prices change over time, $P$ is used to represent the lowest price; the cost of more expensive compressors is expressed in terms of $P$.

Whatever compressor you get, three devices should always be attached to it: a dehumidifier, a pressure regulator, and a pressure gauge.

In the process of compression, the water molecules that are always present in the air condense. The drops will be drawn through the hose and into the airbrush spray to create ugly accidents on artwork unless a dehumidifier is attached to the compressor. It is a simple glass, metal, or plastic container in which the water drops can collect, to be emptied periodically.

A pressure regulator is necessary to maintain uniform pressure from day to day and to change the air pressure to accommodate a change of airbrush dimension, medium viscosity, style or purpose of a work, or for subjective preference.

The air pressure is checked with the pressure gauge. You should be familiar with the meaning of the symbols printed on the gauge (Figure 1-26). The two that appear most often are *psi*—pounds per square inch—and *bar*—$10^6$ dynes/cm² (a dyne is the pressure required to accelerate 1 gram of free mass 1 centimeter per second, per second). These complicated expressions are scientifically determined units of measure. You certainly do not need to know more about the physical principles involved; simply remember that for an airbrush that is used for fine artwork the ideal pressure is about 20 psi (1.4 bar), adjustable according to specific needs.

Pressure regulators must be purchased separately for tanks and small compressors, but they are included with larger compressors, which often have a built-in gauge as well. More specific information about air sources can be found in dealers' catalogs.

Figure 1-26. The pressure-gauge scale.

## TYPES OF AIR SOURCES

| COST | TYPE | ADVANTAGES | DISADVANTAGES | COMMENTS |
|---|---|---|---|---|
| P | TANK | Most economical. Available in different sizes. Completely silent. Practically no maintenance required. No energy consumption. Clean. | Needs refilling. Heavy, therefore not easily portable. Two needed in case one runs out unexpectedly. | RECOMMENDED |
| P | MINI COMPRESSOR | Small, lightweight, not cumbersome. | Noisy, despite advertising claims. Uneven supply of air could spoil work. | NOT RECOMMENDED |
| 1.5P | PUMP COMPRESSOR | No need to oil. Compact. | Somewhat noisy. | RECOMMENDED |
| 2P | PISTON COMPRESSOR | No need to oil. Very sturdy and durable. Capable of powerful air supply. | Quite noisy. | RECOMMENDED |
| 2.5P | TANK COMPRESSOR | Useful for more than one airbrush used simultaneously. Good for spray-gun pressure. Pressurizes automatically when needed. | Needs oiling and maintenance. Usually very large and noisy. | CAUTIOUSLY RECOMMENDED |
| 5P | SILENT TANK COMPRESSOR | Made especially for airbrush use. Silent. Excellent adjustability. Pressurizes automatically. | Needs oiling and maintenance. | FULLY RECOMMENDED |

# CLEANING, MAINTENANCE, REPAIRS, AND HYGIENE

Your knowledge of an instrument is not complete unless you know how to care for it. Even before you have mastered airbrush technique you will be using the instrument for training and exercises, so now is the time to become familiar with routine maintenance.

## Cleaning

If your airbrush is to last for a long time, you must follow this rule: **clean the airbrush thoroughly after every single use,** even if you sprayed a color for only one second. Even in a second the color has enough time to enter the cap and contaminate all parts with potentially clogging material. Undoubtedly, cleaning is the most annoying facet of airbrush handling, but it is absolutely essential.

For routine cleaning after use, follow these steps:

1. Stop spraying, but do not cut off the airflow from the compressor.
2. Detach the fluid container.
3. Point the tip of the airbrush into an absorbent cloth held in your hand and activate the spray to remove any color left inside. Spray until no color is released in the air stream.
4. Plunge the airbrush, head down, into a container of water (Figure 2-1). Move the lever to admit air, work the needle back and forth, and, with the index finger of the opposite hand, alternately obstruct and release the tip so that water is forced back into the fluid pipe. Continue until the bubbles are completely colorless; then spray any water left inside the airbrush.

If you are merely changing colors, the cleaning

Figure 2-1. To clean the fluid pipe of the airbrush, work the lever with one hand while you alternately block and release the nozzle with the other.

operation ends here. If you are stopping work altogether, continue with the following steps:

5. Stop the compressor.
6. Detach the airbrush from the hose.
7. Unscrew the handle and remove the needle and cap.
8. Hold the airbrush under a powerful stream of hot water from the tap (Figure 2-2) so that the hole connecting the body with the color cup is directly under pressure. Wash until a

Figure 2-2. Allow a strong stream of hot water to penetrate the connection hole of the paint container. A thin jet of water should be forced out from the tip when the airbrush is clean.

fine stream of water comes out of the bare tip. If it does not, gently push the needle into the tip until it appears, release it, and repeat the washing until you see a stream of water.

9. Blow the remaining water out from the back of the needle system; then suck the tip (Figure 2-3). Look through the fluid pipe into a light source. If you see the light distinctly as a small circle, the airbrush is clean. If you do not, repeat the cleaning procedure as needed.

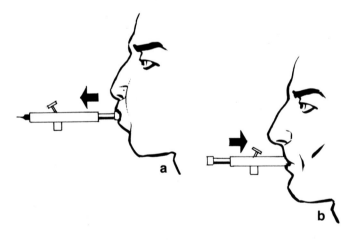

Figure 2-3. Eliminate water by blowing from the tail (a) and sucking from the tip (b).

10. Smear soap between the thumb and index finger of one hand and with them grasp the tip of the needle. Roll the needle in your soapy fingers three or four times, and it should be clean. If the color has dried and hardened, scraping carefully with a fingernail might help.

11. Pass an old number 7 or 8 sable paintbrush over a bar of soap and brush the cap inside and out; then rinse it.

12. Repeat step 11 with any paint containers you used.

These steps apply only to water-soluble mediums, of course. For oils you would use turpentine and for acrylics, lukewarm water. Cleaning must be done *immediately* after spraying.

If you are careful, this cleaning should be sufficient; only very seldom will you have to check the lever joint and air valve for accumulated dirt. Occasionally you should also check the lid of the paint container to see that the pipe and hole are clean.

## Maintenance

In addition to routine cleaning, you should remember to take the following precautions to keep your airbrush in good working order.

At the beginning of a working day, check the parts of the head under a magnifying glass, even if you have noticed no signs of trouble. Then spray some clear water to check for normal functioning (see Chapter 7) and to clean out dust.

Never leave the airbrush attached to the compressor when you will not be using it for four hours or more. Keep it in its box, with the needle withdrawn to protect it from accidental bending. If you are taking a break of at least a quarter hour but not more than four hours, leave the airbrush connected to the hose and hang it on a special airbrush hanger (Figure 2-4). If you do not have a hanger,

Figure 2-4. (Left) Special airbrush hangers are available that you can use to hold the airbrush when it is not in use.

Figure 2-5. (Right) A Roto-Tray makes an acceptable substitute for the airbrush hanger.

stick the handle into an empty hole of a Roto-Tray (Figure 2-5). In either case, detach the paint container; hang the airbrush with the container attached *only* for very short, emergency interruptions. Never leave the airbrush lying on your work table while it is attached to the air hose.

Once every couple of months, lightly oil the needle spring and smear an extremely small amount of petroleum jelly on the joint of the lever and the spring of the air-admission valve. Be very careful when you do this; the slightest excess will ruin the instrument for a while.

The compressor requires fewer precautions. The instructions accompanying a new unit will indicate if and when you should change the oil in the motor box, change the air-admission filter, or inspect the valves. The following steps are recommended for all air sources:

1. Disconnect the compressor from the electrical source when it is not in use.
2. Empty the tank or lower the pressure if you do not plan to use the compressor for more than one week.
3. Empty the dehumidifier at least once a week but more often if necessary.
4. Keep the compressor under some sort of cover, preferably plastic, to protect it from dust, sunlight, and humidity.
5. If your compressor is very large and powerful, set rubber supports underneath it to reduce vibrations. (You may also wish to keep it in a room away from your work space to cut down on noise.)

## Repairs

Once you have studied the construction of your airbrush, you will know the location of the joints that may occasionally need lubrication. Chapter 7 explains how to diagnose problems with the instrument; here are a couple of repairs you can make on your own.

If bubbles of fluid appear where the head joins the body, or if the fluid sprays spasmodically, the washer or beeswax (see Figure 1-23, page 19) in the head may have worn out. If you do not have a replacement, you can use a white plastic glue such as Elmer's. Form an even ring around the screw tip (Figure 2-6), let it dry for half an hour, and gently screw the piece back into the socket. Be sure that no dried glue covers the air-admission opening.

If there are indications that the needle is bent— droplets are too large or the spray lacks uniformity— first scrutinize it with a magnifying glass or linen tester to make sure it has not also cracked. If it has,

Figure 2-6. Apply white plastic glue to the tip screw to replace a worn-out washer.

Figure 2-7. Straighten a bent needle by rolling it on a smooth surface.

you must replace it. If it is only bent, you can sometimes straighten it by rolling the tip with your index finger on a smooth surface like desk-top vinyl (Figure 2-7).

## Hygiene

The airbrush can be likened to a musical instrument in many ways, but unlike a musical instrument it can present certain health hazards unless you take adequate precautions.

**Lungs** When you spray close to the paper or board to make fine lines, very little medium is deposited in a gentle stream of air. When you spray large areas with maximum air and fluid pressure, a rather large percentage of colorant particles bounce back from the surface. Enough of them enter the

Figure 2-8. *(a)* An overhead light for vertical work is best placed slightly behind you. *(b)* If it must be closer to the wall or easel, use a shade.

surrounding air, depositing on furniture and in your lungs, to pose a potential hazard. (Blow your nose after such a spray and notice how much color you have breathed in.) There have been cases of airbrush workers with heavy smoking habits who have developed serious lung diseases, some malignant. So take the following preventive measures:

1. Choose dyes and pigments carefully. *Never* spray toxic colors. You may have to compromise somewhat to achieve the tone you seek with nontoxic colors, but this disadvantage is minor compared to the risk to your health.
2. Always work in a well-ventilated room. Keep windows open if possible.
3. Do not smoke. (And not just during spraying!)
4. Use a face mask for added protection when you do especially heavy spraying.

**Eyes** Natural light is the best light in which to work. Fluorescent light tires your eyes, as well as distorts colors, even if it is compensated.

You will probably need artificial light to supplement daylight. If you work at a desk (horizontally), use a desk lamp with at least a 75-watt, and preferably a 100-watt, bulb. If you work on a wall or easel (vertically), the light should come from ceiling lamps positioned either above or slightly behind where you stand, so that the light will not shine in your eyes, or closer to the wall with a shade (Figure 2-8). A light source to your right or left can produce annoying shadows and tire your eyes.

**Ears and Nerves** Noise can be only slightly annoying, or it can actually interfere with your work, depending on your sensitivity. If your compressor is not quiet enough, try to situate it in a different room and muffle vibrations with rubber supports, as suggested earlier.

**Skin** Keep your hands as clean as you can, and not just to protect your artwork. We all unconsciously rub our eyes, scratch, and even put our fingers in or near our mouths; doing so with dye- or pigment-covered fingers may be irritating or even harmful. Wash your hands between sprays if possible; since you must clean the airbrush anyway, this should not be difficult to remember.

For further information, contact the Center for Occupational Hazards, Art Hazards Project, 5 Beekman Street, New York, NY 10038, (212) 227-6220.

# THE MEDIUMS

Any coloring material that is a liquid or can be made into a liquid can be sprayed in the airbrush. All the painting mediums used in airbrush work are composed of dyes or pigments mixed with a vehicle. The accompanying table analyzes the characteristics of the various mediums.

Such a compendium cannot be exact, however. The vehicle in most cases is a more complex mixture of ingredients that each manufacturer will not reveal. The degree of transparence is not fixed; some transparent colors can become opaque when many layers are superimposed, and most opaque colors are transparent when they are very dilute. By the same token, some glossy colors can be made matte with a special matte medium, and matte colors can be made glossy if sprayed in multiple layers with fixatives. Finally, the use of a particular medium depends as much on the personal preference of the artist as on any other consideration. For instance, Kodak colors (dyes) are specially made for one form of photographic retouching, but an artist might wish to use them to create a particular effect in a work of fine art. With these reservations, however, the table is a useful summary of important information about mediums that is discussed more fully in the following sections.

## CHARACTERISTICS OF AIRBRUSH MEDIUMS

| MEDIUM | STATE | COLORANT | VEHICLE | SOLVENT | TRANSPARENCE* | APPEARANCE | USE† |
|---|---|---|---|---|---|---|---|
| INKS | Liquid | Dye | Water or alcohol | Water | 100% | Glossy | TGFM |
| WATER-COLORS | | | | | | | |
| liquid | Liquid | Dye or pigment | Gum arabic | Water | 100% | Matte/ glossy | RTGF |
| tube | Paste | Dye or pigment | Gum arabic | Water | 80% | Matte | RTGF |
| cake | Solid | Dye or pigment | Gum arabic | Water | 70% | Matte | RTG |
| GOUACHE | | | | | | | |
| tube | Paste | Dye or pigment | Gum arabic | Water | 0–20% | Matte | RTGFM |
| cake | Solid | Dye or pigment | Gum arabic | Water | 0–20% | Matte | TGM |
| ACRYLICS | Paste | Dye or pigment | Polymer | Water | 0–30% | Semiglossy | G |
| OILS | Paste | Dye or pigment | Oil | Turpentine | 0–30% | Glossy | F |
| ALKYDS | Paste | Dye or pigment | Synthetic resin | Water | 0–30% | Glossy | GF |

*0% transperance = 100% opacity  
100% transparence = 0% opacity  
†R = retouching  
T = technical illustration  

G = graphic illustration  
F = fine arts  
M = mechanical work

## State

Liquid colors are the easiest to use in the airbrush because they can be poured into the paint container with no preparation, except when a color is too strong and needs to be diluted or when two or more colors must be mixed to obtain a certain shade. Paste colors in tubes require dilution and/or mixing in a separate container before they can be sprayed.

Although cake colors are as good as other colors, they are slightly less suited to airbrush work because diluting them requires more effort, and the resulting liquid can still contain particles that are too large to flow through the airbrush. For extreme transparence and softness, however, transparent cake watercolors are superior to tube watercolors, which are smoother and richer but tend to become opaque when sprayed in many layers.

## Colorant

The two kinds of colorants are dyes and pigments. Both are solid chemical compounds that can be diluted or mixed with a variety of liquid substances. Dyes are chemical compounds, usually solid, dissolved in a solvent such as water or alcohol; when applied to a fibrous surface such as textiles or paper, they penetrate the fiber structure at the molecular level and bond solidly with it. The layer thus formed is uniform in color.

Pigments are also chemical compounds, mostly found in nature, but they are emulsified, not dissolved, in their vehicle—that is, they retain their solid state at a microscopic level. As a result of this property, they do not combine with or penetrate the surface to which they are applied, but rather stick to it, in a separate layer, with the help of binders added during manufacture.

## Solvent

The amount of solvent—whether water or turpentine—is measured in relation to the specific colorant, the type of work being done, and the purpose of the spray.

Dyes and pigments have different degrees of molecular cohesion and coloring power. Some opaque colors, such as blues, yellows, oranges, and a few reds, require only a little solvent to pass through the airbrush; others, like the so-called earth colors (terras, ochres, and umbers), are "heavy" in the sense that they require a great deal of solvent. (Even so, they clog the airbrush more quickly than other colors.) Blues, oranges, and some reds retain their ability to color a surface, whether dark or light, even when highly diluted. Whites, yellows, and some greens, on the other hand, lose their covering power on dark surfaces if they are too dilute. Your own experience will have to guide dilution specifications.

The kind of work you are doing also affects the decision about how much a medium should be diluted. For a delicate work that requires you to work close to the paper or board, the colors must be more dilute so that the color will spray with little lever movement and low air pressure. If you want an intense tone, you could spray a color with very little dilution; however, a high percentage of pigment in solvent means that more particles accumulate at the tip, increasing the risk of clogging. Therefore, **it is better to spray repeatedly with a more dilute color to intensify a tone.** For a larger work that does not contain many details, you would spray from farther away with deeper lever action and higher air pressure. In this case a color that is too dilute might tend to drip or splash on the work; a color with too little solvent might reach the surface as a powder without the ability to stick—a simple touch of a finger would spoil the work. You must experiment with the colors you use to find the proper balance of medium and solvent.

The purpose of spraying—to color or merely to tint—is the third factor that determines the degree of dilution. When you are tinting, for which colors must be transparent and tend to combine with existing layers of color, the medium can be very dilute. For coloring, the spray must cover the existing layers and so must be denser; the dilution should be kept to a minimum. As an example, white medium diluted to the consistency of milk could be used to suggest a foggy atmosphere in a painting. To paint an area snow white, however, you would dilute the medium only to the consistency of buttermilk.

In short, there is no exact formula to follow for determining dilution. The preceding discussion can be used as a guide, but you will learn best from experience.

## Transparence

The degree of transparence or opacity of a medium is probably the most important factor in determining its choice and use, so more space is devoted to the subject here. What follows is theoretical and highly speculative, so you can skip it if you like; but transparence and opacity are so important to the unique qualities of airbrush art that we urge you to try to understand them. First let us examine transparence as a physical phenomenon before relating it to the airbrush.

**The Nature of Light** Light is a form of radiant

energy. Scientists have debated for centuries whether it consists of particles or waves; in fact, modern science, having found no better explanation, has concluded that it consists of both. Most theoretical, experimental, and practical works in optics have upheld the dual nature of light. The number of light particles, or photons, determines the intensity of the light; its wavelength is responsible for its color. Because we are more interested in color than in intensity, the following discussion focuses on light as waves.

White light—sunlight, for example—is the synthesis of the spectrum, the whole range of visible and invisible wavelengths. In order for us to perceive light, the eye must receive it directly on the retina, either from the source itself or by reflection. Light scattered in space or that passes the retina without touching it is invisible. The "sunbeams" we see passing through clouds or trees are themselves invisible; what we see is only the light reflected into our eyes by dust or water molecules in the air.

Sunlight reflected by a mirror can blind us; the mirror reflects the light almost in its entirety.

Reflected off a sheet of white paper, the sunlight remains white and powerful, but it is no longer blinding; its intensity has been reduced, mainly because the paper absorbs a considerable number of photons. In addition, the uneven surface scatters some of the photons. The absorbed photons, or energy packs, are transformed into a different form of energy—heat, motion, electricity, chemical energy (as in photosynthesis)—depending on the surface they strike. Sometimes this energy can alter the appearance or even the structure of the reflecting material.

When light strikes a surface, these three factors—reflectance, absorption, and scattering—determine the message received by the eye. To understand transparence and opacity in dyes and pigments, and how the airbrush artist can use this knowledge, let us examine what happens when solar light shines on various surfaces. For simplicity, only blue, yellow, and red are considered as the major components of the spectrum, rather than the whole range of colors.

**The Impact of Light on Matter** Figure 3-1 illustrates what happens when sunlight strikes four

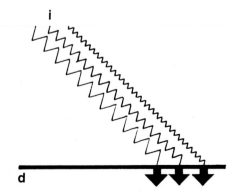

Figure 3-1. Reflections of the three primary colors of the solar spectrum from a mirror *(a)*, white paper *(b)* blue paper *(c)*, and black paper *(d)*.

different surfaces. A mirror (*a*) reflects light almost completely. A piece of white paper (*b*) weakens the reflected light because some is absorbed. A blue surface (*c*) reflects only the blue wavelength and absorbs the rest. Finally, a black surface (*d*) absorbs all wavelengths; no light is reflected.

Now suppose that a transparent blue filter is interposed between the sun and a piece of white paper (Figure 3-2). The filter absorbs the red and yellow wavelengths, but it permits the blue light to hit the paper, which reflects it—and thus appears to be blue. Suppose we changed the position of the filter so that the reflected light also passes through it, as indicated in Figure 3-3. The color seen does not change, but the filter absorbs additional light and decreases the intensity of the reflected light— that is, it seems darker.

There is no indication in Figures 3-2 and 3-3 of the distance between the filter and the surface or of the thickness of the filter. In fact, distance is practically irrelevant, assuming that no other incidental light falls between the two planes; however, the thickness of the filter is responsible in direct proportion for the absorption of light, and therefore the reduction in intensity. In other words, if the number of filters is increased to make a thicker layer, the colored light reflected by the surface will lose even more intensity. Eventually, if the filters or layers are built up to the point where no light reaches the white surface, the light will be reflected by the solid blue layer of filters. At this point the filters have become opaque.

**Dye and Pigment Transparence** This is precisely what happens when dyes are layered on a surface. Like the filters in the preceding examples, transparent layers of dye added on top of other transparent layers eventually become opaque. Pigments, because they remain on the surface of the support instead of bonding with it as dyes do, present a more complicated case.

Figure 3-4 will help clarify the transparence and opacity of pigments and dyes. A transparent blue dye on a yellow surface (*a*) produces a uniform color; the wavelength of the surface color is synthesized

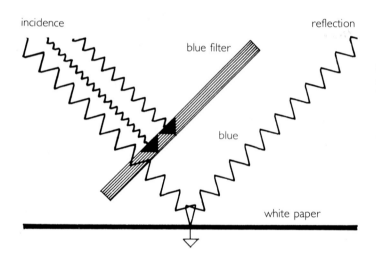

Figure 3-2. White sunlight shining through a blue filter onto white paper reflects blue.

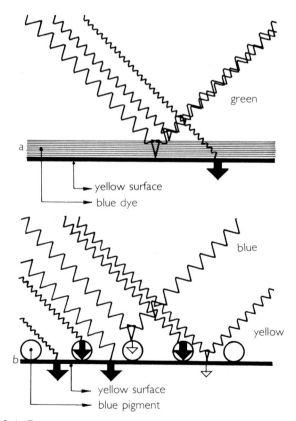

Figure 3-4. Dye transparence versus pigment transparence: in the first case (*a*) the retina receives a synthesized color (green); in the second (*b*), the retina must make its own synthesis of the dual reflection.

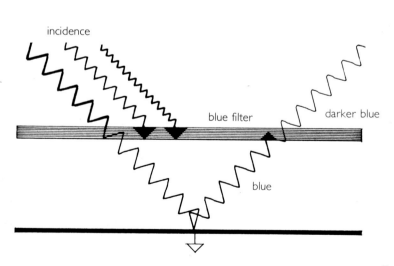

Figure 3-3. If the light reflects back through the same filter, the color is less intense.

with the wavelength of the reflected dye color. The blue pigment (*b*), however, reflects *two* distinct wavelengths—yellow from the surface and blue from the pigment. As long as the dye and pigment are quite dilute, the eye cannot perceive the difference. When the dye and pigment are more strongly concentrated, these facts become evident:

- Because the dye micelle is so small—the size of a molecule—the painted surface appears smooth. The color is uniform; lines and other colors beneath show through its total transparence and are even enhanced.
- Because the pigment particles are considerably larger than dye micelles, the painted surface is uneven; the pigment particles tend to cluster together as they dry. Lines and colors underneath the pigment layer are partially covered by these particles, and so they appear foggy rather than sharp and clear.

**Practical Applications** A single layer of pure, concentrated dye preserves transparence entirely, whereas a pure, concentrated layer of pigment is almost completely opaque. From these observations we can extrapolate methods of obtaining transparence with the airbrush.

- Use dye-based inks and watercolors for superb, crystal-clear transparence when basic drawing elements and/or colors must be preserved or accentuated.
- Use pigment-based watercolors for more delicate transparence, when you want to wash a sort of chromatic veil over basic drawing or color elements, or when you need a subtle tint.
- Use gouache, oils, acrylics, or alkyds in opaque

dilution for an effect that we might call transitional transparence—a smooth transition from a background color to a completely different color. Except for pastels, which are dry, pulverized pigments, blended on a surface rough enough to produce such effects, no other medium or technique performs so beautifully.

Microscopic views of dye (Figure 3-5) and pigment (Figure 3-6) airbrushed onto a clear glass microscopic slide and lit from behind demonstrate the fundamental difference in their transparence. Superimposed discrete droplets of transparent watercolor (dye) produce a darker transparent color; pigment particles block light entirely. A drop of dye on glass crystallizes as it dries because it does not interact with the glass. On paper, however, it penetrates and reacts with the fibers to produce a smooth, continuous finish.

**Airbrush Brilliance** At this point we shall try to explain a related phenomenon that is unique to gouache airbrushing. As you know, red and green, blue and orange, and yellow and purple are complementary colors. If you were to use a regular paintbrush to paint complementary colors in gouache next to each other and blend them at the line of adjacency, the area where the colors overlap would inevitably be a dirty brown color. If you were to apply the same colors with an airbrush, only two operations (two sprays) would be required rather

Figure 3-5. (Left) Microscopic view of airbrushed dye; magnification × 100. The spray was done with Dr. Martin's Transparent Water Color in orange. The drops are not drops of dye but of water containing and outlining the dye. Because the dye particles are molecular in size, they cannot be perceived in a light microscope. Observe that two superimposed drops produce a darker tone.

Figure 3-6. (Right) Microscopic view of airbrushed pigment; magnification × 100. This spray was done with Winsor & Newton lamp black gouache. The actual pigment particles are visible as tiny black dots; the surrounding clear material is composed of the other ingredients of gouache: glue, gum arabic, solvent, and so on.

Figure 3-7. Pigment applied with a brush is flattened, resulting in a relatively smooth surface. Light reflects at a more uniform angle.

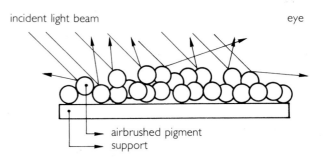

Figure 3-8. Airbrushed pigment particles remain spherical. The resulting surface reflects light in a multitude of angles.

than three as with brushing (two colors plus the blending strokes). More important, the result would be so strikingly vibrant that the colors would seem to be fluorescent.

The following explanation for this phenomenon is only hypothetical; it is not substantiated by any scientific research. Even if the hypothesis proved true, it would probably be incomplete, because it ignores the possible contribution of retinal reactions. Yet it is worthwhile to speculate about this feature of gouache airbrushing because it is a unique effect.

Applying gouache on smooth illustration board with a brush tends to flatten the particles of the medium. The result (Figure 3-7) produces a uniform reflection and very little light scattering. Applying the color with an airbrush, on the other hand, preserves the spherical shape of the particles (Figure 3-8), which can then reflect light in a variety of directions. Thus much more reflected light reaches the eye, and the colored light we perceive is more intense.

To investigate the difference, try this simple experiment (Figure 3-9). Observe a layer of gouache painted with a brush and, separately, another of the same color painted with an airbrush. View the two patches of color from three positions: from the same direction as the light source (1), against the light (2), and from above (3) the surface.

Figure 3-9. Observation of light reflected from brushed and airbrushed gouache from three positions reveals different reflective qualities.

With the brushed color there is almost no reflection from the first position; the color is deep. From the second position, almost all the reflected light is perceived, especially if the angle of incidence and reflection ($\alpha$) is acute and absorption is negligible. At the third viewing angle there is a moderate amount of reflected light.

The airbrushed color is perceived differently. From the first position you can see a considerable amount of reflected light, because of the spherical shape of the particles (which we have accepted in theory); the color is lighter. At the second viewing angle—against the light—the particles are seen on their shaded side, and so the amount of reflection is less. From above, an intermediate amount of reflection is visible, but as was explained earlier (Figure

3-8), the eye receives more light than it would from brushed color. This last observation suggests that one factor of the intensity of an airbrushed color is the structure of the sprayed layer.

A second experiment is a historical one: the work of the Impressionists, particularly of the group known as Pointillists. Painters such as Georges Seurat (1859–1891), inspired by the newly discovered optical theories of light and color, painted with pure primary colors in tiny dots, hoping to achieve a brilliance unobtainable with conventional color mixtures. The results were disappointing; colors synthesized by the eye rather than premixed tended to be dull. According to Faber Birren in *The History of Color in Painting: With New Principles in Color Expression* (Van Nostrand Reinhold, 1980), dots of, say, orange next to dots of violet on a white background in normal illumination lose their iden-

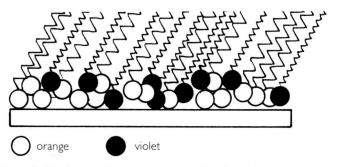

○ orange  ● violet

Figure 3-10. Overlapping colors applied with a brush have an irregular arrangement.

tity and become dull. The former become pinker; the latter, bluer. The eye presumably cannot perceive small particles clearly. Pointillist dots, as if they were an enormous enlargement of a color mixture, suffer from arbitrary, uneven, handmade juxtaposition of irregular amounts of impure pigment (Figure 3-10). Because of the way they are distributed, their wavelengths compose unharmoni-

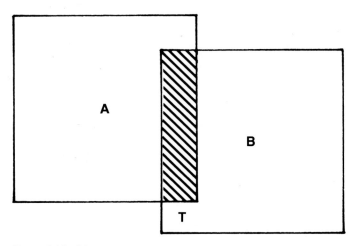

Figure 3-11. Schematic representation of a transchromatic (T) zone.

ous intensities that tend to negate each other. Unlike these Pointillist experiments, in which practice failed to confirm theory, airbrush brilliance is a fact that we can only try to understand.

**The T Zone** The operation of airbrushing two colors side by side with no definite linear border between them is not necessarily fading or grading or shading, and it is certainly not blending. It is rather an overlapping of sprays so that the junction forms a smooth transitional band. We shall call this common area containing both colors the transchromatic (T) zone. One color (A) is always sprayed first and is overlapped by spraying a second color (B) (Figure 3-11)—the colors and sequence are arbitrary. Obviously, the T zone, which begins with 100 percent A and ends with 100 percent B, can be narrow or wide, depending on the design.

Figure 3-12. One color airbrushed over another is applied in a harmonious arrangement.

Figure 3-13. The same colors applied in reversed sequence.

A diagram of the T zone at the microscopic level (Figure 3-12) shows how the evenness of the airbrush spray creates a rhythmical overlapping of B particles over a continuous layer of A particles. In theory this regular pattern reaches the retina of the eye in harmoniously alternating wavelengths, resulting in amplification of the colors. Layer B will cast shadows on layer A, of course; thus the overlapping layer, which benefits from more light, determines the specific hue of the T zone. If the sequence of sprays were reversed—A on top of B—the effect would be different (Figure 3-13).

To test this hypothesis, we selected colors at random—cadmium yellow pale, Bengal rose, and Parma violet (all Winsor & Newton designer's gouache). The first test was with violet over yellow and yellow over violet; the second, with rose on yellow and vice versa. When violet was sprayed over yellow, the T zone was a warm reddish color with no trace of muddy brown; with yellow over violet, the T zone was colder, more green than red, but again with no hint of muddiness. The rose-over-yellow combination produced a fiery, almost fluorescent

orange in the T zone; yellow over rose also resulted in an orange T zone but one that was calmer, more subdued. The conclusion seems to be that a dark color sprayed over a lighter one produces a warm T zone, whereas a light color sprayed over a dark one creates a cool T zone.

Such effects are common in other painting techniques with transparent mediums, but the airbrush has the ability to enhance the brilliance of the T zone. But an additional experiment with the same airbrushed colors produces a curious result. When a black piece of paper with a narrow slit in it (Figure 3-14) is applied over the T zone of the Bengal rose—cadmium yellow combination, the color appears to be an ordinary orange, without fluorescence. The implication is that the fluorescence is

screen

Figure 3-14. The T-zone experiment.

the result of a visual process, an optical illusion produced by the interaction of two color fields. Again, this is merely speculation; there is no scientific basis for the conclusion, and experiments would have to be made with a great many more color combinations to compile useful data. Note also that these phenomena can be affected by a bleeding color underneath or by an insufficiently opaque second color; in both cases the T zone would not be transitional but darker or hue-alien, disrupting the entity. The effects are visible only with stable and 100 percent opaque mediums.

**Conclusions** This book is not a treatise on color; you can extend these preliminary experiments on your own. The important lesson to extract from the preceding digression is that **airbrush opens a new chapter in color illusion.**

The foregoing discussion of pseudo-fluorescence and unusual brilliance of color was not illustrated in color, for an obvious reason. If these visual effects depend on the three-dimensional structure of the layers of colorant, a photograph, which is only a two-dimensional image, cannot capture them. The practical implication of this is that you must consider in advance whether your artwork can be

enjoyed in its original brilliance or is to be reproduced photographically, in which case these effects will be lost.

A final note on transparent colors: inks and watercolors are manufactured in concentrated liquids or color-saturated cakes or pastes that must be diluted before use. If you spray one layer too many of them, the color becomes too dark; multiple layers restore the initial, predilution concentration of the color. Unless you are very skillful and experienced, you can ruin the artwork in a flash. For this reason it is advisable to begin to use the airbrush with gouache; no matter how many layers you spray, the prepared tone remains exactly the same. This book is based upon gouache techniques for that reason.

## Use

Some mediums are more suitable than others for a particular use. Here are some recommendations for their use, in addition to the chart on page 25.

For retouching glossy black-and-white or color photographs, transparent watercolor dyes are the best choice. They go on smoothly and are undetectable on the photograph. Inks are not always clean and even and should not be used where great evenness is required. For matte photographs in black-and-white, gray sets in warm, cool, or neutral tones are used; gouache is used for color.

For technical illustration the acceptable choices are inks, dye watercolors, and gouache for their precision and stability.

Commercial graphic illustrations (such as architectural renderings or medical illustrations) are suited to gouache because of its evenness and opacity; watercolors occasionally are used for special effects such as glass, water, or deep shade. Acrylics are used, but rarely. For relatively small works, tube watercolors produce very smooth, clean results.

The fine arts allow the artist complete freedom of choice; the selection of medium depends solely on the artistic vision and technical strategy. There are a few limitations, however. Some colors are fugitive (impermanent), especially in gouache, and therefore obviously unsuitable for lasting works of art. Also, some dye-based mediums can bleed badly into successive layers. Although gouache is chemically more stable than oils or acrylics, it is more delicate and susceptible to mechanical and climatic decay, and there is no good fixative for it.

# THE SUPPORTS

Theoretically, one can spray on any solid material. Generally, the supports range from cloth and paper to metal, plastic, and glass. Because this book is limited to the study of commercial and fine art, however, the relevant supports are fibrous materials: paper, illustration board, and canvas. Working with airbrush requires some knowledge of how to choose and prepare the support. The accompanying chart classifies those that are suitable for airbrush. These classifications, based as they are on personal experience, should be taken as suggestions rather than precise prescriptions.

## CHARACTERISTICS OF SUPPORTS

| SUPPORT | TYPES | COLORANT* | SUITABLE MEDIUMS† | NEED FOR PREPARATION |
|---|---|---|---|---|
| *White* | | | | |
| Paper | Chrome-coated | T | I | No |
| | Glossy | TD | IW | No |
| | Watercolor | | | |
| |   hot-pressed | D | W | Yes |
| |   cold-pressed | DP | WG | Yes |
| Illustration | | | | |
| board | Hot-pressed | TD | IW | No |
| | Cold-pressed | DP | IWGAK | No |
| Canvas | Fine-textured | DP | IWOAK | Yes/No |
| | Coarse-textured | DP | OAK | Yes/No |
| *Colored* | | | | |
| Paper | Silk-screened | TDP | IWGOAK | Yes |
| | (Coloraid, | | | |
| | Chromarama) | | | |
| | Printed—glossy | TD | IOAK | Yes |
| | Printed—matte | TDP | IWGAK | Yes |
| Illustration | | | | |
| board | Matte | DP | IWGAK | No |
| | Semiglossy | TDP | IWGAK | Yes |

*T = india ink    †I = inks    O = oils
D = dye            W = watercolors    A = acrylics
P = pigment       G = gouache      K = alkyds

## Support Materials

There is such a vast variety of papers that the airbrush artist should never have difficulty finding exactly the right kind for a specific job. Paper is a mixture of various proportions of cotton or linen rag and wood pulp. As the proportion of wood pulp decreases, the quality of the paper improves. Although in theory, as we have said, you could use any paper for airbrush work, in practice you should avoid papers, even fine-quality ones, that are not 100 percent rag. A nonhomogeneous surface absorbs water erratically, and the wood fibers tend to curl up above the surface, making it "hairy." This unpleasant effect is peculiar to airbrush painting; "conventional" brushwork flattens these curls. Airbrush work dampens any support with fluid and makes it curl; proper preparation of paper and canvas is the first step toward preventing fluid damage.

Illustration boards are already strengthened with glues and layers of paper to resist curling, though a great deal of water could still warp them. Hot-pressed illustration boards have been subjected (as the name indicates) to powerful pressure under heat, so that their surface is smooth and can be worked on with penetrating dyes or inks. They are more suitable for precise and mechanical works. Cold-pressed illustration boards, manufactured without heat, have a rougher surface, so they grip pigment and vehicular glues better.

There is such great variety in types of canvas—textile materials, coarseness, flexibility, durability—that the choice is a matter of subjective preference. A white canvas sprayed with dye watercolor needs no preparation, but oils and acrylics work much better on gesso-prepared surfaces.

## Colorant and the Choice of Support

As we discussed in Chapter 3, the colorant of all mediums that can be used in the airbrush is either dye or pigment. Dye-based colors can be used on almost all fiber supports because of the ability of dyes to interact with fibers. The exception is chrome-coated paper, which is coated with a layer of chalk that prevents interaction with dyes.

Pigments, which do not interact with the support but stick to it superficially, need an uneven surface or "tooth" to form a stronger bond. As the table indicates, cold-pressed white paper and illustration board, nonglossy colored paper and illustration board, and canvas are the best choices for pigment-based mediums.

## Medium and the Choice of Support

Totally liquid mediums—inks and watercolors—can be sprayed on any type of paper or illustration board. More viscous mediums (those that have a consistency more like buttermilk than milk) should be sprayed on less smooth, more richly textured surfaces for a better grip.

Gouache and acrylics can be used on any sort of cold-pressed (texturized) paper or illustration board. Gouache, oils, and acrylics work exceptionally well on silk-screened papers (brand names Coloraid and Chromarama). Their layer of printing ink repels water, and they have a superbly matte, velvety-textured surface. It is difficult to brush gouache on such a surface, but gouache is easily applied with the airbrush. Oils are traditionally sprayed on prepared canvas, but they work perfectly on silk-screened supports; the oil cannot penetrate the surface to stain, smear, transpire, or distort.

## Transparence and the Choice of Support

Transparent colors are more often used on white, off-white, or barely tinted supports so that the underlying color does not complicate the effect. With opaque colors the support color is less important. Many artists prefer to paint on white, but sometimes using a colored background can simplify and enrich the values of the work to be done. From an artistic point of view, an overall mood created by a certain dominant color or a transparent illusion can influence the choice between a white and a colored support.

## Colored Supports

Colors are available in illustration papers, illustration boards, and silk-screened papers. You can also make your own colored support. We shall evaluate each of these separately.

Colored illustration papers and boards are not usually used in airbrush work. The papers were not designed for airbrush and are available in only a limited range of colors. If you decide to use them for a particular reason, they must be prepared as described in the following section. Most colored illustration boards are of poor quality; they were designed for rough poster work, signs, and show cards. The number of available colors is limited as well. They are definitely not recommended for airbrush work.

Mat boards, mainly Bainbridge boards, although manufactured for another use entirely, are quite suitable for airbrush work. Their texture is good, and they are available in a wide variety of elegant tones. They are recommended, but you must consider their wood-pulp content as described for paper.

Silk-screened papers—Coloraid and Chromarama—are superb airbrush supports. Each

brand is available in about two hundred clear, even hues. The sheets are very thin and wrinkle easily, so they must be prepared according to the directions in the next section.

There may be times when you cannot find the exact color you want in ready-made colored paper, or when the color is not available in the kind of paper or board you need; in such cases you can prepare your own colored support. Use white illustration board, or paper prepared with the method described in the following section, and apply gouache with a 3- or 4-inch (7½- or 10-cm) camel-hair or synthetic brush. Paint in parallel strokes from top to bottom, then from left to right in strokes perpendicular to the vertical ones. Repeat alternating vertical and horizontal brushstrokes until you can observe no brush marks in the wet paint. If you complete the whole operation while the paint is still wet, the dried finish will be very smooth. You will have to practice doing this to get just the right dilution of the gouache and the proper number of coats, and to acquire some skill in brush stroking and pressure.

A method of painting custom backgrounds, uniform or graded, with the airbrush is described in Chapter 7.

## Preparation of Papers

The airbrush artist faces the same unpleasant problem with paper as do artists who use gouache and watercolor with brushes: paper tends to expand under the influence of liquid. The difficulty is perhaps more acute in airbrush work, where even a slight change of angle between spray and support can produce unexpected and undesirable effects. (Some airbrush artists have learned to take advantage of these effects by wrinkling and creasing the support, then spraying at a certain angle to obtain unusual textures and patterns.)

**Mounting Paper on a Board** Illustration board is sufficiently rigid to resist water distortion, but papers must be stabilized on a support. The usual board for this is inexpensive "newsboard," which is thick, heavy, gray, and sturdier than illustration board. The procedure described here for pasting paper to board is valid for any type of paper you may choose to work on.

1. Set the paper (P in Figure 4-1) loosely on top of the support board (S); if the paper is colored, place the colored side down.
2. Pour some rubber cement (G) onto the middle of the paper.
3. Spread it over the paper in an even layer with a piece of cardboard (a metal spatula would

Figure 4-1. Paper (P) must be stabilized by mounting it on a board (S). Spread rubber cement (G) all over the paper with a spatula made of cardboard (B).

scratch the paper, and a brush is too soft, slow, and uneven), cut to 3 by 9 inches (7.5 by 23 cm). Work quickly, before the cement begins to dry, and be sure to cover every inch of the paper. Any excess can overlap onto the edges of the support.

4. Set the paper aside, and cover the board with rubber cement in the same way. Allow paper and board to dry; there should be no pools of wet cement.
5. After making sure that your hands are very clean, hold the paper at the corners with your fingertips and apply it to the board carefully, glued sides together, beginning with one edge (see Figure 4-2). (If the surface is large, you may need someone to help you.) Do not touch the surface of the paper.
6. When it is flat on the support, cover it with tissue paper and gently rub with the palms of your hands. Do not move the tissue; friction could mar the surface of the paper.
7. If any air bubbles remain, do not continue to rub but make a tiny cut with a razor blade on top of the bubble. Press, through the tissue, until the air is expelled from the bubble and the paper lies flat.

Figure 4-2. Carefully apply paper to board, glued sides together. Once the surfaces touch, there is no way to separate them without damage.

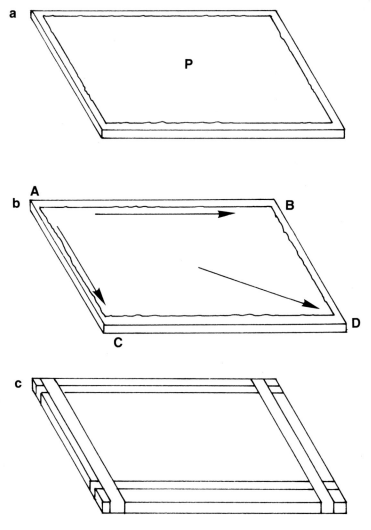

Figure 4-3. Trim paper and board edges together. Use a metal ruler to get the edges straight.

Figure 4-4. Temporarily stabilize paper you do not wish to mount on a board by dampening it on a wooden board (a), stretching and tackling the corners (b), and taping the edges with masking tape.

8. When the paper is smoothly applied, cut off the excess board, biting into the paper as well (see Figure 4-3), so that the finished piece has clean edges. Use a straightedge if you need a guide.

If you prefer to keep a board frame around the paper, use better-quality board and cement the paper to it as instructed. When the paper is smoothly attached, cut around the edges but through the paper only, discard the paper strips, and clean excess rubber cement off the board with your finger or a special pickup. If the cement has stained the surface, clean it with rubber cement thinner on cotton swabs or balls.

If some part of the paper that has been insufficiently glued puckers during spraying, wait until it is completely dry, then press gently with a piece of tissue. The wrinkles should vanish.

**Preparing Paper Without a Board** For various reasons you may not wish to mount the paper, yet it must be reinforced temporarily. For this you need a wooden board large enough for the paper to fit.

1. Lay the paper on the board (refer to Figure 4-4) and dampen it thoroughly with water in a sponge. Wait while the paper expands.
2. Drive a thumbtack or pushpin into corner A and stretch the paper vertically toward corner C. Drive another thumbtack there.
3. Stretch corners B and D and secure them.
4. Apply strips of masking tape 1 or 2 inches (2.5 or 5 cm) wide over all edges of the paper. Press to obtain a strong bond between paper and

board. Let the paper dry.

Do not panic if the paper wrinkles. In 30 minutes or so, depending on the type of paper, it will lie absolutely flat and taut, ready for airbrushing. When the artwork is finished, remove tape and tacks and trim the paper.

## Preservation

Some airbrush works are only temporary, to be used for reproduction; others—fine artwork, including particularly good commercial pieces—need to be preserved. Oils or acrylics on canvas are easily preserved because of the flexibility of the mediums and the durability of the support. Inks and watercolors on paper or silk (dyes spray beautifully on stretched silk) also last well. Gouache, however, is quite fragile.

For short-term preservation, an acetate sheet provides some protection from dust, saliva, finger

marks, water, and abrasion, all of which can double your retouching time or ruin a work altogether. If you want to preserve a gouache work for many years, eliminate all fugitive and semipermanent colors from your palette. Staining colors react chemically with other colors, and impermanent colors will fade and eventually disappear.

No matter how strong the paper is, a valuable airbrush work in gouache should be framed under glass, like pastel and charcoal artworks. The latter can be fixed, but airbrushed gouache can be totally altered by even the clearest fixative, which destroys the brilliance and light-reflective qualities of the colors. If you do not mind losing these characteristics and decide to use a fixative on gouache, note that fixative tends to enhance the transparence of the sprayed colors, so any earlier layers applied with a brush may suddenly resurface and ruin the effect.

# DRAWING TRANSFER

Unless you are painting entirely spontaneously, working out form and color directly on the support as you go, rather than from a preliminary design or even a concept, you must plan an airbrushed work thoroughly before spraying. The nature of this painting instrument—its clean quality and precision—makes sketching on the background undesirable. The support must contain only the minimum number of lines of reference, the information necessary for executing the design accurately. Details that will be covered by initial sprays can be transferred at a later stage.

An illustration will perhaps clarify the meaning of "lines of reference." Suppose you were given the black-and-white photograph shown in Figure 5-1 and were asked to do a detailed rendering of it in color. You could not transfer a detailed drawing to the final support, but only the basic lines that indicate the structure of the face, as shown in Figure 5-2—enough information to guide you in your interpretation of the photograph. The more experienced an artist becomes, the fewer lines of reference he or she needs.

The lines of reference can be transferred, however, only after the drawing is in its final form. Airbrush work can be altered, but it is difficult to do so and the results of attempts are not always accurate. The pencil drawing can be done on any paper you like; however, because you may have to handle the drawing several times—to enlarge it, to cut masks, to transfer additional details—sturdier papers work better. The ideal kind is good-quality vellum, which is fairly rigid and translucent and holds up well during multiple operations.

## Enlargement

The initial pencil drawing need not be done to the same scale as the final airbrushed work; you should not let size requirements hamper your creativity. Most artists can better study a 12-foot-square (10 m²) mural on a 12-inch-square (0.1 m²) sheet of paper. Work out the design in its approximate proportions at whatever size you find convenient; then enlarge it to the correct measurements.

There are several ways of enlarging drawings:

Figure 5-1. Detail of a black-and-white photograph to be copied.

Figure 5-2. Minimal lines of reference drawn for the airbrush rendering of the photograph.

with square grids, by projection, with the camera lucida or camera viewer, and freehand.

**Square Grids** Master artists and pupils alike have for centuries used this enlargement method, which is simply to superimpose a grid of small squares on a drawing, then copy each square into a larger grid. Although it is time-consuming, it does have its advantages. It is extremely accurate. It is useful for high degrees of enlargement, so it permits large designs to be studied and adjusted in a manageable small size. The enlargement is not a mechanical copy; it is a continuation, even a refinement, of the drawing. It is recommended in all cases, especially when a final drawing is necessary and masks must be cut (see Chapter 6).

**Projection** Projection can be achieved with manufactured machines or even with a simple handmade one. This method works well for very large finals when speed is more important than accuracy of shape or size. A principal disadvantage of projection is that the projected image can be considerably distorted laterally and expanded inaccurately in one direction if the lens is of poor quality or if the axis of the conical beam is not perpendicular to the projection surface. Such distortion can be minimized by keeping the image to be projected much smaller than the projectable field (as in perspective drawing or projective geometry, where the visual angle is restricted to some 60 degrees). To test the accuracy of the projection, draw a precise square on the original image and measure the projected image of it. If all the angles are 90 degrees and all the sides are equal in length, there is no distortion. If there is some distortion, adjust the position of the projector until the distortion disappears.

You can easily build your own projector. Follow the diagrams in Figure 5-3 and use the following materials:

1 magnifying glass, 4 inches (10 cm) in diameter (1 in Figure 5-3)
2 200-watt light bulbs (2)
1 cylinder to hold the lens (lens barrel—3)
5 sturdy pieces of plywood, 16 by 16 inches (40.5 by 40.5 cm), for outer walls (4)
5 sturdy pieces of plywood, 14½ by 14½ inches (35.5 by 35.5 cm), for inner walls (5)
6 mirrors, 2 by 13 inches (5 by 33 cm) (6)
2 hinges (H)
1 latch
2 bulb sockets
electrical wire
plug
power switch
nails
white plastic glue (such as Elmer's)

The rear panel is hinged so that it can be opened (dotted lines in the drawing). The image to be projected is taped upside down on this panel (arrow).

This rudimentary projector may seem excessively primitive, but it is quite serviceable. The only caution is that the light bulbs generate a great deal of heat, so only drawings to which you are willing to risk damage can be used. With valuable originals you must either make a copy that can be put into the homemade projector, or use a manufacturer's ventilated model.

**Camera Lucida** This small device has many functions in addition to enlargement: copying, reduction, distortion, correction, reversal. It can even be used with drawings made directly from nature. A virtual image is projected, with the help of a dozen different lenses, onto the drawing paper and must then be copied freehand. The camera lucida is recommended for small projects.

**Camera Viewers** These heavy, expensive office machines are more useful for the art director than for the artist. They are included here because they can be used for enlargements if nothing else is available, or if the original is too small or unclear to be enlarged with square grids. The camera viewer can enlarge only up to four times original size; greater increases require two or three operations.

plan

front view

sagittal section

Figure 5-3. Elevation, plan, and sagittal section of a homemade projector.
Key:   1 = lens □ 2 = light bulbs □ 3 = lens barrel □ 4 = outer walls □ 5 = inner walls (these slide in and out of the outer walls) □ 6 = mirrors □ H = hinges

**Freehand** The fine artist who revises initial drawings in the process of enlargement is better off using the freehand method, in which there is no mechanical interference between artist and artwork. Even the best artist, however, must resort to mechanical assistance for enlargements to mural proportions.

## Transfer

When the drawing has been refined and enlarged, it is time to transfer the lines of reference to the final support. For this process you may use manufactured transfer paper, or you can make it yourself. Except for graphite papers, however, which leave soft lines like pencil marks, commercial transfer papers leave traces that are too harsh for the subtlety of airbrush work. In addition, the lines tend to interfere with the spray, even when they are

claimed to be greaseless. You cannot erase the marks left without spoiling the airbrush work at its most delicate points.

Homemade transfer papers are more often superior; your intuition and experience will help you choose the best kind of transfer device.

For a white, gray, or light neutral background, a graphite transfer is sufficient:

1. Rub a number 6B lead all over the back of the pencil drawing to be transferred.
2. Wrap a piece of cloth or paper towel around an index finger and rub hard over the graphite. Continue until the individual strokes of the lead disappear and merge into an even, foggy gray.
3. Blow away any excess particles of graphite.
4. Place the graphite side of the drawing in

contact with the surface to be sprayed and trace the lines of reference with an F or H pencil. Be careful not to smudge the graphite onto the support.

5. If the design requires a great deal of work, including work with compass, ruler, french curve, and so on, fasten the transfer paper with narrow pieces of masking tape in two corners. This will hold the drawing in position while allowing you to lift it periodically to check for mistakes or omissions.

6. When you have finished the transfer, remove the transfer paper and preserve it; you will need to use it again to cut masks (see Chapter 6), copy details covered by initial layers of paint, and sometimes (though this is undesirable) to make changes in the drawing.

Your lines of reference might show through the spray if they are too powerful or too different in color from the background spray. Therefore, you should have a set of pastels or chalks (they need not be the finest quality) so that you can select an appropriate color for the drawing lines. For example, on a dark blue background that is to be sprayed with light blue, use a medium blue for the transfer; it will be clearly visible on the background, but will fade entirely under the spray. For an orange spray on the same dark blue background, you could use a reddish chalk, which would be sufficiently light to show against the blue but dark enough to be covered by the orange spray.

If the background is nonuniform, use as many different pastels as you need to adapt to the changing colors.

# MASKS

Masking in airbrush technique is as important as having the full number of strings on a violin; you cannot work without it. Whereas brushwork creates its own outlines, airbrush strokes are comparatively fuzzy; precise outlines can be made only with the help of additional devices: masks and shields.

By definition, anything solid interposed between a support and a spraying airbrush is a mask. A coin, a leaf, a shield, a paper clip, a template, a comb, a finger, a piece of gauze or wire (Figure 6-1)—these are only a few random examples of the endless possibilities of masks that already exist, awaiting the artist's inventiveness. The intricacy of design in most airbrush works, however, requires that the artist prepare special shapes for each work.

No matter how complicated it is, a mask is nothing more than curved and straight lines assembled in a particular pattern. Straight lines are easy; they can be drawn and cut either freehand or with a ruler. Curves require more analysis. There are two categories: geometric and geometrically nondefinable; the latter must be drawn freehand. The human profile would be an example of a geometrically nondefinable curve.

## Constructing Curves

To understand the nature of the curves you will use in airbrush work, it is necessary to take an excursion into the realm of geometry. This theoretical subject is difficult, but it is so often neglected—and such an integral part of airbrush technique—that it is worth the effort, so bear with the digression. What follows technically belongs in the chapter on masking technique, but because airbrush rendering demands a precise, accurate mask, the theoretical discussion of curves serves a better purpose here. The two qualities of curves that we shall attempt to explain are *continuity* and *flow*.

**Continuity** Examine the two curves in Figure 6-2. At first they look similar, and indeed to most people they may seem identical, but upon further scrutiny the artist can see that curve *b* is more pleasing than curve *a*. The geometer has no trouble explaining why this is so: curve *a* was obtained by inscribing arcs of four circles from centers $A, B, C$, and $D$ with a compass (Figure 6-3a); curve *b* was obtained by attaching a continuous piece of string to two nails, $A$ and $B$ (Figure 6-3b), and drawing the curve with a pencil ($P$), guided by the taut (and not stretchable) string. The string has a constant length of $a + b + c$. The length of $c$ is always the same; $a$ and $b$ can change, but their sum is constant. Thus the law determining the construction of this curve, which is an ellipse, is valid for every position of $P$. The curve is geometrically continuous.

In Figure 6-3a, on the other hand, arcs $mn$ and $pq$ were drawn with the compass opened to radius $R$, whereas arcs $mp$ and $nq$ have a radius $r$. The change of radius at points $m$, $n$, $p$, and $q$ results in the discontinuity of the curve; arcs $mn$ and $pq$ are defined by the law of $R$, but $mp$ and $nq$ are defined by $r$.

Yet this curve is *optically* continuous because of another law that you should learn (refer to Figure 6-4): arcs of two circles of different radii that join at a point $J$ are optically continuous when point $J$ falls on the same straight line $AB$ as the centers of the two circles. According to this statement, as long as points $C_1$, $C_2$, and $J$ can be connected by the same line, $J$ can be located outside the segment uniting centers $C_1$ and $C_2$, or, as in Figure 6-5, anywhere between them. In the second case the curve is shaped like an $S$; point $J$ determines the reverse of the curvature. In geometry this point is called a point of inflection.

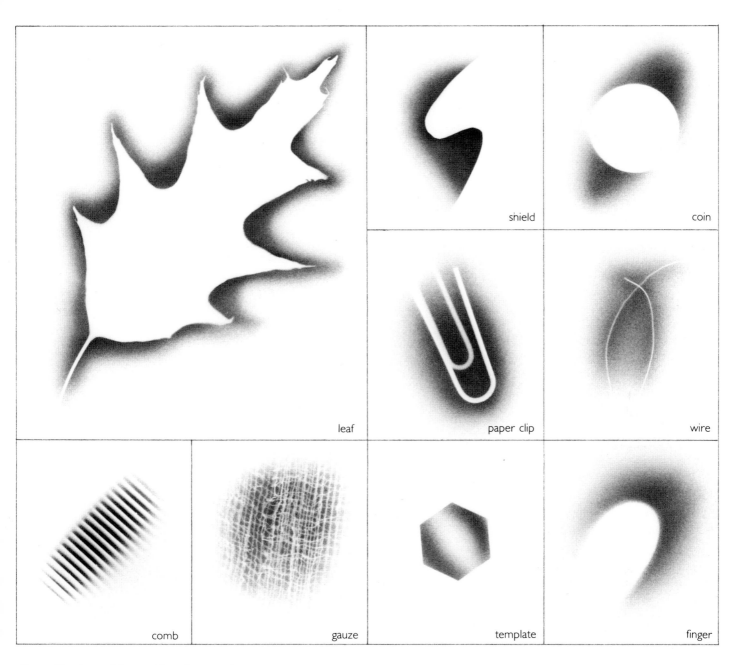

Figure 61-. Any solid material can be a mask.

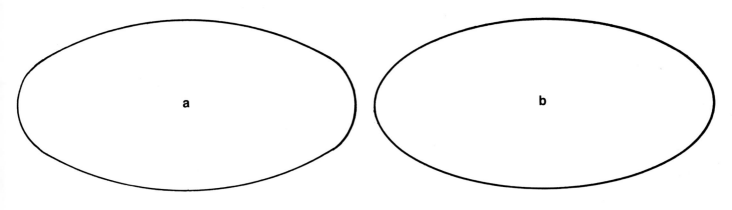

Figure 6-2. These two ovals look almost identical, but they are geometrically different.

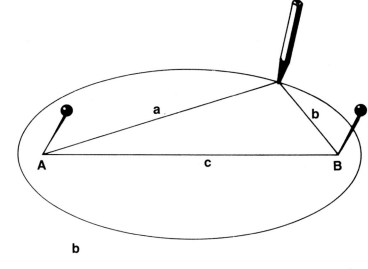

Figure 6-3. *(a)* An oval constructed with four centers and four arcs. *(b)* An ellipse constructed with two centers, taut string, and continuous pencil movement.

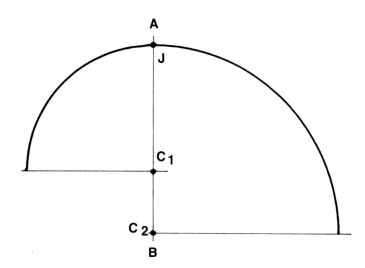

Figure 6-4. A continuous curve constructed from two circles, $C_1$ and $C_2$, that have different radii. Junction point $J$ is located on the same straight segment $AB$ as the centers of the two circles.

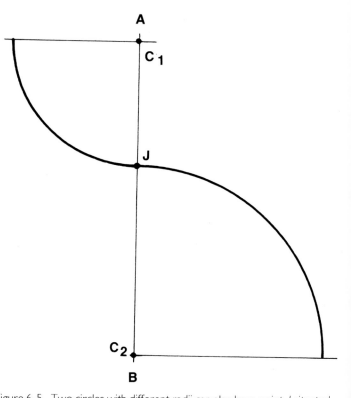

Figure 6-5. Two circles with different radii can also have point $J$ situated between their centers; this is an inflection curve.

The rules learned so far are helpful for constructing curves composed of continuous arcs of circles. In masking and freehand drawing, however, most composed curves are not circle-based and the problem of centers is practically unsolvable. Therefore, we must use another geometrical property. As shown in Figure 6-6, a line drawn at point $P$ on a circle, perpendicular to the radius $R$ and not sectioning the circle but touching it at a single point, is called a tangent. In Figure 6-7, two circles that intersect at point $A$ can have tangents $T_1$ for circle $C_1$ and $T_2$ for circle $C_2$. The tangents intersect at point $A$ to form a certain variable angle $\alpha$.

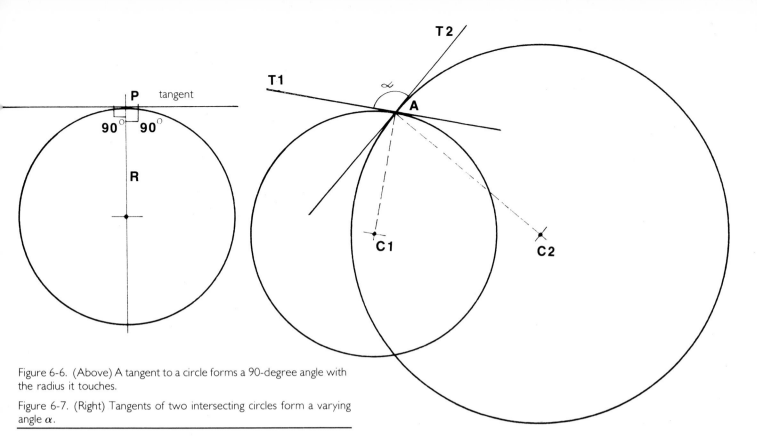

Figure 6-6. (Above) A tangent to a circle forms a 90-degree angle with the radius it touches.

Figure 6-7. (Right) Tangents of two intersecting circles form a varying angle $\alpha$.

Now refer back to Figures 6-4 and 6-5. According to previous statements, tangents drawn through $J$ for circles $C_1$ and $C_2$ would form a 90-degree angle with the common line through the centers $AB$. The two tangents are therefore identical (sketch them in to prove this). We can therefore conclude that two circles—and by generalization two curves—are continuous if they have a unique tangent at their points of intersection.

The best way to draw a continuous curve made up of arcs of circles is to apply the first rule: having their point of intersection fall on a line drawn through the centers of the two circles (Figure 6-8). If the segments of the curve are not arcs of circles, however, a french curve rather than a compass must be used to construct them. In this case the tangent rule is the one to follow. You would proceed as follows (Figure 6-9):

1. Sketch curve $ABCDE$ freehand.
2. Based on your familiarity with french curves, establish practically traceable segments of the curve with end points $A$, $B$, $C$, $D$, and $E$.
3. Draw straight lines $T_1$, $T_2$, $T_3$, $T_4$, and $T_5$ through points $A$, $B$, $C$, $D$, and $E$; these are tangents to the curves.
4. Apply the appropriate french curve to segment $AB$ and adjust it so that it becomes tangent to $T_1$ and $T_2$ at $A$ and $B$ respectively. Draw the segment.
5. Apply the appropriate french curve to segment $BC$. Adjust as in step 4.

6. Draw the segment, paying particular attention to the continuity between segments $AB$ and $BC$ at point $B$.
7. Continue with the same procedure to complete the curve. Note that point $C$ is an inflection point, so the next segment, $CD$, must be drawn from the other side of $T_3$.

**Flow** Suppose you were to succeed in composing a curve whose continuity is so good that no one could say where the $J$ points are, but you are still not satisfied with it. Even though technically beyond reproach, it lacks an aesthetic quality—it has no motion, no life. Figure 6-10 shows such a curve; it is flawlessly continuous, yet it seems clumsy, especially at $A$ and $B$. Of course, you may need exactly this shape for a particular piece of art; but for most applications the connection at $A$ is too sharp, the two sides of $B$ are too straight, and the segment at $B$ which unites the two sides is too small. Geometric logic has nothing further to do with the problem; artistic considerations take over.

With a tissue begin to correct the curve in pencil as shown in Figure 6-11, according to the preceding criticisms. When you have achieved the look you seek—when the curve has *flow*—translate the new shape into a precise line as before with french curves (Figure 6-12).

This is a common example of the difference between a precisely constructed curve and one that flows. A sensitive artist can detect even a hair-thin difference in expressiveness between curves. In

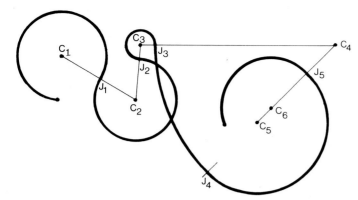

Figure 6-8. A continuous curve composed of arcs of circles is best constructed with straight segments drawn between centers to determine the junction points.

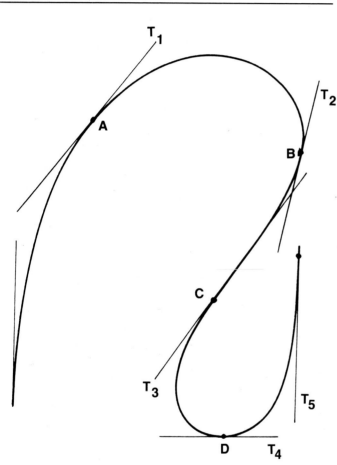

Figure 6-9. A continuous curve of noncircular segments is better constructed with tangents.

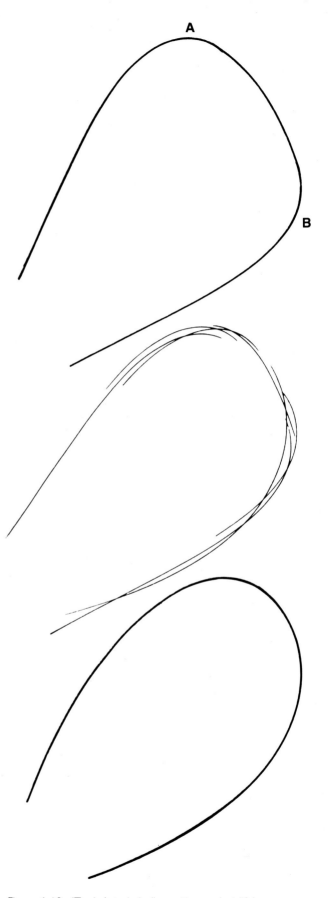

Figure 6-10. (Top) A technically continuous but lifeless curve.

Figure 6-11. (Middle) Sketched attempts to correct the curve.

Figure 6-12. (Bottom) Corrected flowing curve.

Figure 6-13, for example, the continuity at points $A$ and $B$ must remain the same, but curve 1 and curve 2 are alternate connecting segments. The artist must choose the one that better expresses the purpose of the artwork. The ability to perceive and use such subtleties distinguishes the high-quality commercial or fine artist from the ordinary artist. The former strives to express a precise feeling and a precise message through a precise image. When you understand this, you will forgive the length of the preceding theoretical discussion. We can now turn

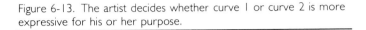

Figure 6-13. The artist decides whether curve 1 or curve 2 is more expressive for his or her purpose.

to the more practical aspects of masking.

## Mask Materials

Masks can be made of paper, vellum, frisket, acetate, or plastic vellum (denril). As we explained in Chapter 5, transfer the lines of reference to the airbrush support first; then transfer the drawing to the mask. The reasons for this sequence will become apparent as you study masks.

**Paper** For rough drawings where precision is secondary to some other purpose, paper is adequate. If it is fairly thick and rigid, it can be used repeatedly for light sprays that do not dampen the paper much. Paper is generally cut freehand with a knife or scissors. It is not, however, the best masking material.

**Vellum** When multiple sprays must be performed, vellum is sometimes used because of its translucence. Glue two sheets together with rubber cement for reinforcement before you transfer the drawing. It is advisable also to spread rubber cement on the surface of the mask so that multiple sprays will not damage it.

**Frisket** This is a ready-made masking material made of paper or plastic coated with a very thin layer of rubber cement or a similar adhesive. Transparent and translucent frisket is available in rolls or sheets, protected by a removable lining. To use frisket, transfer the drawing, cut the frisket *roughly* to the shape of the surface to be sprayed, and apply it to the surface, adhesive side down; only *then* do you cut the mask precisely. You must use a very sharp knife and light pressure so that you will not damage the support. Peel off the frisket that covers the areas to be sprayed.

Friskets are recommended primarily for use on unworked surfaces or areas painted with stable inks, dyes, oils, alkyds, and acrylics. The adhesive can damage surfaces sprayed with gouache or some pigment watercolors. A good frisket is excellent for producing clean, sharp edges, but it can be used only once.

Liquid frisket, which in most cases is a messy bother, is not recommended.

**Acetate** On surfaces painted with gouache, on glue-sensitive supports, and for repetitive masking, the ideal mask material is clear acetate. It will provide accurate cuts and good durability no matter how often it is used. Use acetate from clean, unwrinkled sheets (do not use rolls; they never uncurl completely, so they are more difficult to cut and lay flat). Drawings cannot be transferred to acetate, so you must cut the mask with the drawing positioned underneath. During this operation the drawing must not move; a better method of securing it than the classic one of taping with masking tape at four corners is to completely glue the acetate to the drawing with rubber cement. This leaves both hands free to hold cutting tool and guide (Figure 6-14), and there is no possibility of drawing distortion due to slight shifting of the acetate or drawing. Another advantage of gluing is that if the mask contains cutouts within the larger cut area, the smaller pieces will remain stuck to the drawing until you need them instead of getting lost. The drawing will probably be ruined by the gluing and cutting, but that is why we have recommended transferring lines of reference to the support before making masks. When multiple cuttings are required, it might be necessary in rare instances to make copies of the drawing for as many acetate sheets as you will need to cut. These copies must be made by blueprint; photocopiers tend to distort.

In cases where the support has already been sprayed and you need a precise outline for your next spray, an excellent compromise between frisket and acetate is plastic vellum. This is a very thin, opalescent material, completely resistant to water, like acetate, but offering a matte surface. The drawing can be transferred onto the vellum and the mask cut prior to pasting. Apply a *thin* coat of spray adhesive (like Grumbacher's brand, *not* rubber cement) on its back, wait some 5 minutes for it to dry, and gently apply the mask to the support. It will lie flat and rigid while you spray and will peel off without damaging the surface or leaving a trace. The only drawback to this type of mask is that such plastic vellum is rather expensive.

Figure 6-14. Gluing acetate to a drawing on vellum or paper frees the hands for holding the cutting tool and guide.

cut its own path, veering outward or inward. Circles can be cut more accurately with circle cutters, which are beam compasses with blades specially devised for this purpose.

Ellipsographs are excellent for drawing an infinite number of sizes and proportions of ellipses, but they are less successful when fitted with an adjustable blade to cut ellipses. The best compromise for large ellipses is to use french curves selected for and adjusted to the penciled ellipse as a guide. Small ellipses and circles can be cut easily with the

Figure 6-15. Adjustable blades shown larger than actual size.

## Cutting Tools

A great variety of cutting devices is used to cut all types of masks: knives, special cutters, and scissors. It is not necessary to describe the various types and what they look like, when every art-supply catalog includes a complete listing. Here we shall emphasize the value of each tool in cutting masks; the choice depends on the type of cut (freehand or guided) and the type of mask.

**Knives** Knives are always preferable for freehand cuts. Blades can be rigid, which require periodic sharpening, or replaceable, which can be changed when they become dull. Most rigid-blade knives have been supplanted by the replaceable-blade type to avoid the necessity of sharpening.

Swivel knives, which have a replaceable blade mounted on a ball bearing support, require a steady hand and good mastery of free curvatures; this type is used mainly to cut sinuous, meandering, rather small continuous curves without much hand pressure or mask rotation. A fourth type of knife has a one-sided razor blade, especially for desk work (straight lines, deletions, and so on). It is not used much in airbrush work.

**Special Cutters** The special tools are used principally for guided cuts. The so-called adjustable blades (Figure 6-15) can be inserted in a compass, mechanical pencil, or ellipsograph. They are not the best for cutting circles, however; an ordinary compass is not sufficiently rigid, and if the blade is not precisely perpendicular to the radius of the circle to be cut (which is nearly impossible), it will

guidance of templates. All these cuts can be made wonderfully well with a steel needle. This is an indispensable tool, especially for cutting acetate; X-Acto manufactures a good one. It needs sharpening, but not very often (buy a sharpening stone, which will last for ten years or longer). A needle will never damage your cutting guides.

When you cut acetate with a needle, do not make the cut all the way through to the paper. Make a groove; then bend the acetate back and forth on the groove to complete the cut. The pieces will pull apart easily. To cut composed curves accurately, adjust the guide after cutting the first segment; then find the J point with the needle. The needle must fall into the existing groove to make a continuous cut (Figure 6-16). If the curve in the resulting mask is not completely smooth, however, you can sand it with fine sandpaper.

**Scissors** Scissors can be used to cut paper masks, which as we have said are not often used. Their main use is to cut universal masks, which are described later in this chapter.

## Cutting Guides and Other Tools

Shapes that must be precise, particularly curves that must be continuous, require cutting with guides. Most guides—rulers, triangles, french curves, templates—are made of plastic or wood, which can be damaged by knives. Metal guides are better for knife-cut masks. Transparent plastic guides, on the other hand, permit you to see where you are cutting as well as where you have already

Figure 6-16. Cutting a continuous curve with a needle following the existing groove.
1. Guide (transparent french curve) □ 2. Acetate mask □ 3. Needle □ 4. Groove already cut □ 5. Path of next cut □ 6. Pencil drawing on vellum □ J Continuity point

Figure 6-17. Typical shield.

cut, which is an especially valuable feature when you need to control the continuity and flow of curves. Needles will not damage plastic guides.

To complete your arsenal of masking tools, you will need twenty to thirty typographic slugs to press nonadhesive masks firmly against the working surface. Slugs are the metal bars of type that were used in the Linotype process before the advent of photographic typesetting; you may still be able to get them free from a printer who has stashed them away

in some forgotten corner. They are thin, heavy, flat rectangles of metal about 1 by 4 inches (2.5 by 10 cm); if you cannot find them, substitute metal pieces of similar size and shape. They are indispensable for weighting masks.

If you have a mask that is smaller than a slug, say a circle ½ inch (1 cm) in diameter, use two or three drops of rubber cement instead, or pin down the mask with a needle or the handle of a paintbrush held in your hand. Sometimes a mask is so intricate that complete contact between it and the working surface is not possible. In such a case all you can do is try to spray absolutely perpendicular to the surface so that no medium penetrates under the edges of the loose portion of the mask.

## Universal Masks

Universal masks, or shields as we shall call them from now on, are not affixed to the working surface but are held in the opposite hand during spraying and moved from place to place. The method of using the shield is taught in Chapter 9; here we shall focus on its shape and manufacture.

Shields are called *universal* because they provide a variety of curves and inflections to cover every possible drawing situation. A typical shield looks like the drawing in Figure 6-17. A shield must be of the appropriate size for the work being done; edge *a* can vary from 3 inches (7.5 cm) for small, detailed illustrations to 12 inches (30.5 cm) for poster-size works.

Cut shields out of acetate or a moisture-resistant paper, such as photographic paper. If you use an actual photograph, the emulsion will protect the shield from the moisture of the sprayed medium. Acetate, of course, is already water-resistant, but because it is thin it cannot be made too large.

## COMPARISON OF SHIELDS

|  | PAPER | ACETATE | MANUFACTURED |
|---|---|---|---|
| Cost | None | None | Yes |
| Durability | Temporary | Temporary | Permanent |
| Number of curves | Limited | Limited | Complete |
| Smoothness | Fair | Good | Excellent |
| Washability | No | Yes | Yes |
| Elasticity | Fair | Good | Excellent |
| Additional shapes included | No | No | Yes |

# Part Two.
# Fundamentals

# THE FREEHAND AIRBRUSH

Now that we have examined the preparations for airbrushing, we can proceed to a study of the techniques. There are only a few fundamentals to be learned, but you may be surprised at the amount of effort it takes to master them. If you practice the exercises described here, however, and study even your mistakes so that you learn from them, the coordination required for airbrush work will eventually become second nature to you.

## Preparing for the Exercises

Before you begin the exercises themselves, attach the airbrush to the compressor, prepare the medium, and lay out the paper on which you plan to practice. (You will not need the medium and paper right away, but have them ready.)

You can do airbrushing with the support in two positions: horizontal or slightly slanted, or vertical on an easel or wall (Figures 7-1 and 7-2). Your choice depends on the size of the support and the technique you will be using. It is easier to achieve precision in details when the paper or board is flat on a table or desk; however, a large piece may appear to be distorted when positioned horizontally. In addition, you may find it uncomfortable to bend over a flat surface for extended periods of time. For large pieces, then, the vertical position may be more practical. Artwork positioned vertically can be scrutinized up close or studied from afar. (For shield work, which is covered in Chapter 9, the vertical position is almost essential because you must work with both hands.)

Note also in the photographs how the airbrush is held—very much like a pencil—and how the air hose is grasped between the legs.

## Notation

As you know from reading Chapter 1, an airbrush has a lever that either moves vertically to control air admission and back and forth to control release of medium (independent action), or moves only forward and backward for all operations (fixed type).

Figures 7-1 and 7-2. Airbrushing can be done either on a desk or table (horizontally), or on an easel or wall (vertically). Notice that when you work on a desk or table, holding the air hose between the thighs keeps it from dragging across the artwork and rubbing the edge of the desk, and it eases the weight in your hand.

In order to simplify the following instructions so that they will apply to any type of airbrush mechanism, a system of symbols is used to describe the four operations (Figure 7-3):

| | |
|---|---|
| admission of air | +A |
| admission of fluid | +F |
| interruption of fluid | −F |
| interruption of air | −A |

Beginners tend to jump from +A to +F in one operation and from −F to −A in another, and they have trouble coordinating the finger motion with movements of the hand and arm. The first fundamental of airbrush technique is to learn the distinctions among the four operations.

## The Water Test

This test, which requires nothing more than the airbrush and plain water, is designed to help you perceive the differences among the four lever posi-

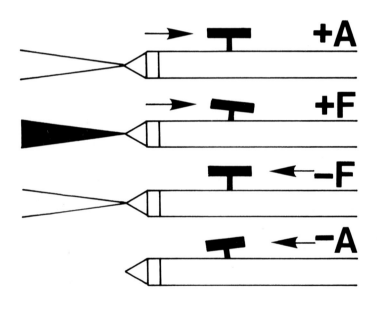

Figure 7-3. The four lever operations: +A, +F, −F, −A.

tions (+A, +F, −F, −A). No medium is used; you must concentrate on the finger movements.

Put some clear water in the airbrush paint container, using a brush or eyedropper. *Slowly* begin to move the lever to admit air (+A). Continue to move the lever—without hurrying—until the water begins to spray (+F), and increase the flow to the limit. Then—again very slowly—reverse the process: move the lever until no more water is ejected (−F), and continue until the air stops as well (−A). Repeat this sequence over and over until you can feel the differences in position and can sense when you are about to cross the threshold to the next position (Figure 7-4). Observe the differences in the

cone of spray made with different degrees of pressure. You will soon feel comfortable holding the airbrush and manipulating the lever, and you will begin to sense the change of operations by touch.

This exercise should be performed before every session with the airbrush—even after you have become an expert—because it can pinpoint problems with the instrument. Use it to check for the following faults:

Figure 7-4. This is a schematic diagram of the threshold between admission of air (+A) and admission of fluid (+F). In reality the point is not necessarily vertical as shown here.

1. The lever does not work smoothly.
   - A very tiny drop of oil may be all that is necessary.
   - If that does not solve the problem, one of the springs has lost its tension and must be replaced; or the lever mechanism is rusted or dirty; or some of its parts are broken or bent.
2. With the lever in +A, put a finger in front of the airbrush tip. If no air comes through:
   - First check the compressor hose; it may have come loose or broken.
   - The admission valve on the compressor may be closed or the air outlet open.
   - Check the air supply in the compressor. You may need to fill or change the tank.
   - If there is nothing wrong with the compressor or hose, the lever system of the airbrush is broken and you need a new one.
3. If you cannot feel a strong enough stream of

air with your finger during +A:

☐ Make sure that the regulator is adjusted to the correct pressure.

☐ Check the air-admission valve in the air-brush; it may not be open sufficiently.

☐ The compressor may need repair or its power may need to be increased.

☐ The air cap may be clogged; clean it thoroughly.

4. Observe the spray of water against a dark background. It should come out with strong, steady pressure. (After some practice and experience, you will be able to tell the difference in *sound* between a good spray and a bad spray.)

☐ If the spray is too strong, reduce the pressure.

☐ If the spray is too weak, increase the pressure or adjust the cap.

☐ If the spray is coarse and uneven, check for dirt in the nozzle or for a broken needle or cap.

☐ If the spray is premature or continues after −F, the needle or the tip is eroded and must be replaced. (Ordinarily, a small amount of dry pigment on the needle or the inside of the tip obstructs complete contact between the two, thus permitting color to flow after the air pressure stops. A thorough cleaning will correct this.)

☐ If the spray wavers, the compressor pressure is inadequate, or the washer on the tip is worn out or missing.

☐ If the spray is released at an angle, the nozzle and/or needle is damaged and must be replaced.

☐ If there is no spray at all, there may be no water in the paint container (or, in suction models, not enough); the air cap may be too loose; the air hole may be clogged; or there may be dirt in the nozzle and/or air cap.

5. Bubbles appear in the paint container.

☐ The air cap needs adjusting or changing.

6. Water leaks around the nozzle.

☐ Check the air cap for a tight fit.

☐ Blow out any excess water left from previous washings.

☐ Check the washers in the mechanism.

In addition to detecting faults, the water test will help you get used to the feel of the airbrush; will help you sense the border between +A and +F; will demonstrate the shape of the spray cone and thus enable you to mentally establish distances between airbrush and paper for the effect you desire; and will help you appreciate the difference between the start of +F and maximum +F.

## The Water Exercises

The following exercises do not test your instrument, but they are crucial to your mastery of the airbrush. Again, symbols are used.

Whereas the water test was

(1)　+A, +F, −F, −A,

this sequence is

(2)　+A, +F, −F, +F, −F, −A.

In other words, you spray twice before interrupting the airflow. When you can do this exercise smoothly without effort, try increasing the number of times you spray liquid, without stopping the airflow, to four:

(3)　+A, +F, −F, +F, −F, +F, −F, +F, −F, −A.

Practice this series of sprays until you can spray rhythmically two times (two +F's) per second and each spray has the same intensity and shape.

So far you have been spraying +F with maximum pressure. Now move the lever to release only the amount of spray that is released at the very beginning of +F. Repeat operations 2 and 3, using only this slight pressure, until you can do almost three +F's per second. Be aware that it takes an almost imperceptible finger movement to cross the line between +F and −F.

From time to time repeat the whole group of water exercises without looking at the spray. Close your eyes and listen to the sound of the air and liquid. You can learn to identify the correct pressure and determine faults by sound as well as sight.

You must practice these exercises conscientiously. Spraying nothing but water may seem pointless, but the operations you learn by doing it are essential to every bit of work you will do with an airbrush. Nor should you be discouraged by the appearance of symbols and formulas. It is worth recalling that other artistic endeavors, such as piano playing, require the same sort of almost mathematical rigidity and learning of symbols at first. Symbols that replace words ease communication and speed activities. Here, as in piano playing, persistence pays off; it is through the mastery of strict methods that artistry is achieved.

## The Dot

The basic geometric constituents of all shapes are the point (here called *the dot*), the line, and the

surface. In this series of exercises you will learn to make the first of these. For all the illustrations in this chapter, Winsor & Newton ivory black gouache was used on 100 percent rag white illustration board. Some are reproduced actual size so that you can duplicate them exactly. Gouache has been used because it reproduces well, but more important because its viscosity, which is higher than that of inks and dyes, makes it easier for the beginner to control. A more transparent medium would create problems in these exercises, as was explained in Chapter 3.

The airbrush sprays a cone of fluid (Figure 7-5) in a constant quantity per time unit for a stable lever position. No matter how far the paper is from the nozzle, it receives the same amount of colorant. It is logical, then, that if the same amount of colorant is distributed in a small area as in a larger area, the density of the color in the two areas will differ. The colorant will be more concentrated in the small area, more diffuse in the larger area. The distance of the airbrush from the paper therefore affects both the intensity of the color and the area it covers.

The first part of the exercise is to spray dots at low pressure $(+F_1)$, medium pressure $(+F_2)$, and full pressure $(+F_3)$ from different distances ($a$, $b$, and $c$)

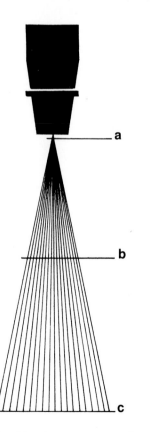

Figure 7-5. Because the airbrush sprays a cone of medium, the space between fluid particles increases in direct proportion to the distance of the nozzle from the paper. The result is a greater area covered with the same amount of medium, and therefore decreased coverage.

with different amounts of time (1, 2, and 3 seconds) between $+F$ and $-F$, without moving the hand.

As you can see in Figure 7-6, $+F_2$ (medium fluid pressure) and $+F_3$ (full pressure) produce ugly spots, whereas $+F_1$ for 1 second results in a tiny, much neater dot. The dots formed at distances $b$ and $c$ are not very dark, as you would expect. Can you think of a way to darken them? You could increase the time or pressure of $+F$, but so much fluid would accumulate that a pool of color would form and the airbrush effect would be lost. The solution—remember the water exercise—is to interrupt the flow of colorant $(+F)$ momentarily to permit each layer to dry (with the help of $+A$), then to spray again—without stopping the air and without moving the airbrush. The effect of this maneuver is illustrated in Figure 7-7, which shows dots obtained by constant pressure $(+F_1)$, constant distance from airbrush to paper, and constant time of each $+F$. The only variable among the fifteen dots illustrated is the *number* of sprays. Try making such a series yourself: hold the airbrush at a constant distance from the paper, use only light pressure, and do not spray for more than 1 second at a time. Concentrate on maintaining your rhythm.

The next exercise will sharpen your aim. With a pencil draw several grids of 1-inch (25-mm) squares. As has been done in Figure 7-8, spray dots at the intersections of these grids. Increase your speed until no more than 1 second elapses between the end of one dot and the beginning of the next one. Obviously, there is no time to stop the airflow after each $+F$; you must switch smoothly between $+F$ and $-F$ *and* coordinate this finger movement with the motion of your arm from grid crossing to grid crossing. Start slowly, however; you will need to fill in many grids before you attain speed and accuracy. Your goal is to spray dots that are almost identical.

## The Line

In geometry a line is a one-dimensional element generated by a moving point. In airbrush work, however, a line is any straight or curved trace left by a single stroke, regardless of its thickness.

In the point exercises you formed dots of various sizes by releasing medium onto paper—$+F$ to $-F$—without changing the position of your arm. To make a line, you increase the time of $+F$ to $-F$ and, while spraying, move your hand and arm between points (the "moving point" of the geometry definition). You must begin moving your hand and arm precisely when $+F$ starts and stop moving exactly when you reach $-F$. This is a delicate maneuver and not at all easy. Keep working at it; when you succeed, you will have mastered the cornerstone of airbrush.

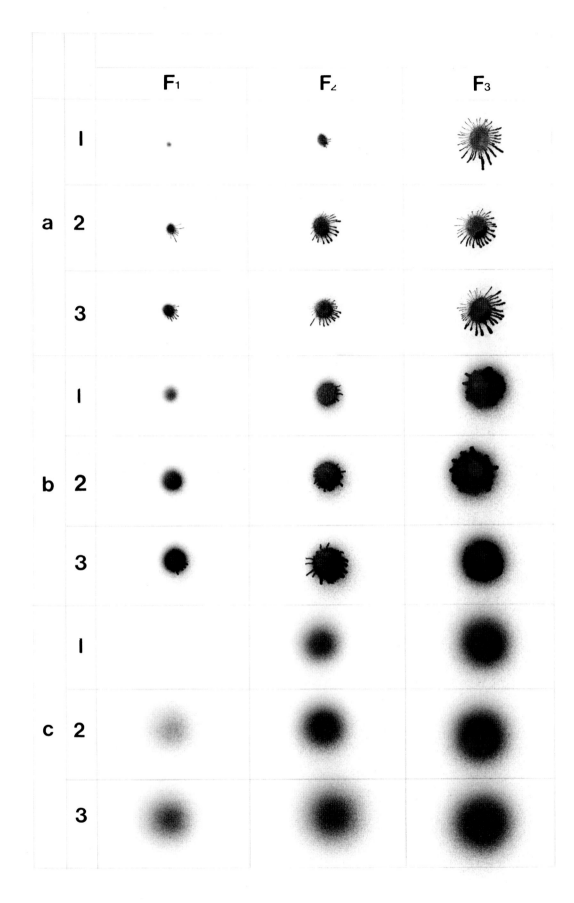

Figure 7-6. This chart displays the results of different combinations of distance (*a*, *b*, and *c*), pressure, and time (in seconds) for spraying a single dot. Your experiments may produce quite different results because of the many variables involved.

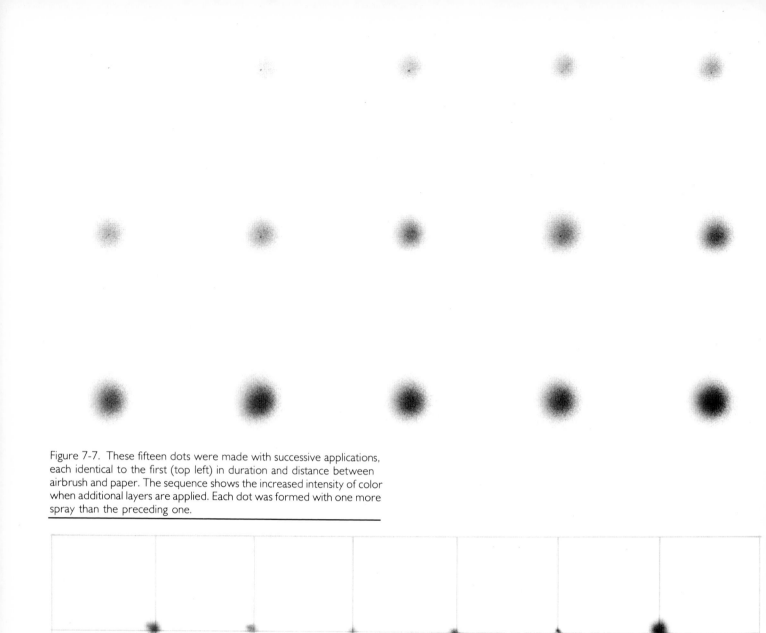

Figure 7-7. These fifteen dots were made with successive applications, each identical to the first (top left) in duration and distance between airbrush and paper. The sequence shows the increased intensity of color when additional layers are applied. Each dot was formed with one more spray than the preceding one.

Figure 7-8. Aim your airbrush at the crosspoints of a 1-inch (25-mm) grid like this one to sharpen your accuracy. Your goal is to make dots as nearly identical as possible.

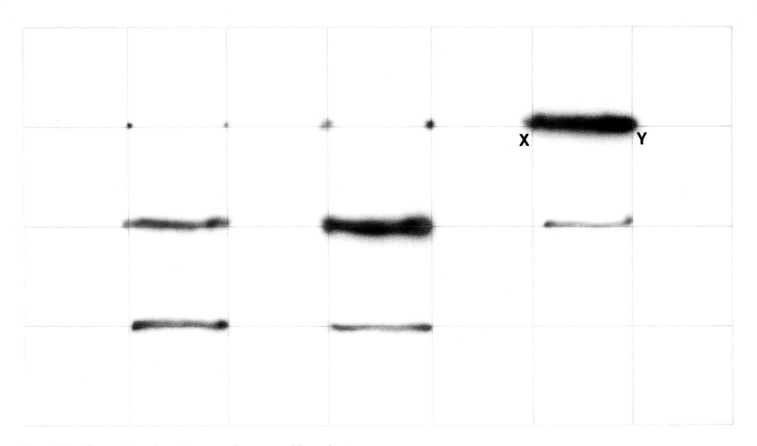

Figure 7-9. After making a few dots, move from one grid crossing to another while still in +F (from *X* to *Y* in the illustration).

START                    STOP

Figure 7-10. The coordination of finger and arm is shown here diagrammatically. The lever is in +A when the hand is not moving. The finger begins to move the lever to +F at the same instant the arm begins to move, and it returns the lever to +A exactly when the arm stops, like a metronome. The finger motion, traced here by the arrow, must be a smooth and continuous wave.

To practice, make your pencil grids as described for the dot exercises. Make a few dots; then continue in +F from one grid crossing to the next (X to Y in Figure 7-9). Concentrate on releasing *exactly* when you reach the crosspoint.

If the lines you make are still awkward after some practice, and you have diligently worked through the water, dot, and line exercises, try the activity illustrated in Figure 7-10. Move your hand freely left to right and back—without the airbrush—pressing an imaginary lever in +F as you begin each stroke and releasing it to −F as you end it. Your arm must move rhythmically, like a metronome arm, with your elbow as the equivalent of the pivot; do not pause at either end. When you become accustomed to this motion, transfer it to the airbrush, but remember never to release the lever to −A after the strokes (return to the water exercises if you have trouble with this). Your index finger may tire, but practice will strengthen it.

Before undertaking the following practice exercises, check your airbrush with the water test for cleanliness and proper functioning.

**Practice Exercise 1** Hold the airbrush 3 to 4 inches (7.5 to 10 cm) from the support and stroke fairly thick straight and curved lines (Figure 7-11). Press the lever to maximum +F first; then use a bit less pressure for each subsequent line. As you did in the dot exercises, go back over the light lines to darken them.

Figure 7-11. Your first attempts to produce straight and curved lines should be no more precise than these. Experiment with distances and pressures, and note the changes in the kinds of lines these variables produce. Go back and strengthen some of your lines with additional strokes at the same pressure and distance.

**Practice Exercise 2** Repeat the lines you made in the preceding exercise, but with the airbrush closer to the paper to obtain finer lines (Figure 7-12).

Figure 7-12. This is a refinement of the experiment shown in Figure 7-11, more difficult because you must maintain more control over distance and pressure to achieve finer, more definite lines. As you can see, there was no attempt to be exact when the first three circles were reinforced. Be accurate, but you do not have to be rigid.

**Practice Exercise 3** Draw lines quickly from left to right only, keeping the airbrush in −F as you move it back into position to begin the next line (Figure 7-13). (Figure 7-14 shows the sequence schematically.) Then begin the strokes alternately on the right and the left. Finally, make circles both clockwise and counterclockwise.

Figure 7-14. A diagram of the arm motions used to make the lines in Figure 7-13.

Figure 7-13. This exercise will improve your hand speed when spraying fine lines. First spray lines only from left to right (a), then both ways (b). Make circles both clockwise (a) and counterclockwise (b). Do not worry about the number of lines for each circle or about making sure the circles are closed; precision is not the objective here.

**Practice Exercise 4** Different kinds of lines can produce a variety of effects. In Figure 7-15, for instance, you can compare the tracing made with long, continuous strokes with the one made with short strokes. The effects are quite different. Experiment this way to see the number of possibilities.

You can probably devise endless variations of these activities for your own practice sessions—zigzags, curves, broken lines, and so on. Combinations of these lines allow you to create any linear shape you can imagine.

Figure 7-15. The airbrush can be used as if it were a pencil. The mosque was rendered with slow, continuous sprays. (With a very steady hand you can make an even more accurate rendition.) The dog, in contrast, was "drawn" with repeated short sprays—even the eyes and nose. The different characteristics of these strokes are evident.

## The Surface

A surface can be flat, bent, convex, concave, broken, wrinkled, smooth, glossy, matte, wet, dry, and so on. The more complex surfaces are covered in Chapter 8; for now we shall focus on the basic method of creating a uniform flat surface. After freehand line spraying, it is child's play.

A uniform flat surface can be sprayed accurately if at least half its area can be covered by one dot spray. Thus, the smaller the area to be covered, the nearer the airbrush should be to the surface. The situation exactly parallels that of a paintbrush: the larger the area to be covered, the larger the brush used. This size relationship ensures an even distribution of medium.

Transparent mediums are poor choices for rendering a uniform surface because the tone changes in each overlapping droplet. They are better for smaller surfaces, which are more controllable; very pale tints sprayed with care should be used, or tones corresponding to the darkest pile-up. Watercolor is particularly good because of the splendid smoothness of its final surface. In general, opaque gouache, oils, and acrylics are preferable for uniform, velvety surfaces (see Chapter 3).

Airbrushing a large, uniformly colored background is unusual today because of the availability of commercially made papers and boards in a full range of colors (see Chapter 4). The technique of spraying a surface is more often used for partial areas. The important factor to consider when dealing with surfaces is their definition against the adjoining surface or background—their degree of *resolution*, a term borrowed from microscopy. Study Figure 7-16, which shows a scale of resolutions. Each strip is 100 percent black on the left and 100 percent white on the right; the variable among the strips is the distance between support and airbrush, which is what produced the varying degrees of fading. Strip 1, which has a sharp linear division, is the first degree of resolution; it is not obtainable freehand. (Can you think how it might be achieved with an airbrush?) In strip 10, the other extreme, black and white have disappeared—they are imaginary, beyond the scope of the strip.

To simplify explanations, the degree of resolution is referred to hereafter as R, on a scale of 1 to 10 to correspond to Figure 7-16. A notation of $R_{2-3}$, for example, means a degree of resolution between what you see in strips 2 and 3 on the scale; a notation of $R_1$ means a linear transition. (Did you guess how $R_1$ can be made? With shields or masks, as discussed in Chapters 8 and 9.) Because resolution is a function of distance, this abbreviated

terminology is particularly useful; different airbrushes held at the same distance from the support may produce different resolutions, so it is more practical to refer to an objective scale of resolution than to a variable distance. You must experiment with your instrument to determine how it matches the scale. Try to reproduce each strip of the ten-point scale exactly on a full page, beginning with the line of separation, and note the distance from the paper as you make each one. When you become proficient, extend your work with fading beyond straight lines to squares, circles, crescents, and other shapes, with different degrees of resolution.

Finally, study the line-and-surface effects shown in Figure 7-17. Each strip shows a different combination of resolution (R) and fluid pressure (F); M (multiple) and the numbers preceding R indicate the number of strokes needed to reinforce color intensity. Practice reproducing these strips exactly, not in bordered spaces as shown here, but on open surfaces. That is more difficult, because you must end your strokes cleanly, using the no-colorant zone (+A and −F) frequently. As you practice, study the factors that contribute to each effect. Knowing exactly how to produce the effect you want is very important. After all the theoretical explanations, only continuous training will polish your technique. There are no shortcuts, but the hard work you do will result in mastery of handling.

The mastery of freehand technique is the secret of good airbrush work. Artists who rely only on masking without the additional subtleties of freehand technique are condemned to the production of mediocre or starkly technical art. It is true that a technical rendering is supposed to represent some surfaces, no matter how intricate, accurately and precisely—and such work can be done with masks. However, as an example, look at the back of your hand and you will see that not even a fraction of an inch of the surface is uniform in value. Only freehand technique can be used to render such a surface. As we travel from technical to artistic work, freehand work becomes more applicable.

## Faults and Accidents

Mistakes and accidents are inevitable, even for the experienced professional. You should learn about potential errors, not only in order to avoid them, but also to know when and how you can correct them, or how to use them.

The air pressure from the compressor is frequently a source of trouble. When you work with mediums of high viscosity for opaque effects, more air pressure is necessary; insufficient pressure with heavy fluids

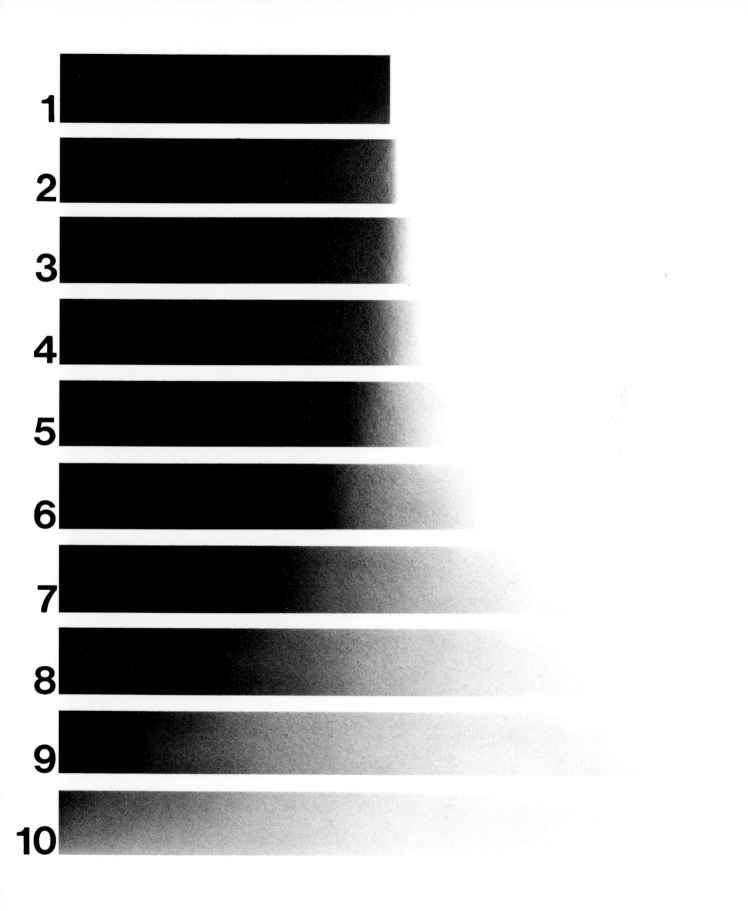

Figure 7-16. Scale of resolutions. The sharpest degree of resolution is $R_1$, with a distinct division between black and white. $R_{10}$ is the least definitive. The first three degrees are most usual in line airbrushing; the rest are used mostly for surface grading. Familiarize yourself with this scale, because it will be referred to frequently in subsequent chapters.

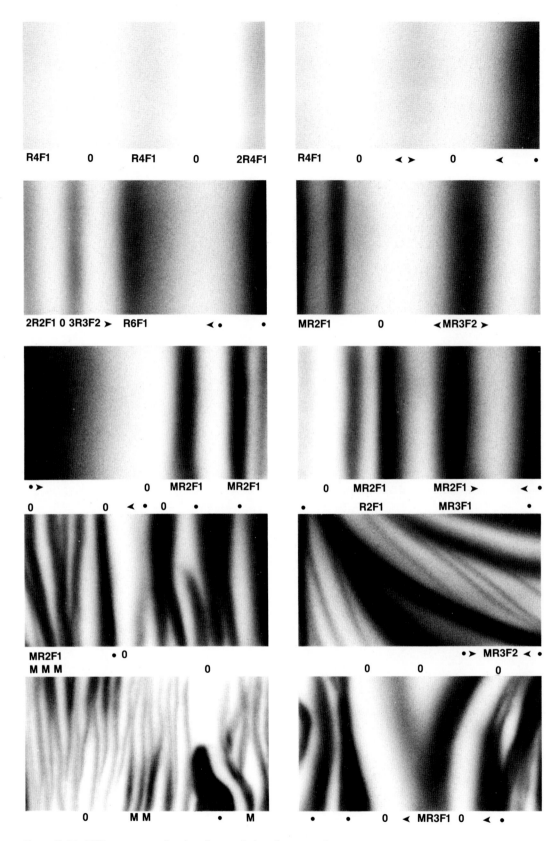

Figure 7-17. Different types of surface-line gradations (because of space limitations not all strokes have been labeled). F = pressure; RF = one stroke; 2RF = two strokes; MRF = multiple strokes; o = no spray (the tint is from adjacent sprays); ● = black, to be sprayed as you wish. The arrows show the direction of fading, always from dark to light. Wherever a tone is sprayed over another tone, the lighter one should be sprayed first.

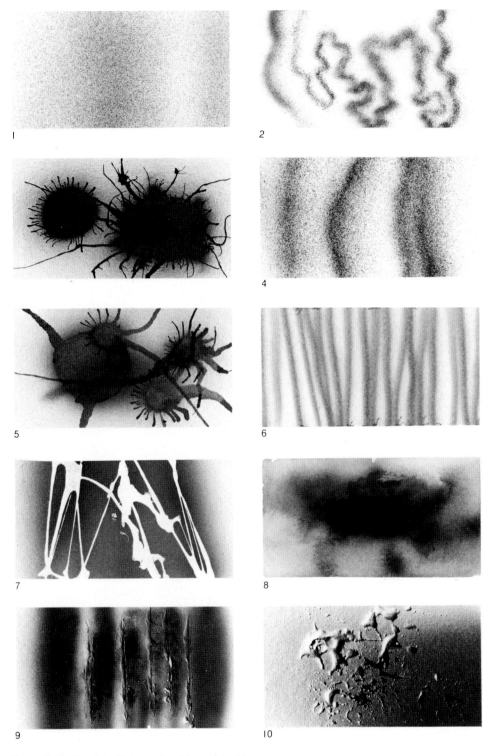

Figure 7-18. Special effects made with useful mistakes:
1. High viscosity, low pressure, $R_5R_1$ (sand and pebbles)
2. High viscosity, low pressure, $R_2F_1$ (microscopic DNA)
3. High viscosity, high pressure, $R_2F_3$ (dry plants)
4. Low viscosity, low pressure, $R_3F_1$ (sand dunes)
5. Low viscosity, high pressure, $R_2F_3$ (bacteria)
6. Low viscosity, high pressure, $R_2F_2$ (transparent curtain)
7. Black spray on rubber cement, removed after spraying (batik)
8. Spray on wet surface (watercolor, old manuscript)
9. Slanted spray on white gouache applied with a razor blade
10. Very slanted (almost parallel to the paper) spray of black on sponge-applied white gouache (lunar landscape)

Figure 7-19. The freehand airbrush eye.

1. Spray sketchy outlines of the whole basic drawing with light, almost invisible traces.

2. Strongly outline the light spot with $MR_2F_1$ to 100 percent black (repetitive circular motion).

3. Outline the pupil with $MR_2F_1$; then fill the whole area to 100 percent black. Resolution remains low in order to stay within the outlines. You might use $F_2$ at the center of the pupil.

4. Spray the iris outline, fading it at the lower part, using $MR_3F_2$. This circle is not as sharply outlined as the pupil. Continue drawing the dark traces, utilizing $MR_2F_1$ (with special attention to eyebrows and eyelashes). Then fade from black to light, using $R_4$ liberally.

Figure 7-20. A 75 percent reduction changes the apparent resolution; notice that the outline of the pupils has become $R_1$.

produces a coarse, discontinuous spray and tends to clog the airbrush. On the other hand, transparent, low-viscosity mediums and finely detailed work require less pressure from the compressor. Too much would cause very fluid mediums to spatter.

Another source of trouble, especially for the beginner, is lack of coordination between arm and finger. Mistakes can occur not just because the arm-and-finger motions of airbrushing have not yet become reflex actions to you, but also because you are tired, tense, or just do not feel like working.

To avoid these problems, take the following measures before you begin any session with the airbrush:

1. On a fresh sheet of paper, spray several lines like those in Figure 7-13. This gives you an opportunity to check the air pressure with the type of medium you plan to use.
2. Trace the trajectory of lines *without spraying* to accustom your hand and arm to the motion.
3. Spray $+F_1$ as if you were sketching with a pencil.
4. Adjust the distance and F so that multiple light sprays will achieve the desired color intensity.

Such testing can prevent problems, but if you get pools or spots of color anyway, there are some steps you can take to camouflage them.

Wait for the spot to dry; it may simply blend into the surrounding area. If it has a definite outline, however, it will most probably be visible even after it dries. Try retouching it with additional slow, careful applications of the same color.

A spot with a border—an almost microscopic difference of level between the paper and the spot—cannot usually be disguised with additional spraying. The raised effect remains no matter how many times you cover it. You might be able to hide a very small spot of this nature with color applied with a very fine watercolor brush (number 0 or 1). You must work under a magnifying glass so that you touch only the edges of the spot.

If you should accidentally spill a large puddle of color on your artwork, it is probably best to start over again. If you are in the late stages, however, and want to try to salvage the piece, you must act quickly. Immediately, *before* the spot has had a chance to begin drying, blot it with a paper towel to

absorb as much of the color as possible. Then use a cotton swab to blend the edges of the stain into the surrounding surface. If you catch the spill in time, you should be able to cover it with successive layers of color with almost complete success.

A more subtle problem, which occurs in spraying large surfaces, is uneven color. If you think that a continuous tone is uneven, examine it closely by flooding it with light from as many directions as you can. If the surface seems even when lit this way, the problem is that dry medium has piled up. Rub the surface gently with a piece of rough cloth or fine sandpaper to level out the color. If the surface is still uneven: (1) a lower layer of medium is bleeding through; (2) you have sprayed too thinly and the background color is showing through; (3) the color you used has separated in the paint container; or (4) you mixed additional color to a different dilution. Although you can do nothing about bleeding, you can avoid the other three problems by spraying enough layers to cover earlier applications, by mixing separable colors thoroughly, and by preparing more color than you think you will need for a particular job to ensure having enough of the same dilution. In some instances (bleeding included) when repeated spraying is ineffective, spray a coat of fixative (like Grumbacher's Mistone), and the next sprays of color might cover the damage.

Making a mistake is not necessarily totally negative. If you analyze the ones you make, you can avoid them in your future work—but you can also learn to use the same circumstances intentionally to create special effects. Figure 7-18 shows how some mistakes can be incorporated into your work.

## A Freehand Project

If you have studied this chapter carefully, your theoretical knowledge of freehand airbrushing is complete; now you must put that knowledge into practice. As a final exercise, examine Figure 7-19, a freehand rendering of an eye. Before you read the method of working in the caption, try to figure out for yourself how to approach the task. Compare your sequence with the steps in the caption; then try to reproduce the illustration both ways. You may achieve equally good results with your own method. There is nothing rigid about airbrush work once you have mastered the fundamentals.

# AIRBRUSH MASKING

Chapter 6 described what masks are and how to make them. You already know that some masks are adhesive, some not; the choice is determined not by the intrinsic superiority of one or the other but by several variables. These can be classified as *material factors*—the kind and quality of the paper, type of medium, background, whether any areas have already been sprayed, and so on—and *strategic factors*—your plan of approach to the work.

The strategic factors are undoubtedly the most complex and intricate part of airbrush masking, because they are theoretical. We can perhaps explain them best by working out two examples.

## Example 1: Black-and-Gray Square

Suppose you have been given the following assignment: spray a 5-inch (13-cm) black square on a 7-inch (18-cm) gray square (Figure 8-1). (These dimensions were chosen so that the black and gray surfaces would be nearly equal.) You are asked to produce a very accurate graphic work, with no visible traces of brushstrokes, in which the gray is approximately 50 percent black. The surfaces are not to be graded, but flat, clean, and uniform. You are not told what medium to use or whether a glossy or matte effect is required. You therefore have the following four options:
1. Glossy frame and square
2. Matte frame and square
3. Glossy frame, matte square
4. Matte frame, glossy square

All-glossy squares would be preferable for photographic retouching; all-matte, for print reproduction. The mixed effects could be used for decorative or fine-arts effects. The surface texture is irrelevant for works that are to be reproduced, but it is crucial for original art, where the choice is determined by

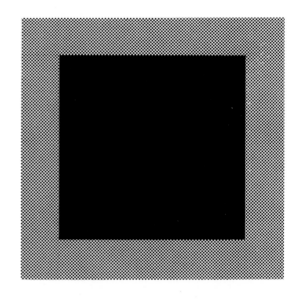

Figure 8-1. Your hypothetical assignment is to render this figure.

the aesthetic goals of the artist.

**Material Factors** Each of these alternatives in turn suggests particular supports that could be used:
1. Glossy frame and square
   a. White chrome-coated paper
   b. White hot-pressed illustration board
   c. Gray glossy paper
   d. Black glossy paper
2. Matte frame and square
   a. White cold-pressed illustration board
   b. Gray Coloraid or Chromarama
   c. Black Coloraid or Chromarama
3. Glossy frame, matte square
   a. White chrome-coated paper
   b. White hot-pressed illustration board
   c. Gray glossy paper
4. Matte frame, glossy square
   a. White chrome-coated paper

**b.** White hot-pressed illustration board
**c.** Black glossy paper

The next step is to select the medium; this choice is limited by the effect to be produced as well as by the support (letters here correspond to the choices of support, above):

1. Glossy frame and square
   **a.** Dye watercolors or india ink
   **b.** Dye watercolors, india ink, oils, or acrylics
   **c.** India ink, oils, or acrylics
   **d.** Oils or acrylics
2. Matte frame and square
   **a.** Pigment watercolors or gouache
   **b.** Gouache
   **c.** Gouache
3. Glossy frame, matte square
   **a.** Dye watercolors or india ink for frame; gouache for square
   **b.** Dye watercolors, india ink, oils, or acrylics for frame; gouache for square
   **c.** Gouache for square
4. Matte frame, glossy square
   **a.** Dye watercolors or india ink for square; gouache for frame
   **b.** Dye watercolors, india ink, oils, or acrylics for square; gouache for frame
   **c.** Gouache for frame

We have thus established a complete list of options for support and medium, the material factors that determine the choice between adhesive and nonadhesive masks. Upon examining the list, we can see that with the exception of gouache on white illustration board (*2a*), all the combinations could be sprayed with either adhesive or nonadhesive masks. Adhesive masks, in fact, are preferable for their accuracy. (Gouache can be harmed by adhesives, so wherever a mask must be used on already sprayed gouache it should be nonadhesive.) The use of oils or acrylics might necessitate a stronger adhesive than frisket; you could use broad white masking tape instead, though it is less useful on more fragile supports or for complicated shapes.

All of the combinations listed could also be produced with nonadhesive masks as well, such as acetate and weights. How do you decide? This is where the strategic factors come into play.

**Strategic Factors** The first goal of masking strategy is to evaluate the surface in order to determine how to achieve the effect you want with the smallest possible sprayed area. This is only common sense, but it does not always work out; in our example, for instance, the surface areas are equal, so there is no clear preference. If the black square were much smaller in relation to the gray area, however, the

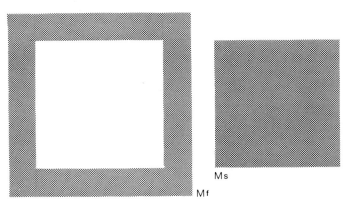

Figure 8-2. The mask for the frame *(Mf)* and the mask for the square *(Ms)* are the only masks used in this illustration.

obvious strategy would be to spray a small black square on a gray support.

The second factor to consider is how to spray with the minimum number of masks. To simplify the discussion, we shall identify the mask of the frame as $M_f$ and the mask of the square as $M_s$ (Figure 8-2).

For an *adhesive mask*, the strategy for two sprays, whether opaque or transparent, would be as follows:

1. Apply frisket over the whole surface.
2. Cut the outline of $M_s$ (the inside border of $M_f$).
3. Lift and dispose of $M_s$ and spray black.
4. Cut the outside border of $M_f$.
5. Lift and dispose of $M_f$.
6. Spray 50 percent black ($MR_3F_2$).

The process is simplified if the background is already gray; you would have to spray only the 100 percent black. If the background is black, remove $M_f$ only and spray gray gouache for the frame. (Remember this for the numerous occasions when reducing the number of sprays will save you considerable work and time.)

*Nonadhesive masks,* as you know, are prepared separately, not on the artwork the way adhesive masks are. In our example, $M_s$ and $M_f$ are obtained with only one outline cut. Each resulting piece serves alternately as a mask; they can be applied, removed, and applied again. The ability to be reused gives nonadhesive masks an enormous advantage over adhesive masks; they are especially beneficial for repetitive shapes, as we shall see shortly.

In the list of alternatives for creating the squares, gouache on white illustration board is the only option that *cannot* be sprayed with adhesive masks. Because this combination of support and medium is one of the most frequently used, it is important to work out the simplest method of nonadhesive masking for it.

Using only one mask, proceed in the following way (Figure 8-3):

Figure 8-3. In this method of spraying the first color without a mask, only opaque colors can be used.

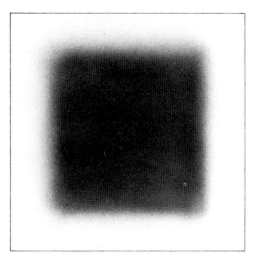

Figure 8-4. An alternative is to spray the square first, but this method is less desirable.

1. Spray gray over the frame area, without using a mask, leaving an area in the center that is roughly equivalent to the square.
2. Apply $M_f$.
3. Spray black.

Because black is opaque, this simple method works quite well. You could also reverse the order of sprays (Figure 8-4):

1. Spray black to cover the area of the square approximately; use no mask.
2. Apply $M_s$.
3. Spray gray.

For this procedure to work, the gray must obviously be opaque. This sequence might be used in unusual circumstances, but it is not recommended. In general, it is preferable to spray light tones first and cover them with darker tones.

Now that we have examined masking strategies, we can compile a complete list of alternatives that includes a preference of adhesive (A) or nonadhe-sive (NA) masks.

Clearly, the predominant choice for the simple case of a black square in a gray frame is an adhesive mask. The analysis can be extended to all similar cases where two tones of the same color are to be sprayed, regardless of the pattern. In the case of hues that are altogether different, however, some factors change.

## Example 2: Colored Squares

Suppose your assignment is to spray squares of the same dimensions as before, but with a fiery red square in a Prussian blue frame. The options are generally the same as for the black-and-gray example, with a few important exceptions.

**Opaque Colors** Light colors, even those with great covering capability, are altered slightly when applied over darker colors. It would be better, therefore, to spray the red square before the blue. On a white support, you would spray red without a mask (see Figure 8-4), apply $M_s$, and spray blue. On a red support you could eliminate one spray.

On a Prussian blue support, you have more than one option. If you will be satisfied with a duller red (it will inevitably be influenced by the blue background), apply $M_f$ and spray red. If you wish the red to appear in its full brilliance, apply $M_f$, spray *white*; then spray the red. Light is reflected not only by the red, but also by the white underneath, which enhances the red. You may think this extra spray complicates the process ridiculously and should not even be considered, because there are much easier alternatives. In most cases you would be correct; however, when a dark background has been chosen as the best support for other reasons, an initial white spray is the only solution.

**Transparent Colors** Unlike opaque dark tones on light, a transparent color cannot be sprayed over another without altering both and creating a third, undesirable hue. The only way to spray the squares of the example with transparent colors is to use both $M_f$ and $M_s$ (the sequence is not important) and spray each color so that not a drop of one overlaps the other. The masking must be done with absolute precision; if the mask does not cover the already sprayed color exactly, you will obtain a slight line of background on one side of the square and a slight line of overlap in a third hue on the other side (Figure 8-5). This overlap is almost inevitable, and even though slight, the eye detects it. Because it can happen despite precautions, artists avoid using adjacent transparent colors, replacing one or both with opaque colors; or they deliberately exaggerate the effect for some artistic purpose.

## OPTIONS FOR BLACK SQUARE, GRAY FRAME

| EFFECT | SUPPORT | MEDIUM* | MASK† | COMMENT |
|---|---|---|---|---|
| 1. Glossy frame and square | a. White chrome-coated paper | Dye W, T | A | Adhesive for greater accuracy and simple handling; only one cut in all cases |
| | b. White hot-pressed illustration board | Dye W, T, O, A | A | |
| | c. Gray glossy paper | T, O, A | A | |
| | d. Black glossy paper | O, A | A | |
| 2. Matte frame and square | a. White cold-pressed illustration board | Pigment W, G | NA | Precaution against spoiling gouache |
| | b. Gray Coloraid or Chromorama | G | A | $M_f$ only |
| | c. Black Coloraid or Chromorama | G | A | $M_s$ only |
| 3. Glossy frame, matte square | a. White chrome-coated paper | Dye W, T (frame) G (square) | A | |
| | b. White hot-pressed illustration board | Dye W, T, O, A (frame); G (square) | A | |
| | c. Gray glossy paper | G (square) | A | $M_f$ only |
| 4. Matte frame, glossy square | a. White chrome-coated paper | Dye W, T (square); G (frame) | A | |
| | b. White hot-pressed illustration board | Dye W, T, O, A (square); G (frame) | A | |
| | c. Black glossy paper | G (frame) | A | $M_s$ only |

*T = india ink     A = acrylics
W = watercolors     †A = adhesive
G = gouache     NA = nonadhesive
O = oils

Figure 8-5. Masks that are not adjusted exactly produce undesirable effects.

The preceding evaluations should give you a general idea of masking procedure. In practice your reasoning will be much less complex, because you will usually have decided on the material factors in advance, thus reducing the number of alternatives. Few strategic factors are involved in the simple square-on-square examples; however, artwork that requires multiple masks and many colors will demand vision and inventiveness. No two projects will require the same masks or the same strategy.

### Freehand Spraying Within Masks

The purpose of this book is to give you complete technical liberty in executing any conceivable form, shape, or color with the airbrush. The previous flat-color squares are certainly of smallest concern; a mask, whether adhesive or nonadhesive, may enclose a more complex structure that requires masks or elaborate freehand airbrushing within it. **Remember that your work is basically freehand airbrushing, even when bordered by a mask.** Your hand should continue to move in accordance with the methods studied in Chapter 7.

To make it a bit easier for you to practice freehand spraying within a mask, use a circle template rather than cutting a special mask. Select one of the circles, say, one that is 1 inch (2.5 cm) in diameter, and mask the surrounding circles out with tape (Figure 8-6). Using black watercolor or gouache in the airbrush and a white, nonglossy support, reconstruct the examples in Figure 8-7. Lay the template on the support, but continue to hold it

Figure 8-6. For the following exercises, mask the neighboring circles of a template for accuracy of spraying.

Figure 8-7. Reproduce all these figures with the circular mask.

so that you can move it easily.

The masks that you use in airbrush work will often be closed outlines, like the circles; other times, however, they will be one-sided (usually nonadhesive ones). Examples 6, 8, 9, 24, and 25 in Figure 8-7 could be rendered successfully with a one-sided half-circle mask. In such cases (especially for situations like example 25), you must spray cautiously to avoid inaccuracies at the virtual point of tangence.

As with previous exercises, you should amplify these with as many different kinds of outlines as you can imagine, challenging yourself to become more and more accurate and to produce specific effects. For example, the partial dots in examples 8 and 9 of Figure 8-7 could be sprayed with a straight mask rather than the circle template, resulting in Figure 8-8—a pattern that is in fact quite frequently sprayed. As you can see, examples 19 through 25 require repetitive use of the circle template. These figures suggest a variety of effects obtained with only one color sprayed with different intensities.

| R2F1 | 2R2F1 | 3R2F1 | R2F2 | 2R2F2 | MR2F2 |

Figure 8-8. Dots interrupted by a straight mask.

## Masks Within Masks

For the following exercises (Figure 8-9), use the same circle template, 1 inch (2.5 cm) in diameter, and a second, smaller one, say, 1/3 inch (0.85 cm). The first notation in the figure is for the larger circle; the second, for the smaller one. The other numbers indicate the approximate percentage of black; remember, you use only *one* color, black, to obtain the various intensities.

## Masking Exercises

The rest of this chapter consists of exercises designed to develop your expertise in choosing the right type of mask. There are twenty-one basic situations, representing an infinite number of particular ones that you will have to handle in the future. Each problem is stated in the form of a

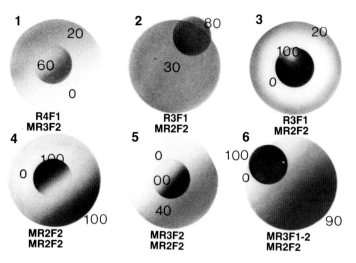

Figure 8-9. Reproduce these figures with two circle templates of different sizes.

question to be answered. Complete solutions are provided at the end of the chapter—but obviously you should first try to work out the answers yourself and implement the illustrations. Then compare your results with the answers given here and decide whether yours are better or worse.

### Problems

How many different ways could you mask to spray these figures? Why would you choose each mask?

How many masks would you need for this symmetrical figure?

What is the easiest way to cut masks for these two figures?

How many masks and what type have been used for this illustration?

What type of masking—adhesive or nonadhesive—
would you use to spray the following shapes?

**8**

**9**

**13**

How would you airbrush this drop of liquid?

**14**

How would you use masks to spray these figures?

**10**

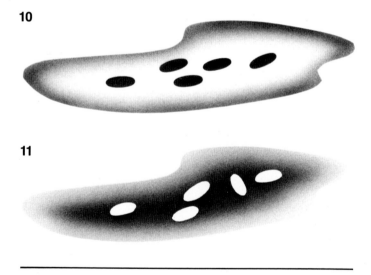

**11**

What shape of mask would you use to produce these
radial effects?

**15**

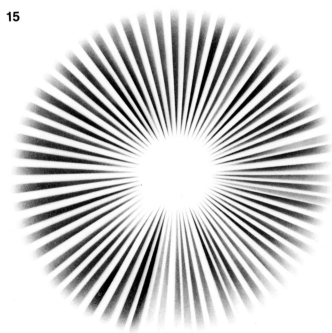

What mask(s) would you use and how would you
spray to obtain these effects?

**12**

**16**

How would you airbrush this figure, which represents the sparkle of light on metal as recorded on photographs?

**17**

How many masks do you need to produce these figures (flat helical ribbon, helical pipe, and DNA double helix)? What would your strategy be?

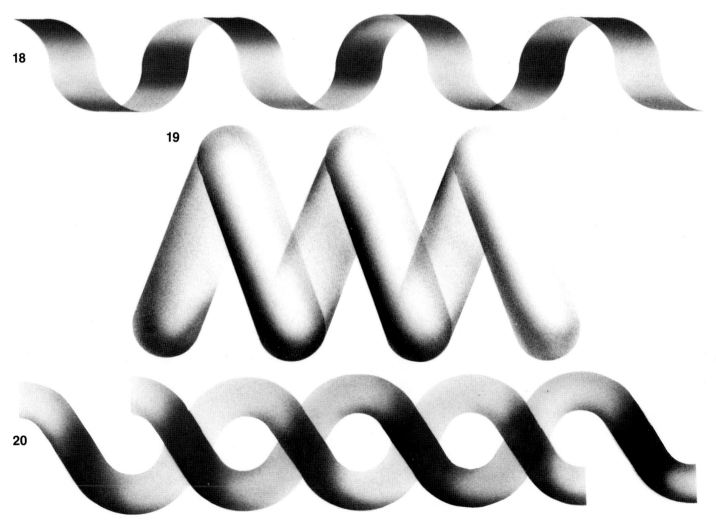

**18**

**19**

**20**

How would you airbrush this chain using masks?

## SOLUTIONS

1. There are four possibilities:

   **a.** Use two pieces of acetate held down with weights for a very simple spray.

   a

   **b.** Fix two pieces of acetate together with tape for repetitive sprays.

   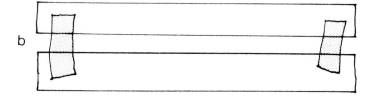

   b

   **c.** Cut a mask from one piece of acetate and use it with weights; this is easier to handle than two strips.

   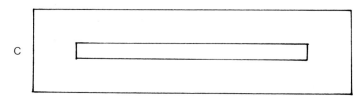

   c

   **d.** Use self-adhesive frisket for one precise spray or multiple-color sprays on the same area.

   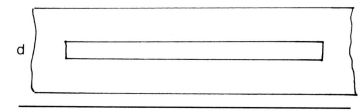

   d

2. Answers *b, c,* and *d* for problem 1 are valid here, too.

3. There are three possibilities:

   **a.** For simple sprays, use three (four for the square) pieces of acetate with weights. Do not forget to protect the background beyond the acetate with some type of paper or acetate, also weighted. No matter how precise your airbrush is and how carefully you spray, particles of colorant will drift beyond the masked area and form ugly and unretouchable spots on uncovered parts of the artwork.

   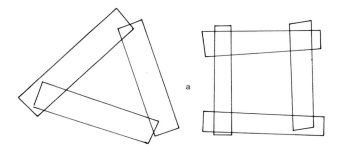

   a

   **b.** Use shapes cut from a single piece of acetate and weight them. This shape can be moved more easily than separate pieces, so it is preferable for multiple sprays or when you need to move the mask around to determine the proper layout. This solution is not recommended for superimposed masks, however, because of the cumbersome weights.

   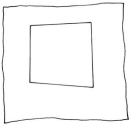

   b

   **c.** For precision, extensive mask or freehand work within masks, or multiple-color airbrushing, cut self-adhesive frisket in the appropriate shapes.

4. Make a *single* cut in a piece of acetate along the required curve, pull the pieces apart to the correct width, and fasten the edges with tape.

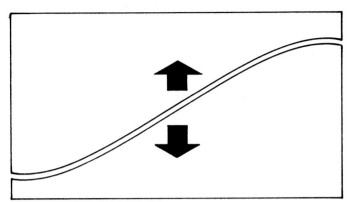

Note that this procedure is possible only within certain limits of curvature. Curves with loops like the one below cannot be sprayed in this way but must be stenciled, either with acetate plus weights or with self-adhesive frisket.

5. The procedure is the same as for number 4.

6. No mask can be cut to be precisely symmetrical. Therefore, cut one half of the figure in acetate, weight it on the surface to be sprayed, and spray; then turn the mask upside down (after making sure that any color on it has dried) and spray the other side of the figure.

7. Only one mask is used: a right triangle, as shown in the diagram, used repeatedly.

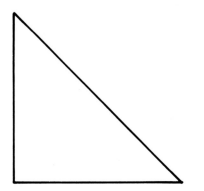

8. Use either an adhesive or a nonadhesive mask:
   a. For precise edges, use a self-adhesive mask cut freehand.
   b. For a more elegant curve, cut acetate with the aid of french curves, as you learned to do in Chapter 6. Do not forget that repetitive and symmetrical patterns require acetate masks.

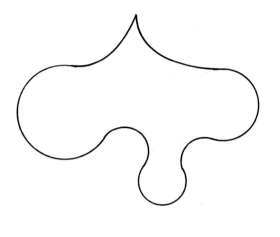

9. A self-adhesive mask is preferable. An acetate mask with weights can be secured everywhere but at points A and B, where air pressure from the airbrush can lift the acetate and cause a blurred, imprecise edge. As a compromise, you could put drops of rubber cement at A and B, let them dry partially, and fasten the mask on the artwork. After spraying, remove the mask and with a finger gently rub off any cement left on the work. It will peel off, leaving no trace.

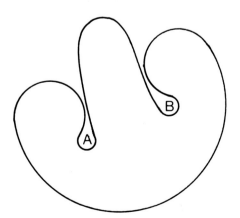

10. Use self-adhesive frisket for the background surface and templates of various sizes for the ellipses. If the interior shapes were not circles, ellipses, or squares and thus could not be sprayed with templates, you would have to cut them separately in acetate.

11. For the background, use self-adhesive frisket. For the holes, you have a choice:
    a. Spray white through templates, as in number 10, for a clean result.
    b. Paint the white shapes with a brush if the work is to be reproduced and surface texture is unimportant.
    c. Cover the ellipses with rubber cement or liquid frisket before spraying; then rub it off when the color has dried.
    d. Cut the ellipses in acetate and apply them with a drop of rubber cement (as in number 9) before spraying.

12. Select one of the masks described in the solution to problem 1 and spray A; then adjust the mask and spray B.

---

13. Cut three masks (1, 2, and 3) from a piece of acetate and use them with weights.
    a. Apply mask 1 and spray $R_6 F_1$ to obtain a uniform 10 or 20 percent gray.
    b. Add mask 2 and grade the initial gray to black in the portion marked XXX.
    c. Remove mask 2 and add mask 3. Grade the initial gray to black in the portion marked XX.

    **Note:** Using acetate with one cut for adjacent areas yields absolutely precise borders. No other masking material performs as well as acetate in such situations.

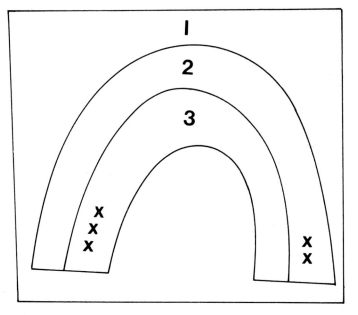

14. Use the following procedure:
    a. Cut acetate as shown, apply A, and spray a uniform 30 to 40 percent gray.
    b. Return with freehand $MR_2F_2$ for the dark bottom of the drop.
    c. Use any of the methods from solution 11 for the white reflection.
    d. Remove A, apply B, and spray the outer shadow.

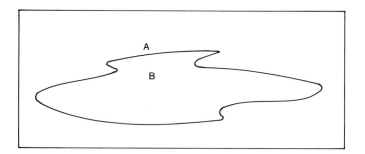

---

15. Cut a single mask in acetate as shown.

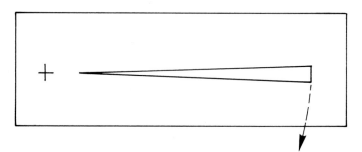

Pin it to the support with a needle or pushpin at the point corresponding to the center and spray repeatedly, rotating the mask as necessary. If the color dries quickly, you can hold the acetate with weights and rotate the mask while the weights are still on; the slight friction will not damage the art.

---

16. The procedure is the same as for number 15. In order to keep the correct distance between the "petals," make tiny dashes on the artwork where you want each one to go; line each mark up with a similar mark on the acetate before spraying.

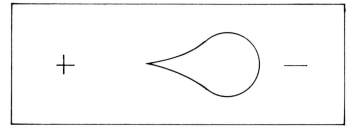

**17.** Assuming a black background:
- **a.** Cut a mask like the one used for number 1 if you are certain you can judge the perpendicular accurately; otherwise cut a cross like the one shown here.

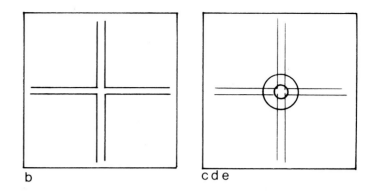

b             c d e

- **b.** Apply the mask and spray the cross, fading away from the center either with white if you have good control of RF percentages and can obtain a dark gray, or with 20 percent gray premixed from black and white.
- **c.** Remove the mask and emphasize the halo with color.
- **d.** Spray the central white dot to complete the work.

---

**18.** The mask is acetate, cut as in the illustration, used with weights.

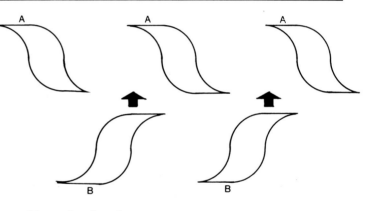

- **a.** Transfer the drawing.
- **b.** Spray all A's.
- **c.** Wash the mask or let it dry. Turn it upside down and spray all B's.

---

**19.** The mask is acetate with weights, cut as in the illustration. Follow a procedure similar to that used for number 18.

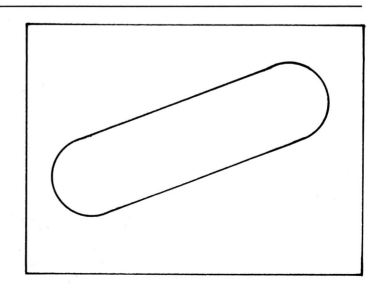

**20.** Cut a mask as shown here.

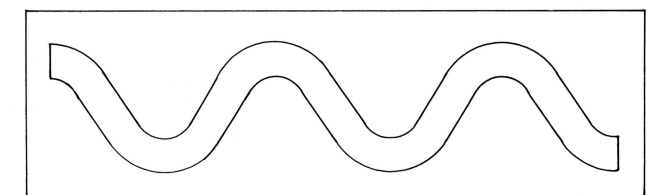

First spray one area of the helix; then move
the mask from *AB* to *A'B'* and repeat the operation.

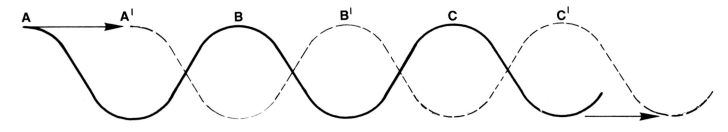

This type of spraying requires visual anticipation. As shown, the sprays must emphasize the visible parts and subdue the hidden areas. Shadows have been ignored in the previous illustration for this exercise, but see if you can figure out where they belong and try to illustrate them.

**21.** Two masks are required for the chain. Cut them in acetate and hold them down with weights.

**a.** Transfer the drawing to the support.

**b.** Spray all parts labeled 2.

**c.** Spray all parts labeled 1.

It is best to begin with number 2 parts for two reasons. First, whenever possible, you should spray objects according to distance, more remote ones first. In this case, the links represented by mask 2 are slightly farther away than the other links. Second, if this were a complete rendering, you would have to include shadows (as shown here), and therefore use additional masks. Spraying number 1 parts after number 2 parts covers any blurs formed by previous sprays.

# THE SHIELD

We have now arrived at the most exciting method of airbrush spraying—the use of the shield, which permits spontaneity, speed, and freedom, leading to creativity in fine art. Because most illustrators use the masking method in their work, airbrushing has acquired the reputation of being a difficult, technical, nonartistic, time-consuming, and tedious technique. The shield has been devised as the antidote to all this.

In airbrush masking, described in the preceding chapter, the mask is applied to the artwork and actually fastened to it during spraying. A shield is a mask held in one hand, not affixed to the surface, while the other hand operates the airbrush (Figure 9-1); it is thus much more flexible and easily manipulated. A mask is cut according to the specific shape needed for a particular piece of art, whereas a shield is an all-purpose mask with a variety of shapes; it is an airbrush-adapted french curve. When you implemented the exercises in Figure 8-7 (page 72), you actually experimented with shield work.

## Airbrush Rendering of Light, Shade, and Shadow

To understand how the shield can be used, it is first necessary to analyze the relationships of light, shade, and shadow and how they can be interpreted in airbrush. The eye perceives the material world in terms of hues and tones of light reflected by matter. The fifteen illustrations in Figure 9-2 show some basic geometric shapes and their patterns of shade and shadow. These are only a few selected randomly among thousands, of course, but if you study and

Figure 9-1. The typical working position for vertical shield airbrushing.

memorize them you will learn the principles involved and can apply them to other shapes. Precise, geometrical accidents on a plane determine the method of executing these shapes in airbrush. (*F* means freehand, *M* means mask.)

For all such precise shapes and volumes—solid matter with definite geometrical borders—masking and freehand methods are adequate. Matter, however, can take much more subtle forms with more intricate surface patterns that cannot possibly be rendered with these two airbrush techniques alone. The nine illustrations in Figure 9-3 are examples of geometrically nondefinable shapes. Illustration 1 is a simple free airbrush exercise related to those studied in Chapter 8; all the others require some sort

Figure 9-2. Geometrically definable accidents on planes and their rendering in airbrush.

straight accidental groove on plane

bent accidental groove on plane

soft mound

accidental irregular mound on plane

accidental mounds around groove on plane

typical merging of two wrinkles

hemispheric mound with ring

fold and shadow

vanishing groove

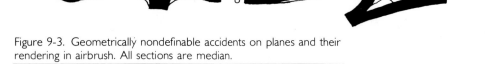

Figure 9-3. Geometrically nondefinable accidents on planes and their rendering in airbrush. All sections are median.

of masking, but it would be a waste of time and energy to cut masks for such simple shapes from frisket or acetate and apply them to the art. Illustration 7, for instance, would require no fewer than three different masks; a complex rendering of an anatomical detail might require literally hundreds of masks. It is for such shapes as these that the shield is most useful. All the illustrations in Figure 9-3 were done with a shield.

It is easy to understand how the shield is used when the curve to be sprayed corresponds exactly to one of its segments, but you might wonder how a more complicated one, like Figure 9-4, could be

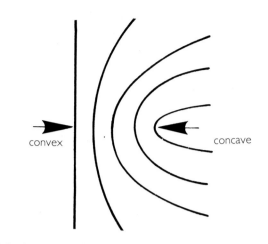

Figure 9-5. A selection of convex and concave curves. Spraying at the left of the curve results in concavity; at the right, in convexity. The labeling does not contradict previous statements; it refers to the line itself, not the airbrushed result.

Figure 9-4. A complex curve implemented with the shield.

sprayed. That is a legitimate question; a satisfactory answer necessitates an explanation of the principles of shield design and a parallel between the shield and the french curve.

## Principles of Shield Design

A complete shield must include the following shapes: a straight line, various convex and concave curves, inflections, and intersections.

**Straight Line** A shield is cut from a rectangular piece of paper or acetate, so one of the four edges should remain straight. Not only does the straight edge enable you to spray straight lines, but it also provides a better grip for your hand.

**Convex and Concave Curves** These are the basic shapes of the shield. Theoretically, the various convex and concave curves should cover an infinite number of curves, as shown selectively in Figure 9-5, but this is impossible in practice; no shield can include more than six or seven convex and concave curves (Figures 9-6 and 9-7).

Because ellipse and circle templates are available for those precise geometric curves, the curves on the shield should be more irregular and asymmetric.

**Inflections** The points where a curve changes its direction are called points of inflection (P in Figure 9-8), as you learned in Chapter 6. An artistically

Figure 9-6. Concave sprays.

Figure 9-7. Convex sprays.

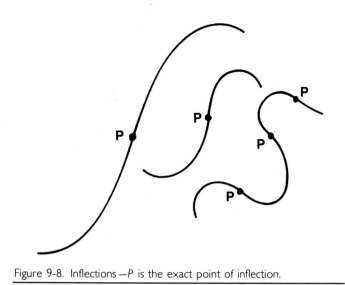

Figure 9-8. Inflections—*P* is the exact point of inflection.

detail in Figure 9-9 reveals a wealth of curves: *A*, *B*, *C*, *AB*, *BC*, and *ABC* are convex curves; *D* and *E* are inflections; *M* and *N* are concave; *BCD* and *EAB* are complex; and if the shield is moved (Figure 9-10*b*), *E* added to *B* makes a complex curve as well. And this is only a small segment of the shield outline!

**Intersections** Without masks, intersections are a delicate matter. Suppose you want to spray a right angle (Figure 9-11) using only your shield. The usual technique would be to hold the straight edge of the shield against first one side and then the other, but inevitably this will result in an imprecise corner (Figure 9-12). The solution is to sacrifice one corner of the shield for an intersection cut (Figure 9-13).

Eventually, as you become more familiar with shield work and know the kinds of shapes you encounter most in your work, you can add more intersections, angles, and holes to the shield (Figure 9-14).

free airbrush rendering is almost inconceivable without them. Alternating convex (CX) and concave (CC) curves on the shield results in almost double the number of inflections (Figure 9-9), facilitating your work and economizing on space.

An enlargement (Figure 9-10*a*) of the framed

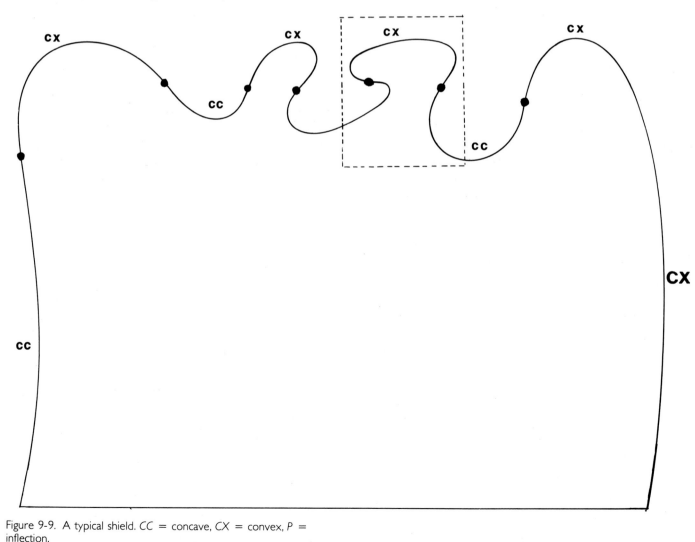

Figure 9-9. A typical shield. *CC* = concave, *CX* = convex, *P* = inflection.

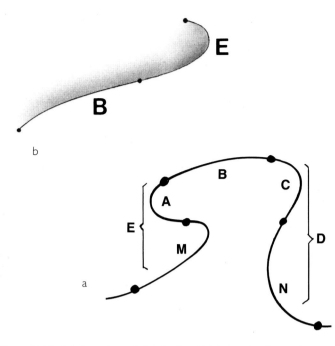

b

a

Figure 9-10. (a) An enlarged detail of a shield showing the main segments of a loop and possible combinations. (b) Two separate segments can be adjusted to make a new combination curve.

Figure 9-11. (Left) A right angle properly airbrushed.

Figure 9-12. (Right) A right angle airbrushed with a straight edge.

Figure 9-13. Your shield should have a cut of 90 degrees for corners.

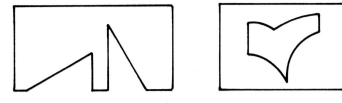

Figure 9-14. Possibilities for additional cuts in the shield: acute angles and curved angularities.

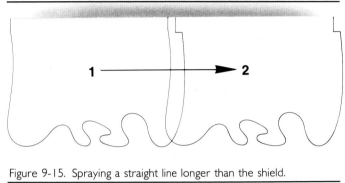

Figure 9-15. Spraying a straight line longer than the shield.

## The Shield and the French Curve

How can you draw a straight pencil line with a ruler that is only half as long? First draw the length of the ruler; then shift the ruler and draw the rest of the line. The same idea applies to the airbrushing of a straight line that is longer than your shield—first spray the length of the shield, move the shield, and continue to spray the rest of the line (Figure 9-15).

These examples may seem obvious to you; but now let us expand the principle to apply to curves. How would you draw the curve in Figure 9-16 with a french curve? First draw portion A of the curve with portion C of the french curve; then turn the french curve upside down and use the same portion to draw B, aligning the two halves at the common joining point. This works with shield airbrushing as well; you would spray portion A of the curve (Figure 9-17) with portion A of the shield and portions B and C with their equivalents. The sequence is important; it would be better to spray ABC or CBA or BAC rather than ACB, because it would be difficult to align segment B with *two* already sprayed segments (A and C).

This is essentially the principle behind constructing complex curvatures with the shield. In theory there is no curve or combination of curves that cannot be airbrushed with the help of shields; however, it is not always easy to combine segments of a shield to obtain an intricate curve precisely. Often four or five or even more segments are needed to implement an apparently simple shape.

## The Value of the Shield

After all this explanation you might think the shield method is too complicated. Is it worth trying? The answer is yes; if you want to progress beyond mere technical skill, it is not merely worthwhile but essential. The technique only seems complicated;

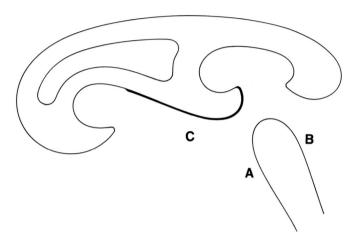

Figure 9-16. Complex curve AB can be drawn accurately by using segment C of the french curve, first right side up, then upside down.

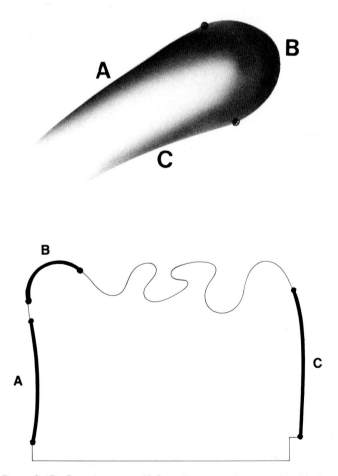

Figure 9-17. Complex curve ABC can be sprayed accurately with the corresponding areas of the shield, indicated by the heavier line.

almost anything is difficult when you first try it, but after you have acquired some skill with the shield, you will see that masks cannot compete with it for speed and versatility.

The advantage of working constantly with the same shield or set of shields is that you become familiar with the tool and through experience learn which curves to combine for a specific shape.

In most cases illustrations can be implemented entirely with one shield, but there are times when two or even three are necessary. Thus you need to have a set of shields of different sizes. It is difficult to build such a set yourself without experience.

## Practical Exercises

The following ten exercises are applications of the previous theoretical discussion. Re-create each one; do not try to make an exact copy, however, but simply try to represent the same surfaces. You will not be able to do these perfectly at first; excellence in airbrushing requires years of practice. Do not choose exercises at random; they are arranged in sequence according to their degree of difficulty, and each one builds on skills learned in the foregoing one. Render each illustration same size, using only black gouache on 100 percent rag illustration board. **A considerable amount of free airbrushing is used in all the following exercises.**

1.  The shield is used exclusively for the central groove. Your shield may have the proper inflection, or you may have to compose the curve from different segments or even from more than one shield. Note the unique type of surface that necessitates using the shield: the sharp border between two planes. All other smooth changes of surface angle can be treated with free airbrushing.

2. Here there are two grooves instead of one; the configuration resembles a double wrinkle seen through a good magnifying glass. Again, the shield is used only for the two grooves.

4. Two bubbles should present no more difficulty than one. Rendering this illustration will help you understand the next one.

3. In this exercise the grooves from the first two exercises unite at the top, forming a kind of bubble. The shield is used carefully at the transition from light to shadow on the bubble and on the surrounding surface.

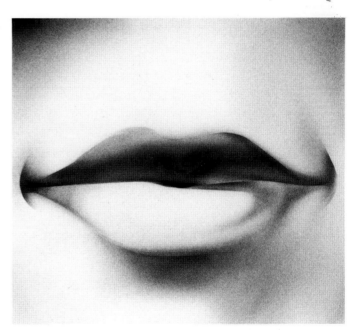

5. Study people's faces or some photographs of faces in the proper lighting before you attempt this exercise, which is your first approach to a real face. Once you have done the bubbles in the preceding exercise, you should have no trouble with this one. Do not worry about the beauty of the lips, but concentrate on rendering their shape.

6. These lips have less substance but more expression than the previous pair. It is necessary to solve such airbrush problems even when the subject seems flat and uninteresting. Lips alone convey nothing; an indication of nose and cheeks enhances the expression.

8. There is a change of orientation from mound to nose. The two stones have become nostrils (you see only one); the problem is to sense and render the differences between organic and inorganic matter.

7. This is a mound and two stones against a cloudy background, a relatively simple problem. Although the stones are precisely outlined solids, only a shield was used. The shield must be placed and turned so that all necessary shapes can be airbrushed with it. Use the shield exclusively for such problems and exercises so that you can eventually free yourself as much as possible from the burden of masking.

9. A nose is easier to render in profile than frontally. A frontal view of a nose, like this one, requires deeper understanding of its three-dimensional proportions and the way light and shadow define it. Again, the use of the shield is minimal but essential.

10. This ear is distorted; anatomical accuracy was deliberately disregarded to show that the use of airbrush can create an atmosphere of realism even when the subject is nonrealistic or surreal. Treating the same ear without the shield at all, using only the freehand technique, would create a fuzzy, dreamy atmosphere, an altogether different concept.

Figure 9-18. Frisket is the most accurate outlining mask.

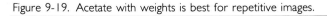

Figure 9-19. Acetate with weights is best for repetitive images.

Figure 9-20. Shields are irreplaceable for spontaneous, quick, nontechnical works.

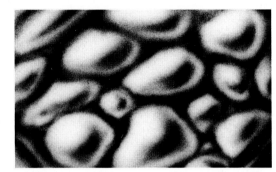

Figure 9-21. Freehand spraying is the basis of all airbrush techniques — the work of your hand is most important of all.

## Summary of Airbrush Methods

This is a good place to pause and summarize the uses of the mask, shield, and freehand techniques you have been studying.

- □ Use self-adhesive frisket mainly for complete outlines of objects, generally where the outlines must be precise and accurate (Figure 9-18). Avoid frisket wherever possible, however; artwork can be damaged by the coating of adhesive and the fact that it is cut directly on the support.
- □ Use acetate held down with weights for complete outlines when frisket should not be used, for partial surfaces within complete outlines, and for repetitive images (Figure 9-19).
- □ Use shields for detailed and intricate folds on surfaces, for transitions between mask and freehand airbrushing, and for quickly executed, spontaneous works where technical precision is not required (Figure 9-20).
- □ Use freehand airbrushing for wavy accidents of surfaces and all other graphic gradings (Figure 9-21).

As your proficiency develops, you will probably use frisket and acetate less and less, but you will never totally eliminate them from your work. Experience will dictate when you can substitute a shield or freehand work for a mask, and when a mask is preferable.

# COMPLEX TECHNIQUES

In previous chapters we have examined the three fundamental techniques of airbrush—freehand, mask, and shield—and analyzed examples of their use both alone and in combination. Most of the time, however, airbrush artwork requires additional techniques—color layering, brushwork, and mixing mediums—which enrich a work while they facilitate the working process.

## Layering Colors

In all the exercises up to now, you have used only one color, black. As we mentioned before, artists use more than one tone of a color to obtain a single grading.

Study the two strips in Figure 10-1. Only black was used for illustration *a*; illustration *b* was sprayed first with 30 percent gray and then with black. So that you can see the difference between the two more clearly, the first tone was sprayed on white illustration board in the usual way, but the second tone was sprayed on a superimposed sheet of prepared acetate (Figure 10-2). (Prepared acetate is a sheet of acetate that has been treated chemically so that medium will adhere to it.) By separating the tones in this way we can show you not just the difference in results between a one-tone spray (Figure 10-1*a*) and a two-tone spray (Figure 10-1*b*), but also how the second method is done—what area is gray and what is black. (Because acetate darkens cumulatively, this technique cannot be extended to more than one overlay and consequently more than two colors.) The printing reproduction has probably obscured the difference between *a* and *b* somewhat, so repeat the experiment yourself (without the acetate) so that you can see it clearly.

Figure 10-1. Grading obtained from spraying black only *(a)* and from spraying a layer of gray and then a layer of black *(b)*.

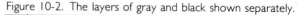

Figure 10-2. The layers of gray and black shown separately.

This procedure of adding layers of medium on acetate, devised for visual clarity, has practical applications as well. You can use acetate in this way to test one tone or hue over another one, or when (for print reproduction, for example) layers of color must remain separable.

The apparently simple principle of layered tones plays a tremendous role in the artistic richness of airbrush work. An analogy will suggest how a complex illustration can be built in layers. If you

Figure 10-3. Stages of development of a black-and-white photograph. Note that at the beginning the tones are very close to the white of the background; toward the end of the process they intensify to the appropriate tones.

have ever assisted a photographer in the darkroom, or observed a Polaroid photograph developing, you have seen that the photographic image emerges gradually, first in very light tones, then in progressively darker ones, until the final image is obtained (Figure 10-3). The airbrush can imitate this chemical transformation; **the first tones sprayed should be those closest to the background color, whether it is white, black, or any other color.** For a black-and-white rendering on a white background, for instance, the first spray should be 10 to 20 percent gray—a mixture of 10 to 20 percent black and 80 to 90 percent white for opaque colors (Figure 10-4). The next layer would be sprayed with 30 to 40 percent gray (30 to 40 percent black with 70 to 60 percent white for opaque colors). The last layer is 50 to 60 percent gray. Always use 100 percent black sparingly; it represents the absence of light reflection and therefore should be reserved for very deep, dark corners, holes, and accents.

As you can see in the illustration, the area covered by 20 percent gray in step 1 is larger than the area covered in step 2, which in turn is larger than the darkest areas in step 3, shown schematically in Figure 10-5.

Never try to retouch missed areas of earlier layers, or to spray the step 2 tone directly on the support adjacent to the step 1 tone. Even if you could spray the second tone to match the intensity of the first, the result would be *two* grays of different textures and disharmonic vibrations. Always spray additional tones *over* previous ones, never beside them.

You should now be able to appreciate why gouache is the best educational medium. If you wanted to use transparent colors for Figure 10-4, you would not have to change the color in the paint container of the airbrush; however, you would have to be quite skilled to control the intensity of the layered color. The advantage of opaque colors is that no matter how many layers you spray, the accumulated color will never differ from the color you prepared.

What has been said so far about layering colors refers to grading. In many other instances, however, layering can be simply a crossing of two or more tones. In Figure 10-6, for example, the first illustration indicates an opaque crossing; the second, a transparent crossing. The procedure for rendering these effects differs for opaque and transparent colors. A crossing like this cannot be done without masks in frisket or acetate, of course.

There are four possibilities: transparent effects with opaque colors or with transparent colors, and opaque effects with opaque colors or with transpar-

Figure 10-4. A black-and-white figure airbrushed with three tones: (a) 10 to 20 percent gray, (b) 30 to 40 percent gray, (c) 50 to 60 percent gray.

Figure 10-5. Diagram of the areas airbrushed in layers in Figure 10-4.

Figure 10-6. A simple overlapping of two tones: opaque effect (a) and transparent effect (b).

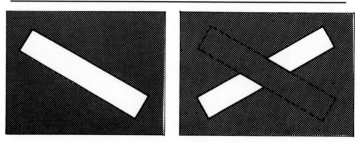

Figure 10-7. (Left) Mask for overlapping strips for opaque colors (for both opaque and transparent effects) or for transparent colors for a transparent effect.

Figure 10-8. (Right) Additional mask needed for an opaque effect when transparent colors are used.

ent colors. With opaque colors, a crossing can be sprayed with only one mask (Figure 10-7). Spray one tone for the first strip; then change the position of the mask and spray the second strip in an opaque layer with a lighter or darker tone for an opaque effect; or, for a transparent effect, not fully opaque. For transparent colors, you would need a second mask, in addition to the one used before, to obtain the opaque effect (Figure 10-8). The same principles apply to any overlapping tones on any shape.

## Brushwork

It is not necessary to do a complete rendering with airbrush only; using brushwork can simplify technical procedures as well as supply structure, solidity, and details that the airbrush cannot.

**Brushwork Underneath Airbrush** *Flat backgrounds.* Despite the availability of a tremendous variety of ready-made colored papers and boards, artists sometimes prefer to make their own backgrounds, either with the airbrush, as described in Chapter 7, or with a brush, as described in Chapter 4. An airbrushed background has incomparable uniformity and a superbly smooth and velvety texture, but the solidity of a brushed background may be preferable in some cases. In addition, an airbrushed background has the disadvantage of being more fragile and susceptible to spotting with unwanted color, which cannot be retouched. With a brushed background, on the other hand, you must take care that the brush marks, which dry almost as microscopic surface ripples, do not interfere with airbrush accuracy (although you may wish to use them for a special effect). Remember, too, that the visual differences between the two kinds of backgrounds will most probably disappear in printed reproduction.

*Faceted surfaces.* Study the illustration in Figure 10-9. You might conclude that masks were cut for each surface and that each one was sprayed with a different gray tone. In fact, the background and the seven shades of gray were painted with a brush; the airbrush (with shield) was used only for spraying plain white. On the original the brush marks are coarse and clearly visible; they have disappeared in reproduction. The obvious conclusion is to use airbrush for a whole piece of art only when necessary and to simplify the work by using a brush when the technical difference is irrelevant.

*Immaterial effects.* A silhouette of a remote castle painted with a brush (no airbrush could render such details) becomes dramatically mysterious when wisps of fog are airbrushed over it (Figure 10-10). The immateriality of fog, as well as of gas, clouds, dust, ghosts, lightning, sparks, light beams, and other phenomena, done in airbrush contrasts with the substantiality of brushed objects.

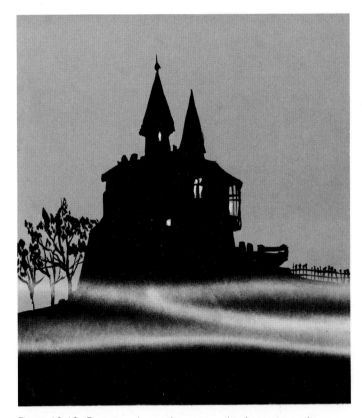

Figure 10-10. Fog around a castle—a very simple spray produces an impressively eerie effect. Everything but the fog was rendered with a brush.

*Retouching.* After completing a work done in brush, or in brush and airbrush combined, artists often feel the need to enhance an overall hue or a certain mood, to intensify a contrast, or to subdue an image. The airbrush can perform such functions subtly and imperceptibly; spraying $R_{10}$ or more with the desired color is the equivalent of an oil-painting glaze. Transparent colors can enhance tones without ruining drawing details; opaque colors can subdue images or details altogether.

*Dead ends.* Complicated shapes like the one shown in Figure 10-11 are common in everyday airbrush work. Cutting a mask for such an outline would be extremely difficult, and a shield would be useless; brushwork is the most satisfactory method for the spot of 100 percent color. The arrows in the illustration indicate where airbrush, used with a shield, takes over.

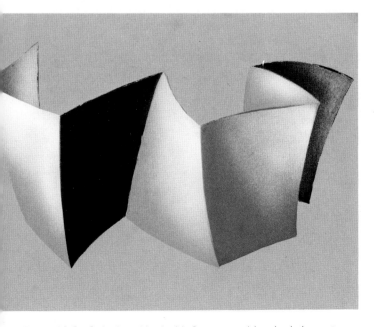

Figure 10-9. Only the white in this figure was airbrushed; the rest was done with a brush.

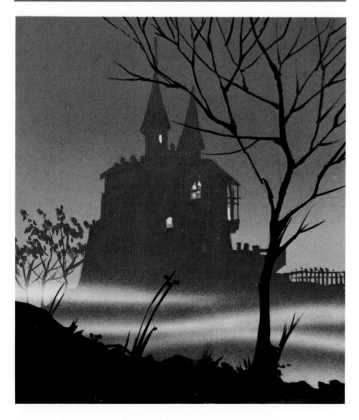

Figure 10-11. A brush can penetrate sharp corners and irregular outlines like this much more easily than any airbrush technique. Once the outlines are brushed, the airbrush can be used with the shield to produce the fading.

Figure 10-12. Fog over a faraway castle. Alternating brush and airbrush work can enhance the illusion of depth.

**Brushwork Over Airbrush** *Depth.* Brushing an object over an airbrushed background can make the object appear to be closer. Compare the previous illustration of a castle (Figure 10-10) with Figure 10-12. Here even the sky was airbrushed. The gray of the castle is slightly lighter than in Figure 10-10; only the front tree and the ground are black silhouettes. The brushed silhouettes against airbrushed atmosphere seem nearer. Figure 10-12 was done in the following sequence: gray number 1 (lower sky), airbrushed; gray number 2 (upper sky), airbrushed; gray number 3 (castle and trees), brushed; diluted white (fog), airbrushed; black (foreground tree and ground), brushed; and white (light in windows), brushed.

*Details.* Delicate objects on which there is no change in value and no play of light and shadow, such as needles, wire, or strands of hair, can be brushed over airbrush work. The brush must be held with a steady hand that does not touch the airbrushed surface; it is best to cover the artwork with tissue or other paper, leaving exposed only the area to be brushed.

*Solidity.* In many instances a flat, opaque object may cover a portion of an airbrush work; an example could be a spacecraft suspended above Earth (Figure 10-13). Here Earth and space were airbrushed; the spacecraft was done with a brush. Details could be added to the ship with either airbrush or brush.

*Finishing touches.* Very dark accents or sparkling light reflections on wet, glossy, or glassy surfaces are

Figure 10-13. A spacecraft seen far above Earth. The planet and surrounding space were airbrushed; the spaceship was brushed and therefore seems more tangible than the remote landscape.

generally added with the brush. The color must be thick and the touch swift, so that no airbrushed color underneath will penetrate and ruin its freshness and brilliance.

*Mechanical work.* Technical drawings (lines, compass-drawn circles, Rapidograph, lettering, and so on) can be done on an airbrushed work when inks and dye-based watercolors are used. Gouache and pigment-based colors in general do not allow accurate tracing, so, when these are used, additional technical work must be performed on a separate piece of paper or on an acetate overlay.

## Mixing Mediums

**Note: The characteristics and uses of various mediums are analyzed in detail in Chapter 3; this is only a reminder that you can combine more than one medium in the same artwork for a multitude of effects. Once you are familiar with what each medium can do, only subjective artistic reasons dictate the way you use them together.**

## The Eye

In order to demonstrate the brush-with-airbrush technique in a more elaborate way, we now return to the rendering of an eye, an exercise in freehand airbrushing in Chapter 7. Here (Figure 10-14), use the following methods and sequence:

1. Use 30 percent black for the basic tones, freehand and with shield; use a circular acetate mask or circle template for the iris (but try to complete it with shield only).
2. Use 60 percent black for the second tone, freehand and with shield. Use the same acetate mask to enhance the border of the iris.
3. Using 100 percent black, brush the eyelashes, pupil, and the connection between them; airbrush the iris, using a circle template.
4. Use thick white gouache (almost undiluted from the tube) to add the iris-pupil highlight with a brush.

Figure 10-14. The eye rendered with complex techniques.

# Chapter 11.

# APPLICATIONS

Having studied freehand, mask, and shield air-brushing, and the complex techniques of color layering, mixing airbrush with brushwork, and mixing mediums, you probably are wondering what you can do with them: How can these techniques be used to build renderings? How can they be handled to realize the artist's vision?

This book is a study of art technique, not of artistic imagination, so the answers to those questions must be given in academic terms. Throughout the history of art, artistic vision has been based on the elaborations of the material world. Whether Realists, Impressionists, Surrealists, or Abstractionists, artists have rendered their works as the interplay of light and matter, even when they used matter to symbolize religious, philosophical, or other abstract concepts. Matter is therefore at the core of artistic study; its relation to light and to the eye provides the answers about the applications of airbrush techniques. Matter is a universal concept; we shall narrow it to objects.

## Object and Vision

The visual image of an object depends on the interaction of the object with the eye of the observer and with light. In general, the relative positions of those three factors and their distance from one another are what determine the object's appearance and therefore the way it should be rendered. However, each of these elements—observer, object, and light—is subject to other particular determinants, which we have tried to list here:

*Observer*
Logical determinants of the artwork: purpose (based on the distinction that a work of com-

mercial art has a psychological purpose to influence a beholder, whereas fine art is the sole expression of the artist—whether the beholder understands the work or not is irrelevant), form (perspective, orthographic, or axonometric projection), color (black-and-white or color)

Emotional determinants of the artwork: purpose (unlimited but controlled), form (distorted, abstract, etc.), color (conventional, realistic, fantastic, etc.)

*Object*
Geometry: point, line, surface, or solid
Shape: geometrically definable or geometrically nondefinable
Structure: opaque, transparent, or translucent
Texture: reflective or absorbent
Nature: inorganic or organic

*Light*
Nature: actual source or reflection
Quantity: number of photons (tone)
Quality: wavelength (hue)
Effects: reflections, shade, and shadows

Consideration of these factors is fundamental to the study of any of the visual arts, not just airbrush, and so it is assumed that you are sufficiently familiar with them to put them to practical use. If not, learn them—you cannot avoid doing so—for without this knowledge your airbrush work will remain amateurish.

## Object and Airbrush

As you have seen repeatedly in previous chapters, point and line are easily rendered with the airbrush.

Because they are less than two-dimensional, point and line are treated either as symbolic, dematerialized shapes of three-dimensional solids or as locuses of intersection between lines and planes respectively. Beyond point and line is the surface— the initial challenge to the airbrush artist, because all solids are perceived as a plurality of surfaces.

For our purposes, surfaces can be classified as *plane* or *curved* (cylindrical, conical, ellipsoidal, parabolical, hyperbolical, spherical, thoroidal, or geometrically nondefinable). An infinite number of combinations of these elementary surfaces defines the infinite variety of the material world. In this chapter we shall study only two such surfaces: the plane, because of its fundamental importance for the airbrush; and the sphere, because it is the simplest smooth, solid-wrapping surface. All other surfaces can be considered components of plane or sphere sectors, or similar to them, or distortions of them; based on your prior knowledge of geometry, light, and shadow, you should be able to extrapolate airbrush technique for plane and sphere and apply it to other forms.

## The Plane

Here we do not refer to a flat background to be airbrushed, but to the representation of a material plane surface. Although a plane is also subject to light factors, an untrained artist might ask, "If a plane is static and has a fixed relationship to the light source and to the eye of the observer, why should the airbrush be used? Under such conditions, isn't the plane uniform in tone and hue?"

To find out the answers, observe carefully every plane surface you can see around you: walls, ceiling, floor, tables, books, and so on. You *know* that these are uniformly colored, and so at first you perceive them to be so. On further examination, however, you will see that there are in fact variations in the surfaces. Several factors account for this:

□ When a uniformly colored surface touches an adjoining nonuniform surface (Figure 11-1), the phenomenon of eye compensation occurs. In this example, the upper region of the surface seems lighter than the lower region. (We have emphasized this illusion here.) You can suggest this compensation in airbrush with an R$_{10}$ grading.

□ The eye also compensates when two or more planes form a fold or a solid (Figure 11-2). This simple phenomenon, plus the difference in the angle of reflected light and the texture of the solid, is the fundamental basis for airbrush rendering of flat, faceted solids.

Figure 11-1. A solid white surface against a background that varies in intensity no longer appears to be an even white because of eye compensation. You can render the visual effect with a light tone and R$_{10}$.

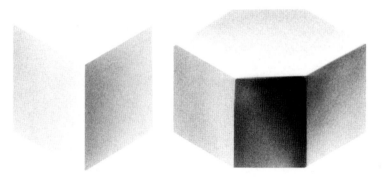

Figure 11-2. Eye compensation is strong when two or more planes intersect.

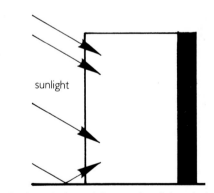

sunlight

Figure 11-3. A vertical panel that receives light principally from the sun will also receive a secondary light reflected from the floor or ground.

□ Except for objects in space, every surface is illuminated by a principal source of light as well as by many major (visible) and minor (negligible) counterlights reflected from its surroundings. A flat, vertical, sunlit panel (Figure 11-3), for example, receives counterlight from the floor—strong if the floor is white marble, weak if it is black carpeting.

□ The eye receives light from a plane, which reflects the light at different angles, each represent-

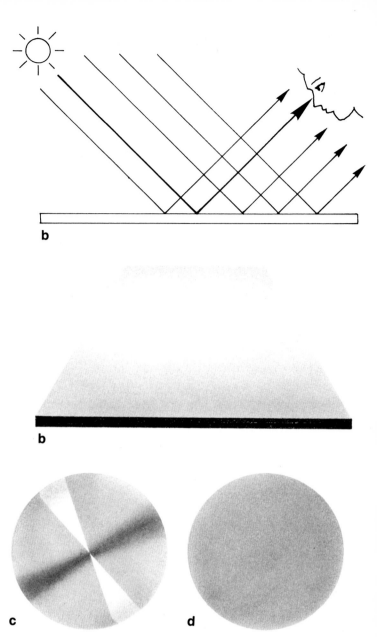

Figure 11-4. (Top) Close range light (a) or sunlight (b) reflected by a plane surface appears to be strongest where the angle of the beam that reflects directly to the observer's eye equals the angle of the incident beam.

Figure 11-5. (Middle) Renderings of a close-range reflection (a) and sun reflection (b) on a plane.

Figure 11-6. (Above) These four illustrations represent sections of metal cylinders. Why does section a reflect the light source? Why does section b reflect in a linear pattern and section c in a radial pattern? Why does section d not reflect at all? Remember that the four cylinders are the same metal; assume the same light source and position for all four. The solution can be found in Figure 11-36.

ing a different number of photons reaching the retina, resulting in a continuous grading (Figure 11-4). Whether the source is at close range (a) or the sun (b), the strongest reflection occurs where the angle of incidence ($\alpha$) reflects symmetrically and directly to the eye. Renderings of these surfaces would look like Figure 11-5. To clarify this, imagine a mirrored plane; in that case, the greatest intensity would be the mirrored reflection of the light source itself.

□ Textures of surfaces, as we have already said, determine more the power of reflection or absorption than the graded changes in tone and hue. A simple problem will challenge you to think about how texture can be reproduced by airbrush. Study the illustrations and caption for Figure 11-6; the answer is given at the end of the chapter.

To represent a uniformly colored plane, then, you must take into account its background, any adjoining surfaces, principal light and counterlights, the angle of reflection of the light, and the texture of the surface itself.

## The Sphere

This solid object has always been poorly elaborated in the literature on airbrush. Instructions are given for cutting the frisket and spraying color so that the sphere looks like Figure 11-7. What is only sometimes mentioned is the change in approach necessitated by differences in the material of the sphere; with this oversimplified technique the sun, the moon, the earth, a billiard ball, and a velvet ball would all be rendered in a very similar way. As should be obvious to you by now, however, many factors determine the appearance of a sphere. The following are some of them.

**Location of Light Source** *Inside the sphere.* The sphere in this case could be the sun, a light bulb, or a lampshade. It might be uniformly colored or have a central accent (Figure 11-8). In either case the eye registers a powerful contrast between the sphere and the background. When the high luminosity of the sphere must be emphasized, spray (using a mask) a thin ring of black around the edge of the sphere, as shown in the figure.

*Infinite distance from the sphere (orthographic projection).* In Figure 11-9 the arrows represent light from the sun or the moon; at these distances the light beams can be considered practically parallel. A sphere in this light is divided into two equal hemispheres, one lit and the other in shadow.

*Finite distance from the sphere (conical projection).* When the source of light is relatively close to the sphere (Figure 11-10), the lighted portion is smaller in diameter than the entire sphere; its size decreases in direct proportion to the distance between sphere and light source.

Figure 11-7. A poor concept of how to render a sphere.

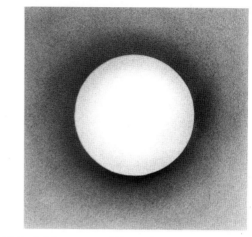

Figure 11-8. A light source within a sphere.

**Orientation of the Light Source** At infinite distances, the shape of the lighted half of a sphere can be a full circle, an ellipse, or a hemisphere, depending on the relative positions of source, sphere, and observer (Figure 11-11). In all cases between full sphere and exact hemisphere, the line that separates light and shadow forms half of an ellipse that seems to end at the poles of the sphere, though it actually continues on the invisible side (Figure 11-12). The possible variations are infinite.

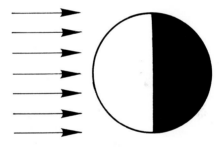

Figure 11-9. Profile view of a sphere receiving light from the sun (infinite distance).

When the sphere is positioned exactly between the observer's eyes and the light source (as in a solar eclipse), it appears to be black (Figure 11-13) with a slight halo around it. If the light source is extremely powerful, the outline of the sphere will be somewhat fuzzy. This effect can be rendered in airbrush by spraying the sphere with a mask that is only loosely applied, so that the white gets under the mask and blurs the edge. You could also remove the mask and spray a very fine $R_2F_1$ in white all around, slightly overlapping the black.

When the light source is closer, the lighted portion of the sphere is smaller, but it, too, changes its shape with changes in orientation. The smaller lighted circles are perceived as complete ellipses before they vanish on the invisible side of the sphere (Figure 11-14).

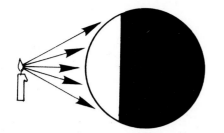

Figure 11-10. Profile view of a sphere receiving light from a candle (close range).

light source turns around equator in front

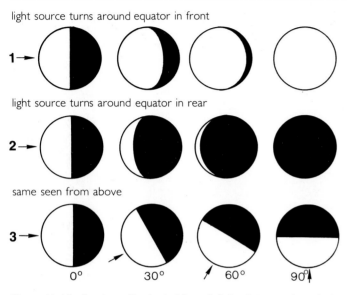

1 →

light source turns around equator in rear

2 →

same seen from above

3 →

0°        30°        60°        90°

Figure 11-11. A sphere illuminated from infinite distance, viewed at various angles, as it appears from the front (1), from the back (2), and from above (3).

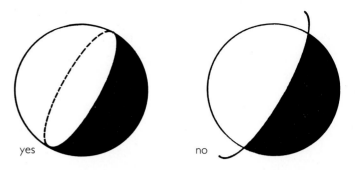

yes                    no

Figure 11-12. The border between light and shadow on a sphere illuminated from an infinite distance forms half of an ellipse (except when the lit portion is seen as a full circle or exact half-circle). The other half of the ellipse is on the invisible side of the sphere.

Figure 11-13. In a total eclipse a slight halo appears at the edge of the circle.

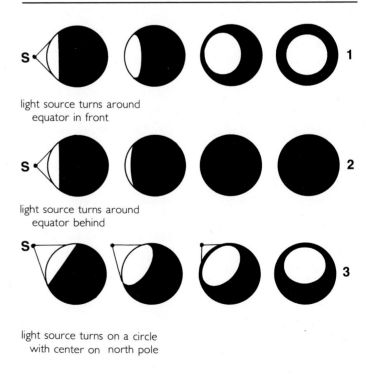

S

light source turns around equator in front

1

S

light source turns around equator behind

2

S

light source turns on a circle with center on north pole

3

Figure 11-14. A sphere illuminated at close range, viewed at various angles, as it appears from the front (1), from the back (2), and when the source of light (S) turns around the pole (3).

**Distance of Observer From Sphere** Even a highly polished sphere (not a mirror) has an irregular microstructure on its surface (Figure 11-15). The eye cannot perceive the pattern itself, but it does perceive the alternating light and shadow caused by the pattern as a more or less smooth grading, which is beautifully rendered with the airbrush.

Figure 11-15 shows three distinct regions: fully lit, light mixed with increasing shadow, and shadowed light decreasing to full shadow. The middle region is where airbrush work accomplishes a smooth grading; the width of this area is one of the factors that determine resolution. On a sphere that is relatively close, this area seems wider and therefore requires more gradual grading—a higher resolution number. In contrast, this area on the moon viewed with the naked eye would need only $R_1$, because it seems narrower, even though in reality the middle region extends hundreds of miles.

**Location of the Sphere in Space** A spherical celestial body reflects only one source of light, the sun, because there is nothing around it—no atmosphere or other bodies—to reflect counterlights (Figure 11-16). A sphere in the earth's atmosphere,

Figure 11-16. The parts of celestial bodies where sunlight does not reach cannot be seen because there is no atmosphere to reflect counterlights.

Figure 11-15. Microstructure of a spherical surface and its role in determining shade grading.

however, is subject not only to a main source of light, but also to a multitude of secondary, reflected light beams. These will be analyzed later in this chapter.

**Structure and Surface Texture of the Sphere** Other important determinants of resolution, and also of contrast, method of working, and need for additional brushwork, are structure and texture. M. C. Escher made more than one study of spheres of clear crystal, mirror, and opaque materials in his printmaking (Figure 11-17); the problem is fascinating in itself, aside from airbrush considerations.

Rendering reflections in mirrored spheres made of highly polished metal or metal-coated glass requires a profound understanding of spherical projective geometry, which is beyond the scope of this book. It is sufficient to say here that such spheres are airbrushed not so much as solids but as distorted reflections of the objects around the observer and around the spheres, including the observer (Figure 11-18). When such a rendering is required, the best thing to do is actually to study a mirrored sphere, produce a detailed pencil drawing of it, then render it with the aid of masks.

Transparent spheres that have the same kind of polished surface pose three problems for the airbrush artist: reflection of the light that hits the surface, the play of light reflected back toward the observer through the sphere, and distortion of the objects behind the sphere. All of these details can be rendered in airbrush (Figure 11-19). If necessary,

the white reflection of the surface light can be accentuated with brushed opaque white. Of course, the outline of the sphere must be defined with a mask, preferably frisket; for the inside of the sphere, all three airbrush methods can be used together, as well as the brushed white highlight.

In opaque, nonmirrored spheres, the degree of polishing determines resolution and intensities of contrast. A polished metal sphere (but not a mirror) reflects light strongly and surrounding objects with some intensity (Figure 11-20). A dull finish softens the contrast between light and shadow to an almost velvety uniformity (Figure 11-21).

A roughly cut sphere can be painted better with brush than with airbrush, which is unsuitable for coarse effects. Airbrush is not an ideal technical solution for all artistic endeavors; it should not be used indiscriminately, but reserved for subjects that require it or that will benefit from its characteristics. Your judgment is the deciding factor.

**Counterlights and Other Light Sources** Unless it is somewhere else in the cosmos, a sphere receives reflected light or light from sources other than the principal one. In black-and-white artwork it is best to have the sphere lit by a major source (M in Figure 11-22) with one slightly more grayish counterlight (C) only. On colored spheres the counterlights are more complex; major lights are warm in tone, whereas counterlights are cooler, or vice versa. In addition, there is a multitude of tones and hues within the counterlights, depending on the number of light sources or reflections. These will be studied in Chapter 12.

**Atmospheric Conditions** On a bright, sunny day a sphere looks entirely different from the way it looks on a dark, foggy day. A nearby sphere has much sharper features than a remote one seen through the atmospheric blanket of gases and dust.

Figure 11-17. M. C. Escher, *Three Spheres*. © Beeldrecht, Amsterdam/Vaga, New York. Collection Haags Gemeente Museum—The Hague, 1981.

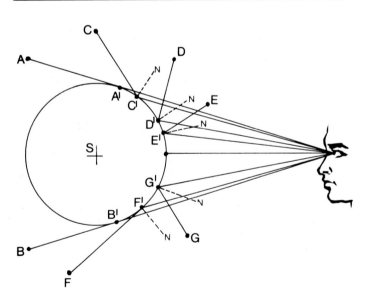

Figure 11-18. A spherical mirror reflects to the observer everything contained between points *A* and *B* clockwise. *S* = center of sphere; *A*, *B*, *C*, *D*, *E*, *F*, *G* = surrounding objects; *N* = normals of reflection; *A'*, *B'*, *C'*, *D'*, *E'*, *F'*, *G'* = reflections of objects.

Bright, warm colors will appear to be cooler at a distance because of the interference of the atmosphere.

**Background** A sphere against a dark background and the same one against a light background must be treated differently (Figure 11-23). The retina of the eye distinguishes sphere from background by analyzing light ratios and accentuating the contrast between them.

With few exceptions, spheres cast a shadow that helps define the relationship between the sphere and its surroundings (Figure 11-24); the cast shadow of a crystal sphere is a fascinating study. Whether a sphere is solid or liquid, remote or near, white or colored, and whether the background is white or colored, attached to the sphere or not—all these factors must be evaluated in each instance. The variety of shadows and their beautiful colors is surprising.

The preceding eight physical factors apply to the naturalistic rendering of a sphere. The number of potential combinations of these factors is exceedingly large (in the millions); but, in addition, for the commercial illustrator and fine artist the logical and emotional factors enumerated at the beginning of this chapter come into play. They can distort, enhance, subdue, or transform a realistic image to communicate its message more clearly or forcefully.

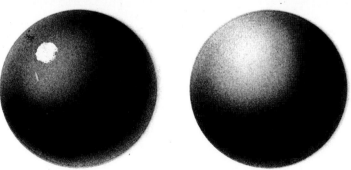

Figure 11-19. A crystal sphere rendered in this sequence: (1) frisket, (2) freehand, (3) acetate, (4) shield, (5) brushwork.

Figure 11-20. (Left) Rendering of a polished metal sphere.

Figure 11-21. (Right) Rendering of a dull metal sphere.

## Shade and Shadow

A few more words must be said about airbrush treatment of shade and shadows in general. For every object (Figure 11-25) shown in similar perspective and lit from a source in a constant relation to it, there is a lighted area, a shaded area, and a cast shadow. Basically, shade is lighter than shadow because it receives more counterlights from its surroundings, and because shadow is perceived in contrast to its surroundings. You can easily see the methods used to render the objects in Figure 11-25: frisket for the outlines, masks for flat planes, and freehand for curved surfaces. Prism c hints at the variation in intensity from light to shade; the flat

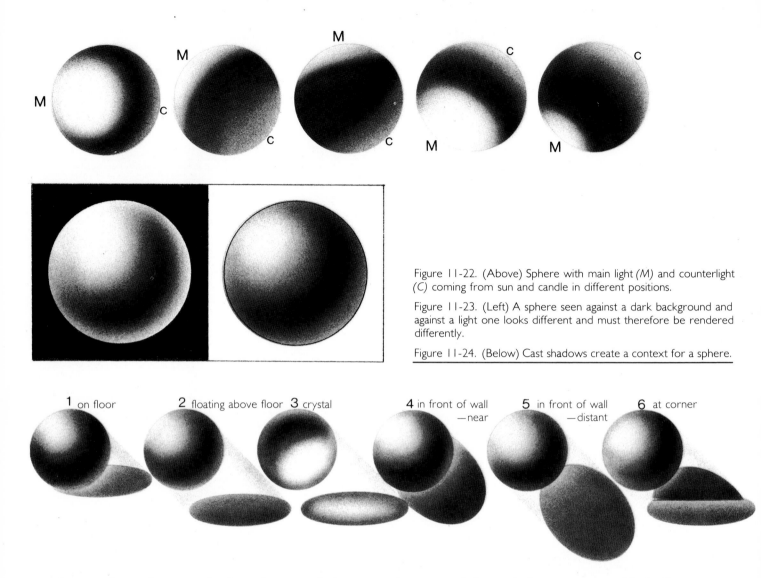

Figure 11-22. (Above) Sphere with main light *(M)* and counterlight *(C)* coming from sun and candle in different positions.

Figure 11-23. (Left) A sphere seen against a dark background and against a light one looks different and must therefore be rendered differently.

Figure 11-24. (Below) Cast shadows create a context for a sphere.

1 on floor  2 floating above floor  3 crystal  4 in front of wall —near  5 in front of wall —distant  6 at corner

surface at the right is in shadow, but it is lighter than the central facet because of the counterlight. The variation on cylinder *d* is even clearer. A parabolic surface (*g*) can be rendered similarly to a spherical sector, but a hyperbolic one (*h*) presents a new element of shadow-shade. This transition from shadow to shade requires shield work. The same method is necessary for the thoroid (*j*), where the overlapping ring limits the back shadow. The inside shadow of a pipe (*i*) can be done either with masks or with a shield if the flat section of the ring is brushed by hand after spraying.

Every object casts shadows on its surroundings as well. A sun-cast shadow of a solid that does not rest directly on the shadow-receiving ground (Figure 11-26a) receives a great deal of reflected light from the surroundings, has no sharp outlines, and can be rendered either with an unfastened acetate mask or freehand. A sun-cast shadow at closer range (Figure 11-26b) is sharp and strong and can be implemented with a mask. A close-range, candle-cast shadow (*c*) has sharp edges but is weaker and more elongated

because of the radial emergence of light beams; it too can be implemented with a mask.

A sun-cast shadow at noon (Figure 11-27a) is uniform and even stronger at its far end, whereas a sun-cast shadow at sunrise or sunset (Figure 11-27b) fades because of perspective distance—it is longer.

All these illustrations of shade and shadow are particular instances. If you are sufficiently trained in perspective, geometry, and the study of shadows, you will be able to infer general applications from these specifics and apply them to any shape.

## Geometrically Nondefinable Surfaces

This special category of surfaces usually includes natural matter, especially organic bodies. Sand, a stone polished by waves and wind, a rose, a frog, and a human face are all examples of geometrically nondefinable surfaces. An inventive and analytical eye, however, can detect geometric structures in all of these. A muscle fiber (longitudinal section shown in Figure 11-28), for example, may have a precise microscopic structure of parallel strips; the fiber

Figure 11-25. Airbrush interpretations of geometrical solids for similar perspective and a constant angle of sunlight:
a. Prism of triangular section □ b. Prism of square section □ c. Prism of hexagonal section □ d. Cylinder □ e. Pyramid with square base □ f. Cone with vertical axis □ g. Paraboloid of revolution □ h. Hyperboloid of one sheet □ i. Section of cylindrical pipe □ j. Thorus

Figure 11-26. Differences in intensity and sharpness of edges between a solar shadow (*a, b*) and a candle-cast shadow (*c*).

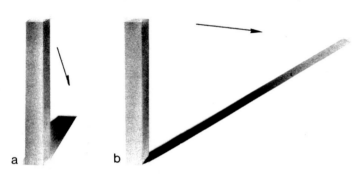

Figure 11-27. A sun-cast shadow at midday (*a*) is shorter and more intense than one at sunrise or sunset (*b*).

Figure 11-28. Microscopic longitudinal section of a muscle fiber.

Figure 11-29. (Left) Defining the approximate geometry of a muscle fiber.

Figure 11-30. (Center) Geometrical equivalent of a muscle fiber.

Figure 11-31. (Right) Softening the rigid geometry leads to a change in airbrush technique; freehand airbrush replaces mask airbrush.

itself, however, can be thought of as two soft cones at the ends of a soft cylinder (Figure 11-29). The cylinder and cones (Figure 11-30) can be airbrushed with a few masks, but what alters the strict geometry is the elimination of the lines separating cylinder and cones (Figure 11-31). This does away with the need for masks; the fiber can be rendered freehand with the airbrush (Figure 11-32).

More complex structures are of course more difficult, but they can still be made manageable if you try to detect their approximate geometric equivalents. For example, line *b* in Figure 11-33 represents the section view of a geometrically nondefinable surface; line *a* would be its geometrically definable equivalent. The surface represented by *a* could be sprayed with the help of masks (Figure 11-34); the surface of *b* would have to be worked freehand and with shields (Figure 11-35).

The most challenging geometrically nondefinable surfaces for the airbrush artist are the human body and face. Chapters 13, 14, and 15 are devoted to these subjects.

Figure 11-32. Final rendering of a muscle fiber.

Figure 11-33. Section of the geometrically definable equivalent (a) of a geometrically nondefinable surface (b).

Figure 11-34. The geometric surface from Figure 11-33 rendered with masks.

Figure 11-35. Freehand and shield rendering of the geometrically nondefinable surface from Figure 11-33.

Figure 11-36. Answers to the questions in Figure 11-6: (a) A surface polished to mirror smoothness, with no microscopic substructure, would reflect the image of the light source. (b) If the cylinder was cut with parallel strokes, the linear pattern would cause linear reflections. (c) Cutting the cylinder with a circular lathe would have a circular pattern that causes radical reflections. (d) Hammering the cylinder until the surface is quite uneven would leave it dull.

# COLOR

We interrupted the discussion of mediums after Chapter 3 in order to study airbrush methods and techniques. We now return to the topic to show how color can be fully exploited to add brilliance and richness to airbrush work.

The principles of color in airbrush are the same as the principles of color in any other art technique. The beginning airbrush artist may have difficulty obtaining the envisioned color combinations and effects, not because of any specific problem with the airbrush, but simply because of a lack of basic training. Therefore, we shall first define the four color relationships: transparence, adjacency, build-up, and sequence. We shall then study these situations for both transparent and opaque colors.

All the illustrations in this chapter were implemented with Winsor & Newton gouache and Dr. Martin's Water Colors. The color names have been specified where appropriate so that you can reproduce the illustrations as practice exercises.

## Transparence

An object is transparent if another object can be seen through it. A shadow is considered transparent when details of the objects in shadow can be perceived clearly. The color of the transparent substance alters the tone or hue of the objects seen through it.

Suppose we were to show a transparent square blue filter overlapping a square red tile. This can be illustrated easily with transparent watercolors; only one acetate mask is used, and each color is sprayed freely (Figure 12-1). When both colors are sprayed to 100 percent value, the common surface, where the squares overlap, becomes purple. Of course, you can stop spraying either or both colors before they

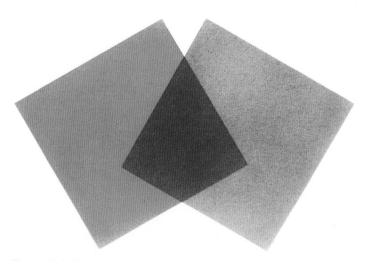

Figure 12-1. Transparent sprays of ultramarine and carmine combine to make purple where the two squares overlap.

reach 100 percent intensity to obtain other shades of purple in the overlapping area. The transparence is obvious in any case.

With gouache, however, a spray of 100 percent value can be used only for the red square, because at 100 percent intensity the blue would be opaque (Figure 12-2). There are two possible ways to represent transparence with gouache in this case: spray the blue to less than 100 percent value, or spray the common surface separately in purple, using a second mask. In the first case microscopic blue dots partially cover the red, so a subdued transparence can be suggested; the degree of transparence depends on the percentage of blue sprayed (that is, the amount of spray). When the second method—spraying purple separately—is used, the same red and blue can be premixed, or another red and blue if a richer color or other particular effect is wanted; your artistic purpose determines the choice.

madder carmine

100% ultramarine

purple lake

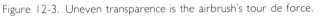

madder carmine

less than 100% ultramarine

Figure 12-2. Opaque ultramarine and madder carmine show no transparence when sprayed 100 percent, but some transparence when the overlapping color is sprayed less than 100 percent. A third spray with purple, to give the appearance of transparence, requires an additional mask.

Here are some different types of transparent effects.

**Uneven Transparence** The airbrush shows its virtuosity especially in cases of uneven transparence, as shown in Figure 12-3, when the surface represented either has varying degrees of transparence or is itself wavy. Such a rendering is extremely difficult with other techniques but very easy and rapid with airbrush.

**Veil Transparence** We have already mentioned the transparence of pigments and dyes sprayed with

Figure 12-3. Uneven transparence is the airbrush's tour de force.

with a shield, not a mask. These substances are not 100 percent transparent, so they should be rendered with light-colored opaque gouache over darker objects, as shown in Figures 12-4 and 12-5.

We have already mentioned the transparence of pigments and dyes sprayed with $R_{10}$ for altering hue and tone. An airbrush work in blue and red can be changed entirely by a spray of another color—

Figure 12-4. A blue and red rendering on a white background (a) is enriched when yellow is sprayed over part of it (b)

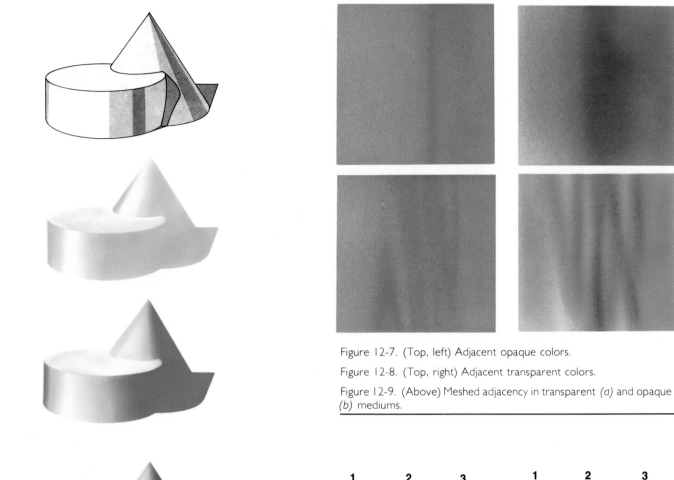

Figure 12-7. (Top, left) Adjacent opaque colors.

Figure 12-8. (Top, right) Adjacent transparent colors.

Figure 12-9. (Above) Meshed adjacency in transparent (a) and opaque (b) mediums.

Figure 12-5. A rendering in one color plus white is not colorful.

Figure 12-6. (a) The first layer of built-up color. (b) The rendering after the second layer was sprayed. (c) The rendering completed with the third layer.

Figure 12-11. A diagram of the four color sequences that were used in Figure 12-12.

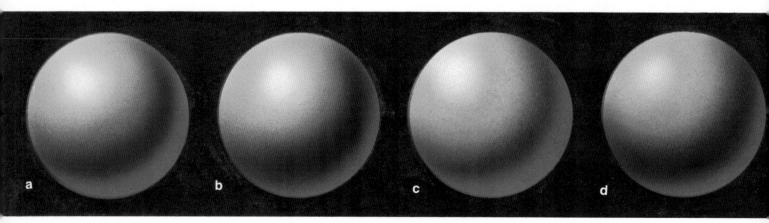

Figure 12-12. Four identical spheres that were sprayed in different sequences of colors.

yellow, in the case of Figure 12-6. Observe how the transparent third color adds innumerable tones and hues to the rendering as the colors overlap in countless combinations.

**Shadow Transparence** In watercolor, the transparence of shadows can be rendered by first spraying the objects in shadow, then the shadow itself. Note that a mask is necessary when the shadow falls only partially on an object. In opaque gouache, shadow transparence must be rendered in the reverse order: first the shadow itself, then the objects in shadow. The objects must be sprayed with opaque colors on top of the opaque colors of the shadow. Another possibility would be to spray the shadow with a mask covering the objects, remove the mask, mask out the shadow, and spray the objects. Not only is this a time-consuming method, but, in addition, the masks limit appreciation of the relationship between the work done and the work in progress. This complicated method is sometimes necessary when the colors must be very clean and sharply differentiated.

**Note:** Artists who use oils or other opaque mediums, as well as makeup artists, know well the importance of a foundation color. Opaque color, even if applied or sprayed to 100 percent value, can still be influenced by the underlying color. Try spraying opaque permanent white over a green background and over a red background. Two totally different hues of white will result. Other experiments of this nature will enrich your mode of expression and enlarge your arsenal of artistic effects. Of course, works implemented for reproduction do not benefit from these subtleties; only original artwork does.

## Adjacency

The junction of tones or hues of two different colors (not different tones or hues of the same color) can be handled in airbrush with different resolutions. As you know, the only resolution that requires a mask is $R_1$; the others are accomplished freehand. Freehand resolutions with two different colors are feasible with opaque colors as demonstrated in Chapter 3, but tricky with transparent watercolors because the T zone will always be darker than either of the two colors—it will form a border rather than a grading (Figures 12-7 and 12-8). An $R_2$ treatment of each color separately, in an attempt to illustrate a meshing of colors (Figure 12-9), results in an unexpectedly rich pattern of tones and hues in both opaque and transparent mediums.

## Buildup

In Chapter 10 you studied overlapping tones and how to build a three-dimensional image by darkening (or lightening) the subsequent layers over a smaller area. The same procedure should be followed whether you use black and white or brown (or any other color) and white. The image in Figure 10-4 (see page 94) can therefore be rendered with white and red instead of black (Figure 12-5).

This does not result in a colorful rendering, however. The following discussion requires great concentration on your part, because it describes the basis of colorful technique in airbrush. If you grasp this, your skill as a colorist will improve dramatically. Let us take the same illustration and add some life to it.

After cutting the frisket, we start spraying the first tone, a mixture of 80 percent white, 15 percent yellow ochre, and 5 percent cadmium orange (Figure 12-6a). The second layer is a mixture of 90 percent yellow ochre, 5 percent Vandyke brown, and 5 percent Winsor emerald (Figure 12-6b). Finally, we use pure Havannah lake to complete the work (Figure 12-6c).

This very simple example illustrates the basis of airbrush coloring. The color combinations used in the demonstration are the result of experience and not random choices; however, they are only one combination among many other possibilities. The general concept to be extracted from the example is that the first layer is warm, the second colder, the third warm again. Alternating warm and cold hues in layers seems to be a way of enriching color. As you will see later in the portrait demonstration, however, this is not necessarily a hard-and-fast rule. Only you can judge what colors will create the image you wish to render. Just remember that layered, built-up colors should differ not only in tone but also in hue.

## Sequence

To the colorist it is no surprise that when warm tones of color appear on a lighted surface, cold tones are on the opposite, counterlit surface of the same object, and vice versa. The airbrush artist should have no special technical difficulty rendering such plays of light; here we only offer a suggestion that might enhance the warm-cold contrast, a consequence of our findings in Chapter 3.

Figure 12-12 represents four spheres, rendered with a circle template, with the same source of warm light and cold counterlight, against the same background (black), and with the same colors:

1. For warm light: permanent white, 60 percent; golden yellow, 25 percent; and cadmium orange, 15 percent
2. For counterlight: permanent white, 40 percent; Parma violet, 20 percent; and oxide of chromium (green), 40 percent
3. For shadow: Parma violet, 100 percent

The only difference among the spheres is the sequence of spraying the colors: (a) 1, 2, 3; (b) 1, 3, 2; (c) 2, 1, 3; and (d) 3, 2, 1. Recall from Chapter 3 that spraying light on dark produces a cold T zone and spraying dark on light, a warm T zone; the best sequence would then seem to be 1, 2,

3. Repeat the experiment yourself, however; the printing reproduction may have obscured the differences in the four spheres, and you may discover in the process a special effect that you can use in the future. In some instances you may need to spray light on dark but want to preserve warmth in the T zone; you could compensate by increasing the color warmth of the light spray.

The study of color in airbrush is vast, but experience will teach you more than theory. There is more information about color in this book, distributed in the following chapters and studied in particular situations that you may use in your own work.

Figure 1.2-13 (above) and Figure 12-14 (below). The ethereal veil transparence of a gauze curtain or a cloud requires freehand spray with a shield, not a mask. These substances are not 100 percent transparent, so they should be rendered with light-colored opaque guache over darker objects.

# Part Three.
# Art

# FIELDS OF SPECIALIZATION

With the methods and techniques you have learned in previous chapters, you should be equipped to work in any art field where the airbrush can be used—you are on your way to becoming an airbrush specialist. The modern world demands a higher degree of specialization, however, and so it is necessary to explore some of the narrower applications of airbrush art: photographic retouching, technical drawing, architectural rendering, medical illustration, science fiction, the human body, and fine art.

It must be said here that there is a substantial difference between an airbrush specialist and an airbrush artist who specializes in, for instance, architectural rendering. Whereas the airbrush specialist has full command of the techniques and methods of airbrushing as they apply to any type of artwork, the specialist in architectural rendering may be fully conversant only with those airbrush techniques he or she uses every day. But, in addition, the architectural renderer must know a great deal more about geometry, perspective, and construction than the airbrush generalist, and he or she must have expertise in any other art technique that is useful in architectural work.

Specialization—learning as much as possible about a skill or subject—is a real accomplishment; on the other hand, it narrows your interests, and (especially in art) invites technical virtuosity to overwhelm creativity. The danger is that your work might become routine, that innovation will be stifled.

Another aspect of specialization to consider is that no particular field of airbrush applications is completely distinct from the others. Architectural renderers must sometimes build renderings on photographs and must therefore have some knowledge of retouching. Conversely, a retoucher working on a photograph of a building must be at least a little familiar with the principles of architecture. There are many other examples; clearly, it is to your advantage to have a broader knowledge than merely what your specialty requires.

## Photographic Retouching

The purpose of retouching is to alter—in form, color, or both—or delete details of a photograph that are overdeveloped, underdeveloped, or otherwise unsatisfactory. When these alterations must be made smoothly and imperceptibly, the airbrush is the tool of choice.

Photographs can be black-and-white or color, glossy or matte. For each of the four possible combinations a specific medium is most appropriate: for glossy black-and-white photographs, dyes (transparent); for matte black-and-white photographs, pigments (opaque). For color photos, dyes (Dr. Martin's or Kodak) are used on glossy finishes, tube watercolors (semi-opaque) for matte finishes.

Opaque colors on matte photographs should present no difficulty to airbrushers who know their technique well. Layers of color are built up gradually in order to cover the unwanted detail. Transparent mediums are less straightforward; they enhance some values but cannot cover details, and they change some hues unless repeatedly airbrushed to opacity, in which case the hue becomes the hue of the medium. When drastic alterations are necessary, the retoucher uses chemicals to remove the photographic emulsion entirely; the white surface of

the paper can then be built upon with layered colors. The advantage of using dyes for glossy photographs is that the retouching remains entirely invisible; the final work shows no patches or marks. For Kodak photographs, Eastman Kodak has developed the three-color retoucher's kit, the colors of which are identical to those of the photographs.

Figure 13-1 is an example of a photograph that required retouching. The shadow, the wires on the wall, and the metallic parts of the chair need to be eliminated and the plastic hose enhanced to show more clearly how it is held between the legs. With frisket covering the body and the table, two gouache layers were sprayed over the unwanted details. White was brushed on the hose. The result: the photograph used for Figure 7-1 (page 51).

The retoucher receives specifications from an art director, who can explain what changes are wanted and why, but who cannot specify hues or how to build up a new image. The skillful retoucher must therefore have a good sense of color and an ability to study and render any kind of object. The really good airbrush retoucher is an artist and a knowledgeable professional.

Figure 13-1. The unretouched photograph of Figure 7-1.

## Technical Drawing

The category of technical drawing includes all works done in precise orthographic (plans, sections), isometric (axonometry), and conical (perspective) projections, the purpose of which is to present accurate details of the anatomy or workings of a structure or mechanism (Figures 13-2, 13-3, and 13-4). Also included are diagrams, schemes, graphs, and symbols rendered for the same purpose—in other words, all visual works that must convey logical, precise, and accurate information with little or no emotional impact. The airbrush artist who is naturally inclined toward logic and accuracy is more likely to succeed in technical drawing than the free and sensitive artist. This specialty requires familiarity with Euclidian and descriptive geometry, drafting methods, types of projection, and technological and mechanical principles. The study of these disciplines, however, represents an enormous amount of effort even for the schooled artist, let alone the beginner. Some airbrushers compensate for a lack of technical education either by working in cooperation with technical draftsmen who implement the structural drawing or by taking refuge in photographic retouching, working on existing photographs. In both cases the artist is dependent on outside help and therefore insufficiently free for a personal vision of the art.

Working sheets of technical drawings generally require no color, but illustrations of technically described objects for books, encyclopedias, posters, and so on must be rendered so that people with little or no knowledge of the subject can easily understand their structure. Here, airbrush is used mainly for two aspects of the work: to apply different colors to different components of the unit illustrated and to add different tones (sometimes also hues) to enhance the form of each part.

## Architectural Rendering

The aim of an architectural rendering is to inform the interested parties about the final appearance of a building that is still in the planning or construction stage. Details, proportions, materials, colors, layout, and site must be depicted accurately. Whether the viewer is an investor or a future owner, buyer, or tenant, the image must be convincing. The renderer is often asked to emphasize the good features of a building and diplomatically downplay its weak points, either by choosing the most favorable angle of vision or by using the most flattering colors. Honesty and professional ethics, of course, preclude altering the actual structure.

The first essential for a good architectural renderer is knowledge of perspective drawing, architectural principles, and construction principles; many renderers are in fact architects. The second essential is mastery of the whole spectrum of art technique—airbrushing is only one—and an ability to choose the proper one for each rendering.

Many authors recommend that an architectural rendering be airbrushed entirely. It is possible and effective, but it is preferable, in our opinion, to restrict the use of the airbrush to details whose

nature requires it: sky, water, glass, chrome, marble, polished floors, neon, electric light, shade, and shadows. When these details are airbrushed, the structure itself, rendered in brushwork, looks even more realistic, powerful, and convincing.

The airbrusher who does architectural renderings uses frisket of all types and does practically no freehand work, except for clouds and shading on curved surfaces. Shields are all but useless.

A typical rendering might be done as shown in Figures 13-5 to 13-8:

1. Spray the sky (Figure 13-5) with a mask over the building so that one wall of the building can remain the white of the paper.
2. Without removing the frisket, cut holes for the windows and the cylinder; spray them (Figure 13-6).
3. Remove the mask over the lake (Figure 13-7) and spray the water, the mirrored building, and the darker shore zone, in that order.

The rest can be worked entirely with a brush—or in airbrush, if you prefer. The final touches are the shadows, airbrushed with masks. The completed rendering, shown in Figure 13-8, is oversimplified, but it illustrates how airbrush and brush work together. (The color scheme is not given because it is irrelevant.)

Architectural rendering in airbrush benefits in the hands of a skillful artist who reproduces the effects of retinal compensation for contrast and adjacent surfaces; situations discussed in Chapter 11. These effects must be handled carefully, however; too-powerful contrast tends to look artificial and theatrical.

## Medical Illustration

As we have just seen, the airbrush usually plays a secondary role in architectural rendering; medical illustration, on the other hand, depends heavily on it. Unless a medical illustration is schematically

Figure 13-2. Orthographic projection. A mechanical device is analyzed in plan, frontal view, and sagittal section. The role of the airbrush is to define surfaces as planar or curved and to differentiate the parts of the device. Accuracy and definition are important, so the line drawing (in black) is preserved by using watercolor in the airbrush.

Figure 13-3. Isometric projection—axonometry. The same device is shown three-dimensionally in its entirety. Each dimension is aligned with one of the three spatial coordinates and can be measured directly on the drawing.

Figure 13-4. Conical projection—perspective. The same device is shown photographically for a visual understanding of its shape. For a more naturalistic result, construction lines have been covered by opaque gouache airbrushed on the surfaces to indicate light, shadow, and the qualities of the materials used in the manufacture of the device.

Figure 13-5. The first step in airbrushing an architectural rendering: the sky. The frisket has been removed so that you can see the whole pencil drawing.

Figure 13-6. A new frisket permits the windows and cylinder to be sprayed.

Figure 13-7. After the outline frisket for the lake has been cut, the water, the building reflection, and the darker grass reflection at the upper edge of the lake can be sprayed.

Figure 13-8. The finished rendering. The final touches were to hand-brush the structure and the grass, airbrush the shadows, and add black details, hand-brushed, to the windows, trees, and bushes. **Note:** The four steps illustrated here were not built on the same support but are separate drawings; they demonstrate the accuracy with which you can implement a work in airbrush.

Figure 13-9. An education illustration of a bronchiole (a part of the lung) clogged with excessive sputum, as in bronchitis.

Figure 13-10. The same information depicted in Figure 13-9, dramatized for commercial purposes.

visualized and designed, it is composed of organs or parts of organs that constitute geometrically nondefinable surfaces. All airbrush methods are extensively used to render them: frisket for outlining organs, acetate masks for major areas within the organs, shields and freehand spraying for elaborating organic tissues.

There are two types of medical illustrations, which differ in their purpose. One is the accurate representation of anatomical, physiological, and biochemical structures and their pathologies to instruct and inform. The other is the dramatic visualization, for commercial purposes, of the same structures, pathologies, and their interactions with drugs. The first type requires a thorough prior study of anatomy; the second, in addition, requires imagination, logic, and a sense of drama. These qualities exist in an embryonic state in most individuals, but in a more developed state in artists; special training is required before they can be applied to medical subjects.

The approach to an educational illustration (Figure 13-9) is closer to that of a technical drawing: it must be clear, scientifically accurate, and devoid of emotional distortions. The information in an educational medical illustration can be conveyed visually with a great many graphic methods, airbrush included. In the commercial illustration (Figure 13-10), accuracy can be distorted—perspective exaggerated or imaginary colors used—for dramatic effect, as long as the information is not thereby

falsified. In other words, the commercial medical illustrator has more latitude for an expressive and emotional contribution. The message of a commercial illustration has two components: a logical one, which the art director generally works out; and an emotional one, which is the artist's contribution. Airbrush is *probably* the most successful technique for mixing scientific accuracy with dramatic emphasis.

The self-education of a medical illustrator is never complete. As medical research delves deeper into the biochemical realm, the medical illustrator's role expands beyond the documentary and commercial; he or she can envision organic and chemical processes that have never been seen. Consequently, the medical illustrator can supply the visual, interpretative link between medical discoveries and their future scientific confirmation.

The field of medical research is wide open, and so are the uses of airbrush as a means of illustrating it. Our best advice is to observe, study, learn—and apply.

## Science Fiction

Science fiction is sometimes more science and sometimes more fiction. In a parallel with the medical illustrator, the airbrush artist who specializes in science fiction must be scientifically accurate where there is an informational purpose, but can be more imaginative and emotional when entertainment is foremost.

The illustrator should understand the difference between scientific fiction, acceptable nonscientific fiction, and misleading fiction—pure fantasy. The best representative of scientific fiction is the work of Jules Verne, the remarkable nineteenth-century genius who predicted some major scientific and technological developments of this century. An example of acceptable nonscientific fiction is the movie *Fantastic Voyage*, in which a team of scientists is reduced to submicroscopic dimensions and sent into a human body to repair brain damage. Such a reduction of human scale is a scientific absurdity, but we accept it as a means of exploring the body from within in an entertaining and suspenseful manner. Finally, misleading fiction is exemplified by the enormous amount of literature about time travel, which is based on erroneous or falsified interpretations of relativistic concepts.

In literary science fiction the illustrator is called on to complement someone else's written fiction or to imagine his or her own version. The illustrator's creative ability, degree of scientific responsibility, and ethics determine whether he or she will cooperate with the writer or reject the job. As in all other disciplines, the problem of technical implementation of a science-fiction illustration is secondary to prior scientific education.

The strong association between present trends in science-fiction illustration and airbrush is symptomatic: new visions require new modes of expression, and scientific fiction seems to respond best to this requirement. Space vehicles, electromagnetic fields, cosmic landscapes, nebulas, lasers, micro-universes, robots, and so many other concepts of the futuristic world can be rendered in any art technique, but never so strikingly and impressively as with the airbrush. Again, our advice is relatively simple: observe, study, learn; then try to imagine the future. If your vision is logical and powerful, and if your airbrush technique is sufficiently developed, your illustrations will evoke positive responses from scientists, readers, and artists alike.

## The Human Body

The human body is a separate category, not a part of medical illustration. In its infinite variety of shapes, proportions, movements, and colors, the human form is the permanent object of observation and inspiration for the scientist and the artist as well. Philosophically speaking, the human body is the center of the universe.

The topic is approached here from the purely aesthetic point of view, not the educational or commercial. The principal focus of study in art

Figure 13-11. A realistic male torso in black-and-white, rendered with shield and freehand within a frisketed outline.

education, along with perspective drawing, is the human body, which is one reason the subject is treated in greater detail here than the other specializations. Keep in mind that airbrushing the body without knowledge of artistic anatomy; of the interplay of light, shade, and shadow; of color; or of practical drawing studies from memory and from life in various mediums is hopeless.

In principle, the body can be considered monochromatic. No portion of it except hair and face details has a drastically different color, so it can be quite effectively rendered with a very limited palette. (The head is part of the body, but for reasons explained later it is studied separately in the following two chapters.)

We begin with a black-and-white rendering (Figure 13-11), a male torso seen from behind, done

Figure 13-12. A realistic rendering of a male torso in gray and black without frisket.

in black watercolor. The methods used should be clear to you: frisket all around, shield and freehand airbrush within the outlines,
built-up layers of black only, resolutions between 1 and 3—nothing more.

This torso is an airbrush interpretation of a charcoal study from Jenö Barcsay's *Anatomy for the Artist* (Leon Amiel Publishers, 1973). It should be emphasized that working from models, drawings, and photographs can be very helpful, but the fundamental anatomical knowledge remains essential. If you, the airbrusher, cannot interpret the maze of light, shadows, and shade defining the body, you cannot duplicate results with the same model.

Imagine now that the same torso is to be done on a panel 10 feet (3 m) tall, in corresponding proportions. Obviously, a frisket of the necessary size is an impossibility, so you would use shields exclusively. This can be done at any scale, however; so, return to Figure 13-11, eliminate the frisket, and work with the shield and freehand airbrush only. Try it; it works. When you become comfortable with this way of working, you will find it the fastest and easiest method. In Figure 13-12 you can see the fuzzy

outlines caused by the absence of frisket; this illustration was done with black plus one shade of gray.

The next study is a female nude implemented in a reverse-buildup technique (Figure 13-13). The background is a medium gray, so the first tone applied, using shields only, was a 10 to 15 percent lighter tone of gray. The next layer (Figure 13-14) was 20 percent lighter than the first gray on the most luminous areas, and the study was finished. The second layer was done on a prepared sheet of acetate so that it could be shown separately, mounted on a black background (Figure 13-15). Two more layers could be added—100 percent white to enhance light reflections and 100 percent black for dark accents—but this creates another meaning of the image; add these final touches yourself to see. Remember, use nothing but shields.

As a practice exercise to teach you the larger spectrum of airbrush possibilities, try rendering the human body in a variety of colors while maintaining realistic values. Take the black-and-white illustration shown in Figure 13-16, enlarge it and transfer it twice onto illustration boards. Look at the printed illustration. You can see that there is a flesh tone, a shadow, and a counterlight. Therefore you can

Figure 13-13. First layer—a gray slightly lighter than the background—of a female nude rendering.

Figure 13-14. The female nude with the second layer applied—an even lighter shade of gray.

Figure 13-15. The second layer shown separately against a black background.

render your first transfer on a neutral background in realistic colors such as golden ochre plus white for the flesh tone, burnt sienna for the shadow, and olive green plus white for the counterlight. To render the illustration in fantastic colors, take the second transfer, paint the background in flat cobalt blue, the flesh tone in fiery red, the shadow in Havannah lake, and the counterlight in emerald green, using all colors pure from the tube. Use identical airbrush techniques and the same realistic style of values in both renderings. The effects will be stunningly different. Obviously, the selection of colors that can be used for this exercise is limitless. The only determinant of the color harmonies, degree of structural alteration and distortion, and the power, intensity and direction of light is the artist's vision of the message to be conveyed.

## Fine Arts

The main question raised by many to be answered here is whether the airbrush is an art instrument or merely a painting instrument. The answer is simple but categorical: it is not the instrument, but rather the artist, that produces art. If the artist has a message, he or she can convey it using even the sole of a shoe. Therefore, the question should really be: When and how will a great artist produce a master-piece with the airbrush? This is difficult to answer.

Many artists have tried to express themselves with the airbrush, but so far no endeavor has resulted in a great work of art. Some explanations for this might be the relative newness of the instrument, the incomplete knowledge of its technical potential, suspicion of a tool that is renowned for its commercial uses, and the difficulty of learning how to use it well compared to the old secure brush. It is impossible to say whether any or all of these reasons are the barrier between technical excellence and artistic freedom. The matter is probably somewhat more complex; consider the following analogy with music.

Many people who play a musical instrument begin their training early, usually during childhood. Some, having no talent, soon abandon their studies; but others exhibit a real interest, which grows as their proficiency increases. As the student progresses, a direct communication develops between brain and instrument; the student hears music through the sounds the instrument makes and composes harmonies and themes through it. In other words, the instrument becomes an extension of the student's thinking process, a new means of expression and communication—like an additional set of vocal cords. If this symbiosis is a key to creative genius, perhaps here is another source of the lack of airbrush masterpieces: so far we have heard of no parents who have presented their child with an airbrush and compressor. Most artists who use the airbrush begin using it much later in life.

This remains speculation, of course. The impor-

Figure 13-16. Detail of a male body done in realistic tones.

tant point for the student of airbrush is that fine-arts applications are in their infancy, so there is no "school" or tradition to instruct your first steps. You have a real opportunity to be a pioneer in this field if your message is sound.

The preceding sections covered some of the major areas of specialization in airbrush, but the list is far from exhausted. As we proposed at the beginning of the book, however, our purpose is to explore the high artistic potential of the instrument and not the rudimentary crafts, which are analyzed elsewhere. If

you have arrived at this page, you are most likely interested in learning more than how to stencil signs. **The main fact you should have absorbed from this chapter is that your general knowledge and study of other subjects, filtered through your artistic sensibility, are at least as important as airbrush technique itself, if not much more important.** Technical superiority is a waste without a corresponding depth of professional knowledge and expansion of intellectual horizons.

# THE HUMAN FACE

To the airbrush artist, the human face is the most interesting and challenging geometrically nondefinable surface. Not only do faces vary from individual to individual; a single face can change from one year to another or from one emotional state to another; a morning-fresh face is not the same as a fatigued one; faces can look different at different angles—no profile can be guessed from a frontal view—and under different lighting conditions. Before the invention of photography, the portrait was the unique way to preserve someone's image; today, the portrait, although sometimes done for the same reasons, is mainly an element of pictorial compositions, a symbol, or an exercise in drawing and coloring. In this book, the face is used as an exercise in freehand and shield airbrush techniques. **Anyone who can master the airbrush rendering of a face will have no technical problems whatsoever with any other specialization or subject.**

It is assumed that you understand drawing, proportion, expressions, and light and shadow, so the preliminary sketching and drawing stages are not illustrated; the exercises begin at the point where the airbrush work starts: with a final study of the head. With one exception, photographs are used as models; a line drawing of each is transferred to the support and sprayed directly, first in black and white, then progressively toward color.

This is not the only way to render airbrush portraits, but it is the best way to learn how. Each exercise is not a recipe but a particular case; you must study the technique and sequence carefully in order to learn the theory of working. The basic technique of applying layers differs substantially from the technique used in oil, gouache, or watercolor brush paintings. **The principle is to apply each color completely before spraying the next one, never returning to a color used previously.** In this respect, airbrush portrait technique is closer to color printing processes, in which each color is printed separately in its entirety. Just as the colors are separated, mechanically or electronically, with photographic images for each filtered color, so the airbrush artist must work all the details in the same color before proceeding.

Portrait airbrushing, and in general complex shield work, produces better results in larger scale; the original artwork for some of these exercises was larger than the reproductions shown. So that you can determine exact scale, each original rendering includes a 1-inch (25-mm) circle. The medium and colors are specified. To assist you in working these exercises, we have devised systematic schemas for each work to indicate how the portrait is to be implemented. On these, the surface to be sprayed is shown in shades of gray; shield work is indicated by black lines. Freehand airbrush at the appropriate resolution is to be used everywhere else.

## Exercise 1: Black-and-White Contrast Portrait

The photograph in Figure 14-1 serves as a model for the simplest type of portrait: a pure black-and-white image with the inevitable airbrush T zones. Subtle tones of gray are ignored. The technique involved—freehand and shield—is already well known to you.

In this exercise the resolution depends solely upon the width of the T zone. Except for the portions where freehand or shield airbrushing is necessary, all the black can be rendered with the brush. Follow the schema in Figure 14-2. In black gouache, the result is clean (Figure 14-3).

It might be more convenient to begin with a black support and spray permanent white gouache instead. This is a slightly more delicate process because you are used to working from light to dark and because white requires more effort to create areas of 100 percent intensity, but try the exercise this way as well.

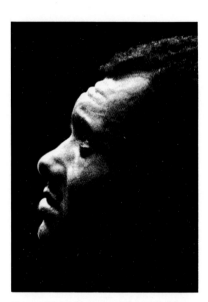

Figure 14-1. Photographic model for Exercise 1.

Figure 14-2. Schema for Exercise 1. Areas to be sprayed are gray; black lines indicate shield work.

Figure 14-3. The finished black-and-white portrait.

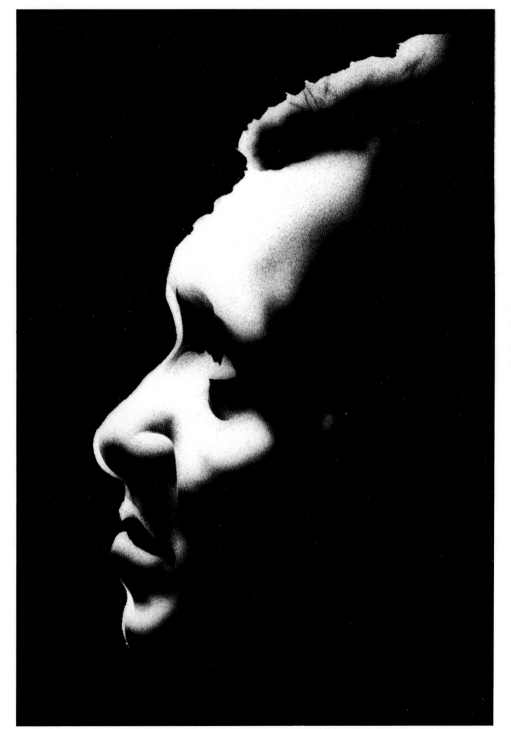

## Exercise 2: Multivalue One-Color Portrait I

The photograph in Figure 14-4 has black, white, and many grays of various intensities. The simplification of values done in Exercise 1 is not only impossible with this image but also undesirable. Again, use black gouache on a white support, following the schema (Figure 14-5). Note that there is an additional gray tone in the schema for the darker areas. This does not change the method of working; after using greater resolution ($R_{4-5}$) for the lighter gray, return with sharper resolutions ($R_{1-3}$) for details, reaching 100 percent black where necessary (Figure 14-6).

In principle, you begin a portrait with resolutions of 4 to 8 and develop it by reducing the resolution values to 1 to 3—in other words, you render the large areas first, then the details. But you need not always respect this principle; resolution flexibility depends upon your technical and artistic abilities and should not be constrained by these guidelines.

In the final rendering, observe the harshness of an illustration done in only one color. This was discussed in Chapter 10, where we recommended layering tones. To use this complex technique on the same portrait, follow the schema, but instead of using all black, first spray a 50 percent gray and only then 100 percent black (Figure 14-7). You may not be able to discern much difference between the one-tone and two-tone renderings in the reproductions here, but in the originals the refinement of the latter is clear. Another benefit of working with gray first is that you do not have to fear that you will intensify it too much as you would with black. The double layer, rather than complicating matters, reduces working time and facilitates smoothness of tones and values.

Figure 14-6. The finished detailed portrait airbrushed in black only.

Figure 14-7. The same face rendered in gray and black.

Figure 14-4. Photographic model for Exercise 2.

Figure 14-5. Schema for Exercise 2.

## Exercise 3: Multivalue One-Color Portrait II

Figure 14-8 is another black-and-white subject for your training in portraiture. Instead of using two tones, however, begin with 20 percent gray, build it up with 60 percent gray, and complete the work with 100 percent black. This time you are on your own; the final rendering is not shown. Work in layers as before, according to the schema (Figure 14-9). In this case, apply the hand-brushed areas of 100 percent black before you spray any black—follow the reverse of the usual light-to-dark sequence (Figure 14-10). The more layers in a portrait, the smaller the areas of 100 percent black; eventually the black is limited to a few almost invisible—*but necessary*—accents, especially in the pupils of the eyes, eyebrows and lashes, nostrils, corners of the mouth, ear holes, and hair.

Figure 14-9. Schema for Exercise 3. The spots in black indicate 100 percent black.

working direction

white                                    gray

gray                                    black
airbrush          airbrush                brushwork
              working direction

Figure 14-10. Sequence for the three-tone portrait: (1) white, (2) gray 1, (3) gray 2, (4) black brushwork, (5) airbrushed black.

Figure 14-8. Photographic model for Exercise 3.

Figure 14-11. Photographic model for Exercise 4.

## Exercise 4: Reverse-Buildup Portrait

Like the portrait in Exercise 1, a portrait on a black background (Figure 14-11) might be easier to render by building up lighter tones. As we have already mentioned several times, it is best to begin with a tone closest to that of the background. So here, instead of using light gray for the first layer as you would on a white support, use dark gray, approximately 80 percent (Figure 14-12). The second tone is a neutral 50 percent gray; a 20 percent gray completes the work. Notice how tiny brushstrokes in pure white make the eyes and lips glisten (Figure 14-13).

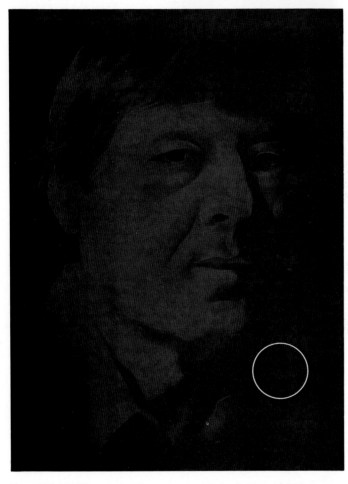

Figure 14-12. Reverse-buildup portrait with the first layer of 80 percent gray.

Figure 14-13. Completed reverse-buildup portrait. Grays of 50 and 20 percent and brushwork in white have been added.

## Exercise 5: Colorful Black-and-White Portrait

Figure 14-14 shows a face lit from both sides, to be rendered in a commercial style as a play of light and shadow. Three colors are used: black for the background and facial shadow, flame red for light areas, and cobalt blue for counterlight. After the pencil lines are transferred to the support, the procedure is simple:

1. Spray red uniformly on the right side of the face, using freehand only—no shield.
2. Spray blue uniformly on the left side of the face. Again, work freehand, without shields. (**Note:** The two colors may overlap in a T zone, but that does not matter because the black will cover it.)
3. Airbrush black over the shadowed center of the face, using shield and freehand.
4. Outline the face and fill the background with brushed black, as in Exercise 1, to complete the portrait cleanly and quickly.

The finished portrait (Figure 14-15) is quite powerful.

Figure 14-14. Photographic model for Exercise 5.

Figure 14-15. The finished portrait. The only methodical airbrush work is the black.

## Understanding Facial Structure

All the preceding exercises were based on photographic models to help you learn, but sooner or later you must test your wings and work without copying values from existing images. Begin by observing the general appearance and the particular details of the faces around you, in different lights. Note how the slightest movement of the head or of the light alters shadow patterns.

To understand shadows three-dimensionally, find comparable geometrically definable solids for each detail. For example, in two previous exercises you rendered an eye to practice airbrush methods, without analyzing why the eye creates the shadows it does. To understand how to do this, follow along with this analysis of the front view of the eye with light coming from the upper left.

The eyeball is a sphere, of which only the area outlined by the dotted lines in Figure 14-16 is visible. Recall from Chapter 11 how to render a white sphere that receives light from the upper left. The iris is a color outlined by a darker color, and the pupil is black because it is a hole and therefore reflects no light whatsoever.

The lids are spherical as well because they envelop a sphere (Figure 14-17). At points A and B, however, the lids change into other geometrical shapes. Point A is smooth and can be rendered freehand; point B is a fold, so shield work is required. Because the light falls at an angle (arrow), the upper lid is lighter than surface C, which is shadowed by the brows. The lower lid is darker too. If the eye has pouches under it, at inflection A, the shield is needed. Finally, the lateral surfaces of the lids, L and L', are dark and light respectively. Also, L casts a shadow from P on the eyeball, so a slight grayish tone is necessary on the white eyeball, done with the shield.

This rudimentary analysis of the eye suggests how you should analyze a face for a portrait. Of course, every detail is infinitely alterable, but some parameters can be considered constant, such as the definition of the iris and pupil or the contrast between L and L'. It is a long way from these guidelines to creating a portrait with expression, emotion, and feeling, but this is where you must start.

Figure 14-16. (Above) The eyeball.

Figure 14-17. (Right) An analysis of the shape, lighting, and shadows of the eye.

## Exercise 6: Black-and-White Portrait in Color

So that you can begin to sever your dependence on existing images and use the method of analysis suggested in the preceding section, this exercise is based on a line drawing (Figure 14-18) rather than a photograph, as if you had made the drawing from life.

So far you have done portraits on a white background and on a black background; a third possibility is a neutral-intensity background, a tone midway between black and white, comparable to 50 percent gray. Such a background is sufficiently distinct from black and from white that you can build up light layers toward light and dark layers toward shadow as well. Even a bright red permits such a buildup.

As you know, gray is neutral when it is the product of an equal mixture of white and black; it becomes a warm hue when the mixture also contains ochre, orange, red, or warm brown, a cool hue when green, blue, or violet is added. (Gray can also be the result of color mixtures with no black or white, such as cobalt blue with ochre, but that does not concern us here.) This applies to other neutral-intensity colors as well, not just gray.

To study portraits on this type of background, take advantage of the freedom of choice and select a colorful support—say, a greenish pastel. Once the choice has been made, the portrait colors can be determined. For the green support shown here, the following combinations were chosen from the myriad possibilities: (1) light tones in white, shadows in black (Figure 14-19); (2) light tones in a mixture of white and the background green, shadows in burnt sienna, an entirely different color (Figure 14-20); and (3) light tones in a mixture of yellow and orange, shadows in a mixture of black and the background green (Figure 14-21). Many other combinations of a light and a dark tone are possible.

In all these variations—and in any others you can think of to try—what changes is the color *only*; the airbrush technique is exactly the same. This final exercise can still be considered a black-and-white portrait because there is no attempt to render realistic or fantasy colors. The light and dark colors never overlap, and the accidental adjoining resolutions are always 1. These simplified portraits all lead to the realistic colorful rendering of a face, which deserves a whole chapter to itself.

Figure 14-18. Drawing model for Exercise 6.

Figure 14-19. Black-and-white rendering on a green background.

Figure 14-20. Light green and burnt sienna replace black and white.

Figure 14-21. Yellow orange and dark green replace black and white.

# THE HUMAN FACE IN COLOR

This chapter contains the critical theory with the step-by-step development of a gouache portrait in full color. This portrait of a woman in normal light, against a white background, and in realistic colors is not necessarily a typical work, nor are the steps given here a formula. The sequence of operations and chromatic choices are offered, without value judgments, as a basis for the experimentation that is essential for every professional. Having studied these fundamentals, you must plunge ahead—sometimes succeeding, sometimes erring, but always having a reason for what you do.

Shown here is the photograph chosen as a model for the full-color rendering. The face will be built up layer by layer; simultaneously, the additional tones and hues that impart life to an airbrush portrait will be explained. Although this portrait may seem technically complex, it is artistically oversimplified; there is a great deal more airbrush work to be done than is described here. Overwhelming you with more information than you need for a first attempt might discourage and confuse you. Besides, you will develop your own style, your own vision, and therefore your own technique of spraying the colors.

Each step of the demonstration includes a description of working technique, a reproduction of the work in progress, a photograph of the preceding step with the schema for the current step on it, and

a color chart. The colors specified are those used in the demonstration; there are of course a hundred times as many options to choose from.

Figure 15-1. Photographic model for the portrait.

## Step 1

Transfer the drawing lines to the support. Establish the first color, Tone 1, by analyzing someone's skin and selecting the lightest tone you perceive. Spray Tone 1 like the first gray of the black-and-white face (Exercise 3, page 129). Work with a shield (including the outline) and freehand, leaving very little background white.

1

Tone 1: **70% permanent + white + 20% yellow ochre + 10% cadmium orange.**

## Step 2

The second flesh tone can be mixed from leftovers of Tone 1 with yellow ochre, which intensifies the tone as well as changes the hue. This is the first diversification and enrichment of color, and also the first disturbing optical illusion: if you compare your work at this stage to the white background, you will probably think the color is too dark. It isn't; to ease your mind, hold a piece of black paper near the work and you will see that you have a long way to go before reaching real darkness.

**Note:** This second layer is not always necessary. For a skilled artist, skipping from step 1 directly to step 3 is easier, even if the richness and subtlety of step 2 are lost. Compensation can be made by refining the color in step 3. However, this second layer enriches the color; the more layers of color there are, the richer the color harmony.

Tone 1: 70% permanent white + 20% yellow ochre + 10% cadmium orange.

**Tone 2: 60% permanent white + 5% cadmium orange + 35% yellow ochre.**

2

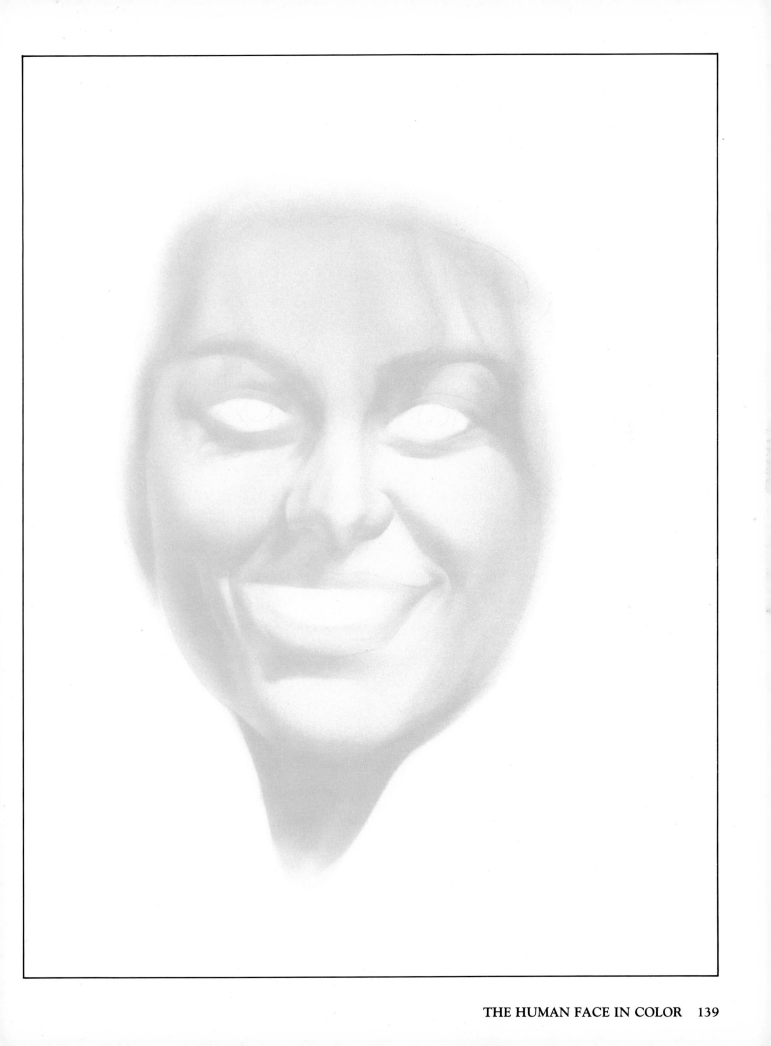

## Step 3

With the third layer you begin to work on the shadows. Tone 3 covers quite a large area where the face is angled more deeply against the light. The shield is used quite a lot at this stage (note the increasing number of black lines in the schema), even though some traces will be covered by the next layer. Disregard the counterlights for now and fill the shadowed area with Tone 3. Spray it also at $R_{10}$ $F_1$ on the left side of the face to enhance the general shadow.

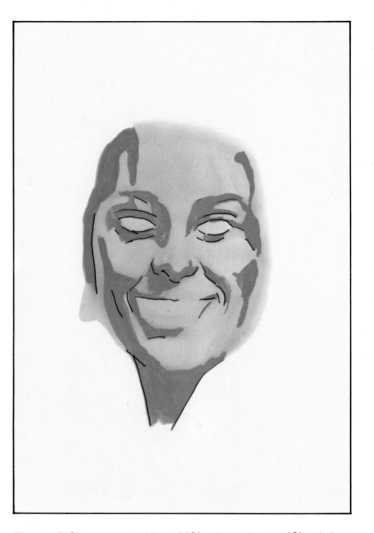

Tone 1: 70% permanent white + 20% yellow ochre + 10% cadmium orange.

Tone 2: 60% permanent white + 5% cadmium orange + 35% yellow ochre

**Tone 3:  10% permanent white + 90% raw umber.**

3

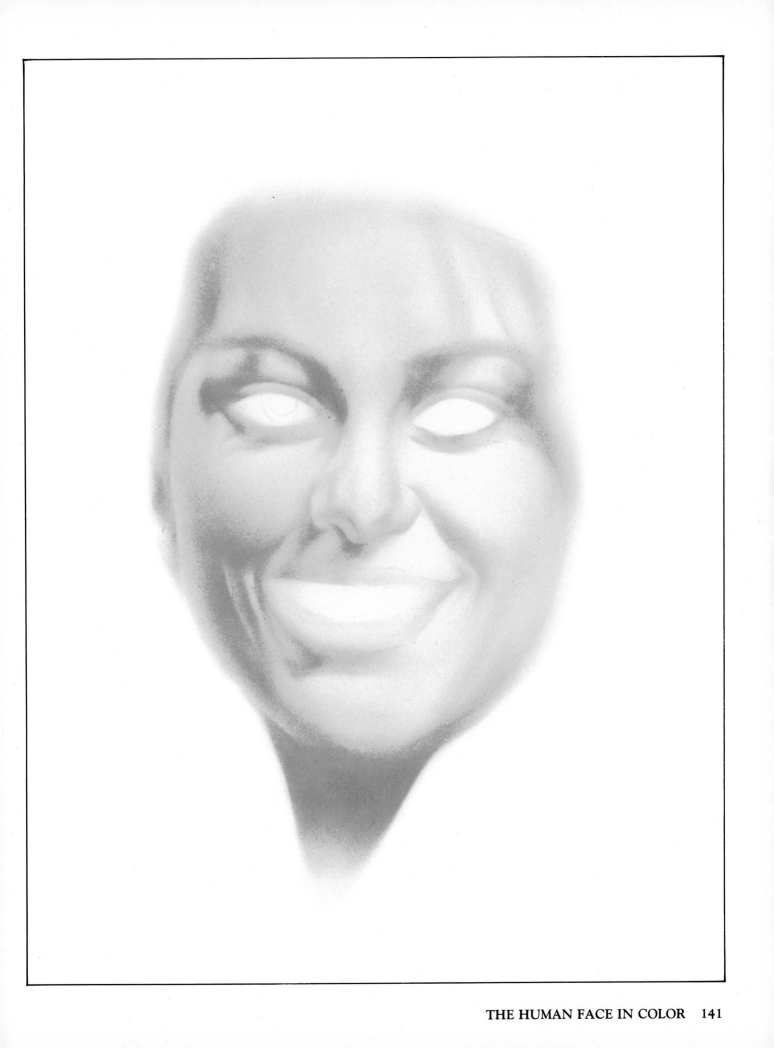

# Step 4

This new, slightly darker tone does for Tone 3 what Tone 2 did for Tone 1: it strengthens the details and enriches the color harmony. The addition of a drop of green is usually necessary because if the brown is too reddish, the skin looks burned. Tones of darker shadow must be colder than the previous dark shadow.

**Note:** If the model had brown eyes, you would color the iris in this step, either by spraying or with brushwork. Because she has blue eyes, they are done in the next step.

Tone 1: 70% permanent white + 20% yellow ochre + 10% cadmium orange

Tone 2: 60% permanent white + 5% cadmium orange + 35% yellow ochre

Tone 3: 10% permanent white + 90% raw umber

**Tone 4: 5% permanent white + 50% raw umber + 45% Vandyke brown + oxide of chromium (if necessary)**

4

## Step 5

At this point, stop building skin tones and concentrate on other details. Several of these are grouped in the same image to simplify the demonstration:

| | |
|---|---|
| Blue irises of eyes (brush or airbrush) | Tone 5 |
| Blue-gray shadows on eyeballs and teeth | Tone 5 |
| Red lips and gums | Tone 6 |
| Cheek color | Tone 6 |
| First hair tone | Tone 7 |

The iris color contains a little black; otherwise the eyes would be too brilliant and seem to pop out of their orbits. The eye tone (even better, a gray blue) can be used faintly to suggest the spherical shape of the eyeballs. Brush and airbrush Tone 5 to define the teeth.

Lips can be many colors, from livid (lighter than Tone 1 with a drop of white or cobalt blue) to dark (Havannah lake). Medium red is used here as a lipstick color. (A man's lips would be slightly darker than his skin, say, like Tone 3 without the green.) The airbrushing of the lips is a rather delicate operation because the resolution is between 1 and 2 for the outline and there is a lot of shield work. Spray the color flatly and uniformly; the value differences will be obtained with other tones in the following steps. Brush gums with the same color.

Use the same lip color, for simplicity's sake, to add pink to the cheeks. This is a delicate $R_{5-6}$ process; too little color will disappear under the next brown tone, and too much will make the woman seem excessively made up. (A man's cheeks would need no red but sometimes a grayish green, also $R_{5-6}$, on the shaved areas.) These cheek details can be added here with gouache, or, if you prefer, as a final step in transparent watercolor.

Hair can be successfully rendered with three layers for black or very dark brown hair, or with four tones for any other color. Dark hair is made with an undertone of color highlights, a brilliant white, and black as the major tone. Fair hair has an almost white gleam, a luminous intermediate tone, and a dark tone of the hair color. Black is used as an accent in spots like the nape of the neck, which is sheltered by the hair, or under the hair that hangs beyond the outline of the face.

This model's hair is chestnut, so the first yellow tone is sprayed on the lightest regions in no specific pattern. Work the hair freehand, using rapid $R_2$ parallel and wavy strokes, in a flat, nearly uniform layer. Sometimes you can use shields rhythmically to suggest bundles of hair near the roots, as is done in the following steps on the hair and eyebrows.

Tone 1: 70% permanent white + 20% yellow ochre + 10% cadmium orange

Tone 2: 60% permanent white + 5% cadmium orange + 35% yellow ochre

Tone 3: 10% permanent white + 90% raw umber

Tone 4: 5% permanent white + 50% raw umber + 45% Vandyke brown + oxide of chromium (if necessary)

**Tone 5: 35% permanent white + 5% lamp black + 60% cerulean blue**

**Tone 6: 10% permanent white + 10% yellow ochre + 80% flame red**

**Tone 7: 100% golden yellow**

5

6

7

## Step 6

Resume the buildup of skin tones with the darkest brown. The area covered by this brown is smaller than that of Tone 4, and the tone does not have to be as cool. The combination creates lively shadows, luminous and dark at the same time. They are sufficiently light that the small amount of black added to the next and final layer of skin tones will be perfectly readable. Because of the minute detail rendered with shields, mostly at $R_1$ and $R_2$, especially around the eyes, nostrils, lips, and ears, the gouache should not be too viscous but rather milky in consistency, so that with a close-range $R_2F_1$ you can trace continuous, thin, wiry lines with no difficulty.

Do not end the brown bluntly at the hairline but go beyond it, just as in reality the shadowed portion of the scalp is covered by lighter hair strands. Only then spray the hair in the manner shown here. You may add stray hair strands at $R_2$ over shadowed areas for greater depth.

Tone 1: 70% permanent white + 20% yellow ochre + 10% cadmium orange

Tone 2: 60% permanent white + 5% cadmium orange + 35% yellow ochre

Tone 3: 10% permanent white + 90% raw umber

Tone 4: 5% permanent white + 50% raw umber + 45% Vandyke brown + oxide of chromium (if necessary)

Tone 5: 35% permanent white + 5% lamp black + 60% cerulean blue

Tone 6: 10% permanent white + 10% yellow ochre + 80% flame red

Tone 7: 100% golden yellow

**Tone 8: 80% Vandyke brown + 20% Havannah lake**

**Tone 9: 10% permanent white + 70% raw sienna + 20% cadmium orange**

# Step 7

Continue with the hair and finish all accents of black as follows:

1. Finish the last hair tone (10), including the darkest areas, which will eventually be sprayed with black.
2. Hand-brush with black (11) the pupils, eyelashes, the corners of the mouth, the deepest part of the ear, and the darkest parts of the hair, as indicated by the solid black areas on the schema.
3. Extend and fade the brushed black, with the airbrush, into the dark brown tone wherever necessary, as shown.

At this stage the portrait is essentially complete; all that remains is the application of cosmetics.

Tone 1: 70% permanent white + 20% yellow ochre + 10% cadmium orange

Tone 2: 60% permanent white + 5% cadmium orange + 35% yellow ochre

Tone 3: 10% permanent white + 90% raw umber

Tone 4: 5% permanent white + 50% raw umber + 45% Vandyke brown

Tone 5: 35% permanent white + 5% lamp black + 60% cerulean blue

Tone 6: 10% permanent white + 10% yellow ochre + 80% flame red

Tone 7: 100% golden yellow

Tone 8: 80% Vandyke brown + 20% Havannah lake

Tone 9: 10% permanent white + 70% raw sienna + 20% cadmium orange

**Tone 10: 70% cadmium orange + 30% raw umber**

**Tone 11: 100% black (ivory)**

## Step 8

The addition of counterlight as indicated in the schema enhances the three-dimensionality of the portrait, creates definite contrast between hair and skin, and enriches the color harmony. The major light is warm, so the choice for counterlight is cool; accentuate the coolness by spraying Tone 12 on top of Tone 10, thus creating a cool T zone as well.

Because most of the skin surface is more or less covered with color in the process of spraying, some luminous touches might be needed at points where light reflects directly from source to observer. For these areas (compare step 7 with step 8) use zinc white (Tone 13), which is more transparent than permanent white, so that even these highlights will be colorful. Apply permanent white (Tone 14) almost dry, with a brush, for the glistening points on eyes and lips.

Tones 15 and 16 are cosmetics, the first for the upper lids, the second for the area between brows and lids; both should be sprayed before Tone 8, but they are not rendered here because they are not necessary to your education at this stage. When you do this portrait, you should include them.

Tone 1: 70% permanent white + 20% yellow ochre + 10% cadmium orange

Tone 2: 60% permanent white + 5% cadmium orange + 35% yellow ochre

Tone 3: 10% permanent white + 90% raw umber

Tone 4: 5% permanent white + 50% raw umber + 45% Vandyke brown

Tone 5: 35% permanent white + 5% lamp black + 60% cerulean blue

Tone 6: 10% permanent white + 10% yellow ochre + 80% flame red

Tone 7: 100% golden yellow

Tone 8: 80% Vandyke brown + 20% Havannah lake

Tone 9: 10% permanent white + 70% raw sienna + 20% cadmium orange

Tone 10: 70% cadmium orange + 30% raw umber

Tone 11: 100% black (ivory)

**Tone 12: 50% oxide of chromium + 30% lamp black + 20% yellow ochre**

**Tone 13: 100% zinc white**

**Tone 14: 100% permanent white**

**Tone 15: 70% Parma violet + 30% permanent white**

**Tone 16: 80% lemon yellow + 10% yellow ochre + 10% permanent white**

**Note:** For obvious technical reasons steps 1 to 7 have been reproduced from transparencies shot during the portrait elaboration. Only step 8 has been reproduced from the completed original. You may detect considerable alterations of colors in the first seven steps.

This portrait is simple. A portrait of an older person would be much more complicated; the wrinkled skin would require a greater amount of shield work. As you master good portrait technique, you will have more flexibility in the sequence of the layers, even while respecting the principle of building from light to dark or the reverse. The number of colors, tones, and hues can be varied endlessly. Instead of having just one counterlight, you can add sources of light and counterlights. The possibilities are infinite.

Now that you have seen the rendering of an airbrush portrait step by step, it is interesting to return to the earlier analogy with the color printing process. As you know, color illustrations in books and magazines are printed with only four colors:

magenta, process yellow, cyan (process blue), and black. If you look at such a reproduction through a linen tester, you can see that the size of the dots and the way they overlap are what create optically the variety of hues and tones. A challenging task would be to re-create the sixteen tones of the portrait demonstration from the four process colors alone. An impossible task would be to *spray* only the four colors to get the same values. Such an exercise would require formidable knowledge of color and color vision, enormous training, and time-consuming effort—the ultimate extension of the theory described here.

This concludes the exposition of airbrush methods and techniques; the practical guidance is over. The remainder of the book consists of a gallery of airbrush works created by a variety of artists and some reflections about you and the airbrush. Although these sections are more entertaining and easier to read, it is no less important that you study and think about them; as you have been reminded so often, technique without thought is pointless.

Figure 15-2. The four process colors: magenta, process yellow, cyan, and black.

# GALLERY

This short portfolio has been devised to demonstrate that the airbrush, far from being a mechanical device, molds itself to each artist's personality; to show that intention, vision, concept, and sensitivity are fundamental ingredients in an inexhaustible number of solutions to the artistic quest; and to show that each artist uses the airbrush differently, making his or her own unique contribution to the endless realm of airbrush experience.

A surprisingly large number of enthusiastic artists offered their works for this purpose; we have chosen some of the most appropriate pieces to illustrate the theme of the book. To these artists goes our gratitude.

*Back to School*
Client: *National Lampoon* (cover, September, 1981)
Art Director: Skip Johnston
20" × 30" (51 × 76 cm); color pencil and dye watercolor on illustration board with frisket and templates

## Jeanette Adams

The hand of Jeanette Adams is always recognizable within the many styles she uses as means of expression. She is constantly in search of new techniques and new "accidental" experiments to expand the spectrum of her artistic values and definitions. A former fine art student, Ms. Adams derives so much personal and professional pleasure from her art that she works constantly, and often refers to herself as a "workaholic."

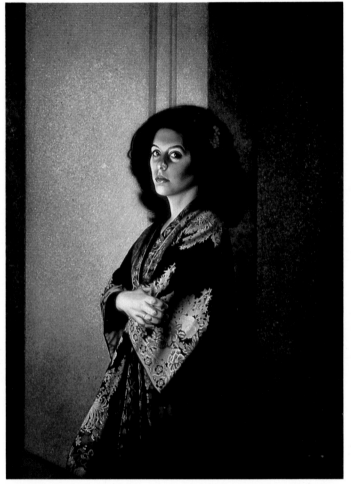

*Lauri Ingber's Portrait*
20" × 30" (51 × 76 cm); gouache dyes and pencil on illustration board; background, freehand airbrush with sponge and toothbrush; robe underpainting, colored pencil and frisket and template with airbrush, and painted face

*RCA. The Changing Corporate Scene*
Client: *Business Week*
Art Director: Malcolm Frouman
16" × 22" (41 × 56 cm); dyes and gouache on illustration board with brush painting underneath and airbrush over frisket and templates

*Birthday Blast*
Client: Paper Moon
13" × 17½" (33 × 44 cm); gouache airbrush, watercolor dyes, and color pencil on illustration board.

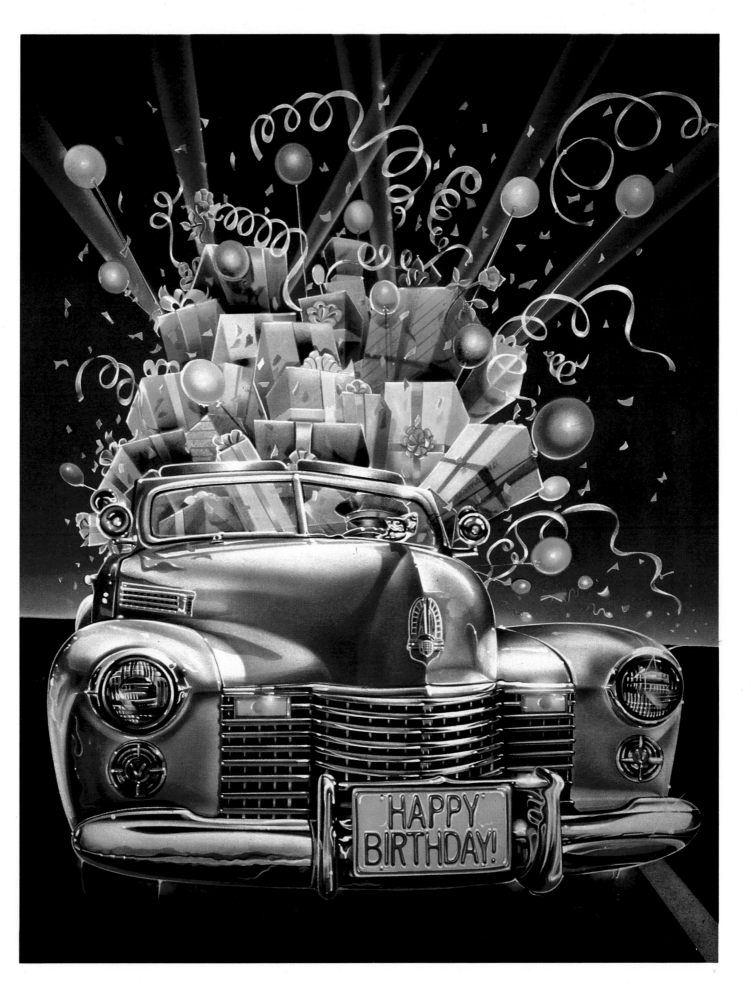

## Leslie Cabarga

Young, intelligent, and talented, Leslie Cabarga is already a major artist who applies a broad spectrum of techniques to diverse subjects and artistic problems. He states that he has always been influenced by the artistic styles of the 1920s and 1930s, and most especially the European poster art of those periods. He enjoys using strong contrasts between shapes, tones, and textures, and prefers to make the fact of his airbrushing obvious in his works. His work has appeared on *Time* magazine covers, record album covers, books, and in many other places.

*Peter Mintun-Deep Purple*
Client: Cue Records
Art Director: Leslie Cabarga
18" × 18" (46 × 46 cm); gouache on illustration board with frisket and acetate

*Lech Walesa*
Client: Time, Inc.
Art Director: Nigel Holmes
17" × 22" (43 × 56 cm); ink and gouache on paper-covered illustration board with frisket and acetate.

(Reprinted by permission from TIME)

*Manhattan Transfer*
Client: Atlantic Records
Art Director: Sandi Young
18" × 18" (46 × 46 cm); gouache on illustration board with frisket and acetate.

## Olivia De Berardinis

Olivia De Berardinis has been creating commercial illustration since 1975, combining fine brush work with airbrush. Her unique style has often been seen on greeting cards, movie posters, magazines, paperback book covers, and video cassettes. Olivia is best known for her "pin-up" style illustrations of sexy women, which are published monthly in six countries.

*Fiorucci I*
Client: Fiorucci
25" × 32" (64 × 81 cm); oil over acrylic on Strathmore illustration board with frisket, acetate, and freehand airbrush

*Fiorucci II*
Client: Fiorucci
25" × 32" (64 × 81 cm); oil over acrylic on Strathmore illustration board with frisket, acetate, and freehand airbrush

## Carol Gillot

Carol Gillot is an artist-illustrator whose artworks are influenced by the delicate lines and color gradations of old Japanese wood-block prints. The air-brush, she finds, is the most suitable method of obtaining these effects.

*Iris Perfume*
Self-promotion
9" × 10" (23 × 25 cm); gouache (cake) and ink on two-ply Bristol paper with frisket

*Morning Glory*
Client: Ruby St. Greeting Cards
8½" × 12½" (22 × 32 cm); gouache (cake) and ink on two-ply Bristol paper with frisket

*Perfume Bottle*
Self-promotion
4⅛" × 7" (10 × 18 cm); gouache on two-ply paper with frisket

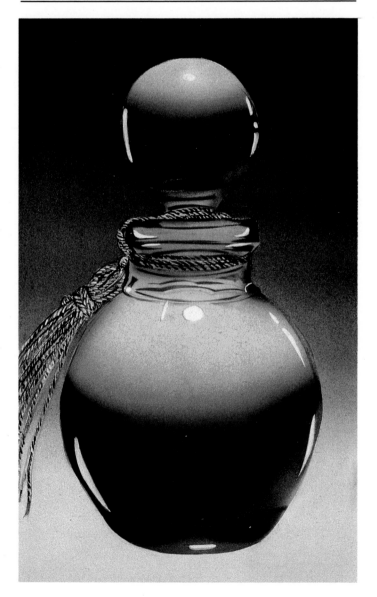

# Ellen Going (Jacobs) Hellams

(Represented by Joanne Palulian)

A prolific imagination and a dramatic sense of color are the hallmarks of Ms. Hellams' style. She has combined her extensive medical training with these talents, and the results have won her the attention and admiration of major pharmaceutical companies and their advertising agencies. Few have her genius for turning villainous microscopic organisms into objects of incredible beauty.

*Plasma Cell*
Client: Postgraduate Medicine
Art Director: Tina Adamec
14" × 14" (36 × 36 cm); gouache, watercolor, acrylic, and colored pencil on colored illustration board, with acetate and paper templates

*Back Talk*
Client: Roche Laboratories
Agency: Mediagraphics, Inc.
Art Directors: John Trentalange and Tom Domanico
16" × 20" (41 × 51 cm); watercolor on two-ply paper with acetate, templates, and freehand airbrush, plus colored pencil

*Staph Wars*
Client: Upjohn International Advertising Department
Art Director: Jack Roderick
20" × 30" (51 × 76 cm); acrylic, gouache, watercolor, and colored pencil on illustration board, with acetate, templates, and freehand airbrush

## Earl L. Kvam

Earl Kvam is undoubtedly a great magician of the airbrush and probably the best visionary of science and medical "humanscape" in the United States. No reproduction can do him justice; his work must be seen in the original in order to be understood and admired. He is one of the few artists who uses the airbrush beyond immediate commercial purposes.

*Internal Potential and Kinetic Energy*
Client: Silver-Burdette Publishers
3⅝" × 9¼" (9 × 23 cm); Elmer's glue with watercolor and gouache for background treatment and acetate and template for illustration

*Hotness + Heat —Internal Motion*
Client: Silver-Burdette Publishers
3⅝" × 9¼" (9 × 23 cm); Elmer's glue with watercolor and gouache for background treatment and acetate and template for illustration

*Middle Ear Structure*
Client: William Douglas McAdams, Inc., for Hoffman-La Roche, Inc.
18" × 24" (46 × 61 cm); gouache on illustration board with acetate and templates

*Pituitary Gland and Environs*
Client: William Douglas McAdams, Inc., for Hoffman-La Roche, Inc.
18" × 24" (46 × 61 cm); gouache on illustration board with acetate and templates

*Goodyear Blimp*
Award: New Jersey Art Directors' Club
20" × 30" (51 × 76 cm); ink on illustration board with freehand airbrush
and frisket.

## Andrea Mistretta

To have developed an impressive list of clients and to have won many awards by the age of twenty-five is quite unusual. Ms. Mistretta, however, has done just that, and is a rising star in American graphic art. With an intense spirit of observation and constant interest in expanding her technical and emotional modes of expression, she is one of the most interesting young artists working in the field of airbrush today.

*The Classy Bag Lady*
Client: Unlimited Possibilities
Awards: Society of Illustrators; New Jersey Art Directors' Club
15" × 20" (38 × 51 cm); ink on illustration board with freehand airbrush and frisket

© 1979 Andrea Mistretta

*Chocolate Bar*
Client: Unlimited Possibilities
Award: New Jersey Art Directors' Club
20" × 30" (51 × 76 cm); ink on illustration board with freehand airbrush and frisket

© 1979 Andrea Mistretta

# Kirk Moldoff

(Represented by Joanne Palulian)

Kirk Moldoff is a multitalented artist who is well known for both his illustrations and his Plexiglas sculptures. His formal background is in medicine and science, but his creative endeavors are not strictly limited to those fields. His latest works illustrate the depth of his concepts and his mastery of the technique. He is a brilliant young man whose originality and inventiveness seem to have no bounds.

*Wishful Thinking*
15" × 20" (38 × 51 cm); gouache and watercolor on illustration board with frisket and acetate

*DNA*
20" × 30" (51 × 76 cm); gouache and watercolor on illustration board with frisket and acetate

*Human Eye*
15" × 20" (38 × 51 cm); watercolor and gouache on illustration board with frisket and acetate

## Dickran Palulian

(Represented by Joanne Palulian)

Dick Palulian has been working as a free-lance illustrator in the New York City area for over a decade. His work has graced the pages of major publications from *Sports Illustrated* to *Penthouse* magazine. He uses stylization as a catalyst and has a great regard for detail, color, and value; his illustrations radiate a surreal rather than a photoreal look. The end result, one feels, is a vitality that both delights and provokes the senses, yet is devoid of pretension.

*Christmas Ball*
Client: Paper Moon Graphics
Agency: Paper Moon Graphics
Art Directors: Roger Carpenter/Dickran Palulian
16" × 14" (41 × 36 cm); gouache on illustration board with combination of techniques

© Dickran Palulian

*Glass Head*
Client: NEC Electronics U.S.A., Inc.
Agency: Hill, Holiday, Conners, Cosmopoulus, Inc.
Art Director: Paul Regan
18" × 24" (46 × 61 cm); gouache on illustration board with combination of techniques

© NEC Electronics U.S.A., Inc.

# Frank Riley

After graduating as an industrial designer, Frank Riley realized he loved the precision of his drawing technique, but could not reproduce the images of his imagination in this field. He then studied illustration while developing his skill with the airbrush. Believing that the airbrush alone can be used to render any surface or texture completely, he has created works for most major publications, as well as record albums, television commercials, and advertising campaigns.

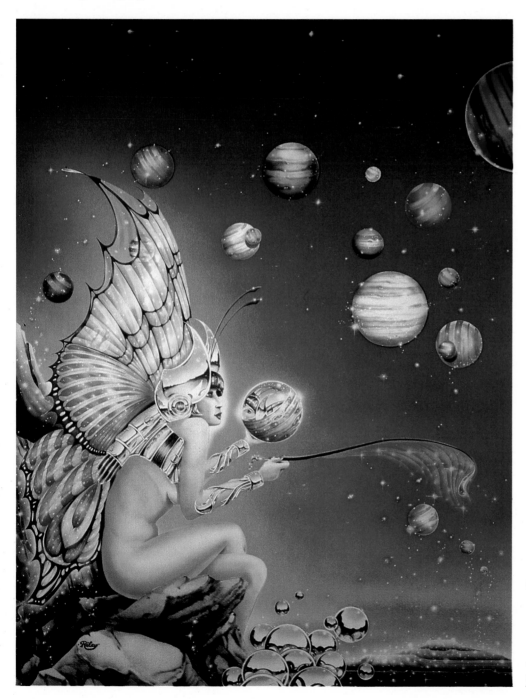

*Designer of the Galaxies*
Client: *Heavy Metal* magazine
Art Directors: John Workman and Frank Riley
15" × 20" (38 × 51 cm); watercolor and gouache on illustration board with acetate, frisket, and freehand airbrush

*Kinky Cable*
Client: Times Fiber Communications, Inc.
Agency: RSM+K
12" × 15" (31 × 38 cm); watercolor on illustration board with freehand
airbrush, friskets, and acetate

*Hybrid Love*
Client: Acard Co.
Art Director: Frank Riley
12" × 16" (31 × 41 cm); watercolor on illustration board with freehand
airbrush and frisket

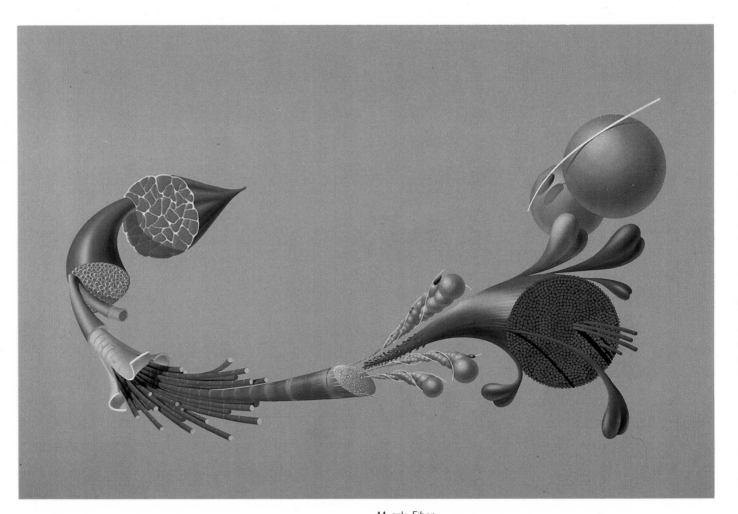

*Muscle Fiber*
Client: Roche Laboratories, Inc.
Agency: William Douglas McAdams
Art Directors: John Trentalange and Tom Domanico
15" × 25" (38 × 64 cm); gouache on illustration board with acetate, shield, and freehand airbrush

© Roche Products Inc.

*Inflamed Bladder*
Client: Roche Laboratories
Agency: William Douglas McAdams
Art Director: Roger Musich
18" × 24" (46 × 61 cm); gouache on Coloraid with freehand airbrush and shield

© Hoffman-LaRoche Inc.

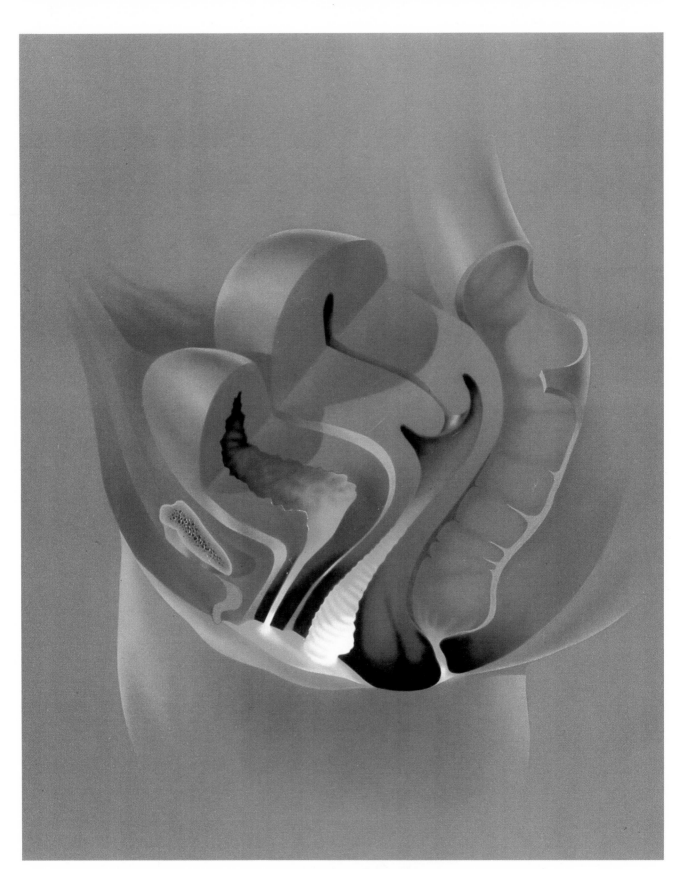

*Urinary Tract Infections*
Client: Roche Laboratories
Agency: William Douglas McAdams
Art Director: Paul Collins
12" × 18" (30 × 46 cm); gouache on Coloraid with acetate and
freehand airbrush

*My Mother*
20" × 30" (51 × 76 cm); Gouache for the portrait, outlined with black acrylic, on
Strathmore cold pressed illustration board. Freehand and shield airbrush with
circle templates for the iris and pupil. Drybrush for the highlights.

VERO

## Kim Whitesides

Mr. Whitesides is a mature artist, and the airbrush is only one technique among the many he uses to realize his concepts. He is very familiar with all of them, but it is in his airbrush works, where drawing and color combine in fascinating visions, that his imagination seems to soar freely.

*Blondie*
Client: The New York *Daily News*
Art Director: Janet Frolich
18" × 27" (46 × 68 cm); watercolor and graphite on illustration board with acetate and shield

(Represented by Madeline Renard)

*Ships*
Client; *D* magazine
Art Director: Fred Woodward
26" × 32" (66 × 81 cm); watercolor on illustration board with acetate and shield

(Represented by Judy Whalen)

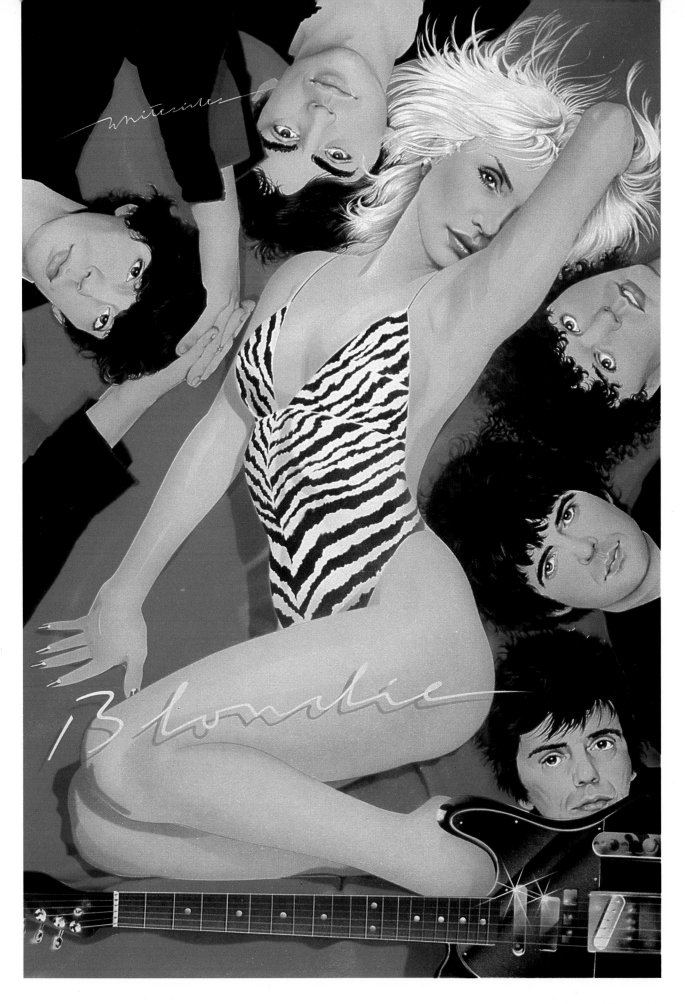

# Constantin Zisu

(Represented by Spano/Roccanova Retouching, Inc.)

Spano/Roccanova Retouching, Inc., is *the* retouching company in New York City. Constantin Zisu, retoucher, is one of the few specialists who combine chemical and graphic techniques with artistic sensibility in order to produce the desired effect that is beyond the requirements of art directors. His sense of color has made the services of Spano/Roccanova much in demand.

(before and after retouching)
Client: Bailey's Irish Cream Liqueur
Agency: Backer and Spielvogel
Art Director: Bruce Dundor
20" × 24" (51 × 61 cm); Paper on illustration board, gouache and watercolor plus Kodak paper dye, frisket, and freehand airbrush

# AFTERWORD:
# REFLECTIONS ON YOU AND THE AIRBRUSH

To most people, letters are symbols of sounds, components of words; they do not really see the letters themselves. Some individuals, however, because of either curiosity or a professional involvement with typography, see letters as entities which they can study and in which they discover a universe of geometry, logic, and sensitivity. To these people, letters are carefully constructed graphic units of our visual language which have been refined to the limits for their structural rhythm. They are capable of appreciating typefaces, criticizing their proportions, proposing changes in them, and even visualizing expressive new designs for them.

You, as a future airbrush worker, must experience a similar mental process, except that your field of observation is the whole world. You will see every object, not as others view it—as one component of the fabric of the universe—but as something that can be analyzed in terms of the airbrush. Think of a clear sky in the evening: from east to west there is an $R_{10}$ transition from dark blue, to purple, to sky blue, to red, to orange, and to yellow if the sun has not yet set. Bend a sheet of paper: with the airbrush in mind, you see the way to render light and shadow; the more you bend the paper, the smaller the resolution of the spray.

Such mental exercises in optical perception, like most other human activities, may attract you increasingly and constantly, or lose their appeal after a while. If your interest is short-lived, you are probably not ready to work; interest is one of the primary symptoms of that mysterious and frightening ability that not everyone has, that those of us who deal with creative art inquire about constantly and uneasily (Do we have it? If we do, how much?): *talent.*

Interest, however, can be motivated by a variety of factors besides talent: a good prospect of making money, the influence of a mentor, ambition and challenge, a need for artistic identity, a desire to work with a certain crowd or live in a particular city. Actually, there is but one motivation that signals artistic talent: the search for intense pleasure in the act of creating art. The true artist enjoys hard work, needs no prodding, no money, and no recognition. Think of Vincent Van Gogh, who painted until he died even though he never sold a single work. Recognition, money, and demand are not always proof of talent but often merely circumstantial necessities.

There are various types of talent. A talent for painting the beauty of a flower is not the same as a talent for painting that same flower as a philosophical symbol. In the one case emotion is portrayed; in the other, reason. Each artist has a different mental attitude through which everything is filtered into a unique personal vision.

Talent cannot be acquired or learned; you have it or you do not. If you do, you can develop it, expand it, and transform it into a means of creative expression. Talent does not survive on its own; hard work is what makes it fruitful.

At this stage of your training you face several fundamental questions: Do I have talent? If so, am I an emotional or a logical person? Do I have something of value to say, and is it original? Why do I want to use the airbrush? Do I have the confidence, patience, and perseverance to work hard, overcome

failures, and strive for excellence? The beginner always grapples with these questions, but you should never lose sight of them. Everyone changes over time, and answers that are true for you today may no longer be valid tomorrow. You must weigh them continually, objectively, and honestly.

**Do You Have Talent?** This is a crucial question, and it is the most difficult to answer. You can work with the airbrush without talent, of course—you can become a skilled technician. Only you can decide if you have talent; ignore all those who tell you that you do not have it or that you do. If the need to work burns in you, if you are restless when you do not work, if you are haunted by visions that you feel you have no choice but to express, you probably have talent.

**Are You an Emotional or a Logical Person?** Your mental makeup plays a decisive role in your artistic development. Few artists ever try to classify themselves as logical or emotional, but it is an important distinction in airbrush work. An emotional person is more at ease with the shield and a logical person with the mask. You know your preferences; if you are interested in geometry and mathematics, even if you do not know much about them, you are logical. If you love nature and poetry, you are more sensitive and emotional. The ideal is a blend of the two, equally developed, contributing equally to artistic endeavor.

**Do You Have Something of Value to Say, And Is It Original?** Vision, whether artistic or scientific, is a characteristic of the creative person, an unexplained mental phenomenon that is the conscious and subconscious elaboration of genetic, educational, and social data. Like the scientist who suddenly envisions the solution to a logical quest, the artist has a sudden response to an emotion or idea; no one understands why. Whether vaguely or sharply defined, the vision is fundamental to the venture, the first step in a long process of hard work that leads to the materialization of the vision. This book deals with the technical aspects of this process of completion. Either you have the vision, which precedes what is written here, or you do not. Some artists imagine in forms; others, in colors. Some imagine in pencil; others, in oil. The study of an instrument or technique, as you saw in the musical analogy in Chapter 13, is an ingredient of the elaboration of vision; it results in a unique relationship between the artist and the instrument or technique. Once you have studied airbrush, your visions will become much more precise in light of what you have learned, like the carpenter who visualizes a cabinet in terms of the wood to be used, the means of assembling its parts, the tools, paints, glues, lacquers, and so on; without knowledge of all these things, the carpenter's work would be seriously handicapped. Airbrush vision is practically impossible without an understanding of the practical aspects of implementation. As vision means you have something to say, to show, it means you have a message. The next question is whether the message has any value.

Beethoven said that one of his main concerns in writing music was his responsibility toward his fellow men. Artistic responsibility means that you must examine your messages critically to assess their potential for positive and negative influence, and their originality and truth.

*Positive or negative influence.* Every action has some impact on the environment. Commercial artists intentionally shape their visions to provoke a desired response in their audience. Their mental process of elaboration from vision to artwork is mainly psychological. Fine artists who express a certain emotion or philosophy or credo influence their audience as well, even if unintentionally. In both cases, the value of the message stems not only from the idea itself, but also from the authenticity of the artist's emotional participation, professional integrity, and means of implementation. Strong negative or positive ideas are weakened if the artist is not emotionally and rationally committed to them. The artist, in sum, must have integrity: you should be selective about the work that you do. As a commercial artist, refuse assignments dealing with products that you consider harmful; as a fine artist, be your harshest critic. In other words, like Beethoven, consider your responsibility to other human beings.

*Originality and truth.* The airbrush itself is an original instrument with an original mode of expression. It is imperative that you study, refine, and exploit airbrush technique to the fullest, so that you do not utilize it like brushwork or pastels. It has its own qualities of texture, vibrance, and harmony that make it original. If your message is not original, however, the originality of a work done with it is merely formal.

**Why Do You Want to Use the Airbrush?** Just as a composer chooses a particular instrument for each piece of music—the piano for one, the violin for another—so you must select the airbrush for precise subjective and objective reasons. There are many reasons why you may wish to express yourself in airbrush: it works quickly; it is clean and precise; it is fashionable; your clients may ask you to; it suits your vision better than any other technique; you love it. The latter reasons are the only valid ones.